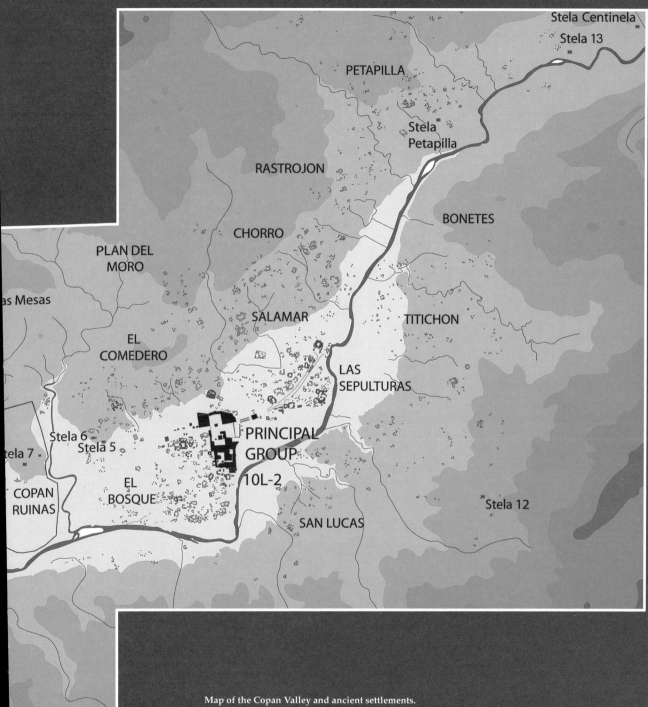

Stela Centinela

Stela 13

PETAPILLA

Stela
Petapilla

RASTROJON

BONETES

CHORRO

PLAN DEL
MORO

as Mesas

SALAMAR

TITICHON

EL
COMEDERO

LAS
SEPULTURAS

Stela 6

Stela 5

PRINCIPAL
GROUP
10L-2

tela 7

COPAN
RUINAS

EL
BOSQUE

Stela 12

SAN LUCAS

Map of the Copan Valley and ancient settlements.
Drawing by Danielle Mirabal and Barbara W. Fash (after Fash and Long in Baudez 1983, vol. 3, maps 25–26).

THE
COPANSCULPTUREMUSEUM

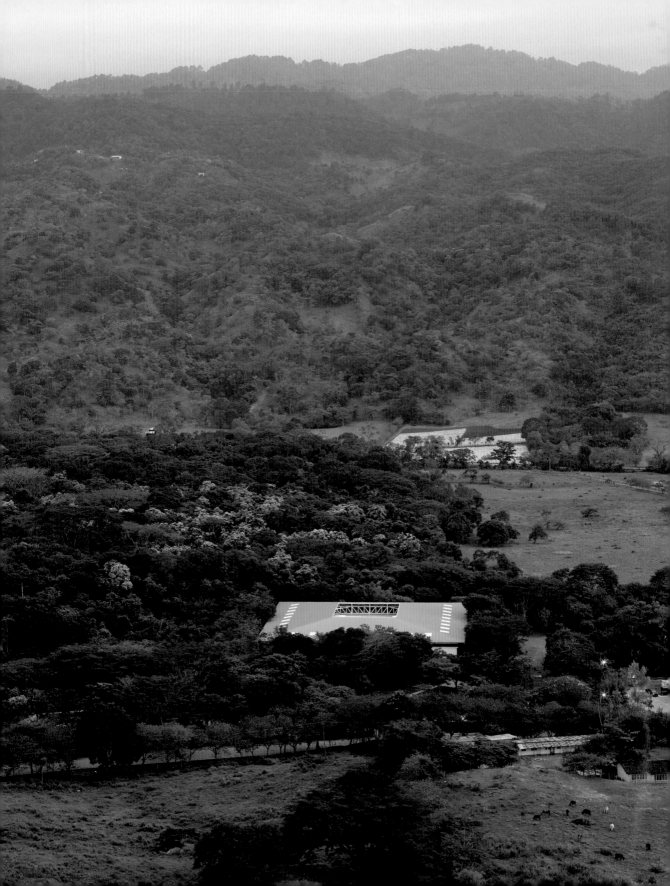

THE
COPANSCULPTUREMUSEUM
ANCIENT MAYA ARTISTRY IN STUCCO AND STONE

Barbara W. Fash

Peabody Museum Press
&
David Rockefeller Center for Latin American Studies
Harvard University
Cambridge, Massachusetts

In association with the
Instituto Hondureño de Antropología e Historia
Tegucigalpa, Honduras

Editorial direction by Joan K. O'Donnell
Editing by Jane Kepp
Design by Daniel Ellis
Composition by Glenna Collett
Production management by Donna Dickerson
Digital prepress by FCI Digital
Printed in China by Everbest Printing Co. through Four Colour Print Group, Louisville, Kentucky

ISBN 978-0-87365-858-4

Library of Congress Cataloging-in-Publication Data:

 Fash, Barbara W., 1955-
 The Copan Sculpture Museum : ancient Maya artistry in stucco and stone / Barbara W. Fash.
 p. cm.
 Includes bibliographical references and index.
 ISBN 978-0-87365-858-4 (English : alk. paper) -- ISBN 978-0-87365-860-7 (Spanish : alk. paper)
1. Museo de Escultura de Copán. 2. Mayas--Honduras--Copán (Dept.)--Antiquities. 3. Maya sculpture--Honduras--Copán (Dept.) 4. Maya architecture--Honduras--Copán (Dept.) 5. Copán (Honduras : Dept.)--Antiquities. 6. Cultural property--Protection--Honduras--Copán (Dept.) 7. Historic preservation--Honduras--Copán (Dept.) I. Title.
 F1435.1.C7F36 2010
 972.83'84--dc22

 2010005198

Front cover: Rosalila replica as seen through the tunnel entrance. Photograph by Ben Fash, 2010.
Back cover: Maize dancer from the Structure 8N-66S façade. Photograph by Barbara W. Fash, 1990.
Frontispiece: View of the Copan Sculpture Museum and surrounding valley in 2009. Photograph by Ben Fash.

For Bill,
who was there every step of the way

For Ricardo,
who saw it through

For Rafael Leonardo Callejas,
who believed in it

For William III, Nathan, and Benjamin,
who survived it

and

For the people of Copán Ruinas,
who made it happen

Foreword

Copan is widely recognized as one of the most important Maya archaeological sites. The Copan Sculpture Museum, which preserves and presents some of the finest examples of stone and stucco sculpture at the site, was inaugurated in 1996 thanks to the unwavering dedication of a Honduran team of archaeologists, artists, masons, technicians, and public servants, working in collaboration with an international group of scholars. This book relates the history of this museum as well as the essential involvement of the Copan community.

The combined generosity and technological support of international institutions, museums, and multilateral agencies have provided the Central American community with a world-class museum whose artwork accurately reflects our past and lovingly commemorates our history. I want to take this opportunity to recognize the involvement of two distinguished Honduran citizens: President Rafael Leonardo Callejas and President Carlos Reina, whose efforts were crucial in the establishment of this museum. As a Central American, I also want to applaud the contributions of Barbara W. Fash, the author of this book; William L. Fash, director of the Copan Acropolis Archaeological Project; and Ricardo Agurcia Fasquelle, executive director of the Asociación Copán, who discovered that great masterpiece of Copan artistry, the "Rosalila" temple; and both the Instituto Hondureño de Antropología e Historia and the Peabody Museum of Archaeology and Ethnology at Harvard University. Without the dedication of these individuals and institutions, the work presented here would not have been possible.

It is an honor for Fundación Uno to support the publication of *The Copan Sculpture Museum,* a book that we believe clearly defines and categorically affirms an important aspect of Central America's cultural identity. We are fortunate to now have both the museum and this publication to celebrate the extraordinary beauty of ancient Maya sculptures.

Ernesto Fernández-Holmann
President, Fundación Uno

Contents

THE
COPANSCULPTUREMUSEUM

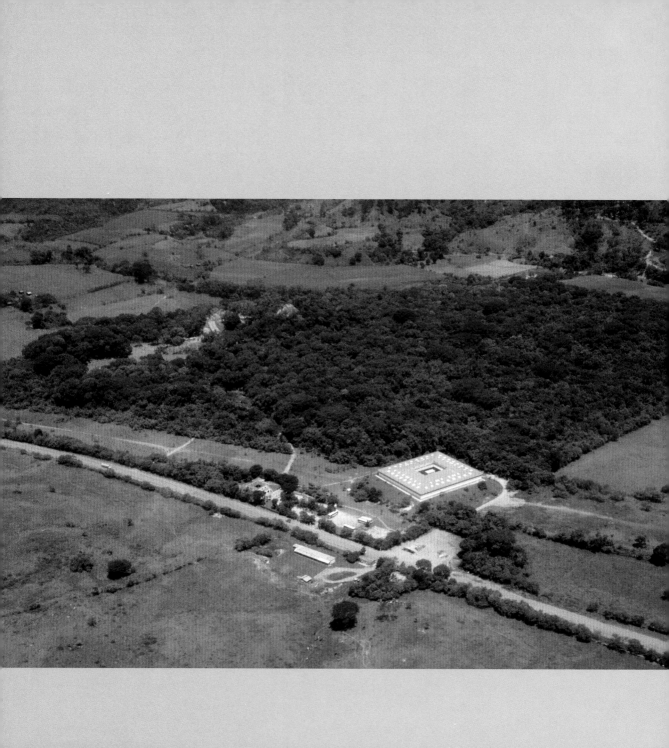

The Story of the Copan Sculpture Museum

The Copan Sculpture Museum features the extraordinary stone carvings of the ancient Maya city known as Copan, which flourished on the banks of the Copan River in what is now western Honduras from about 1400 B.C. until sometime in the ninth century A.D. (**1**). The city's sculptors produced some of the finest and most animated buildings and temples in the Maya area, in addition to stunning monolithic statues (stelae) and altars. Opened on August 3, 1996, the museum was initiated as an international collaboration to preserve Copan's original stone monuments. Today it fosters cultural understanding and promotes Hondurans' identity with the past. The ruins of Copan were named a UNESCO World Heritage site in 1980, and today more than 150,000 national and international tourists visit the ancient city every year. In addition to the Copan Sculpture Museum, the town of Copán Ruinas hosts the Copan Regional Museum of Archaeology, established in 1939.

Copan is justly famous for its intricate high-relief stelae and altars, which are unsurpassed at any other site in Mesoamerica. But its freestanding monuments and architectural sculptures, carved from soft, porous local volcanic tuff, have suffered exposure for centuries to sun, wind, rain, and temperature changes, resulting in flaking, erosion, and loss of details or whole sections of carving. The Copan Sculpture Museum offers a means of conserving many of these vulnerable stone sculptures. Some of the monumental stelae and altars are now protected and exhibited inside the museum, along with lively sculptural façades that archaeologists excavated and

1. The Copan Sculpture Museum from the air, August 1996.

PHOTOGRAPH BY THE AUTHOR.

3

2. Exterior view of the museum, 1996.

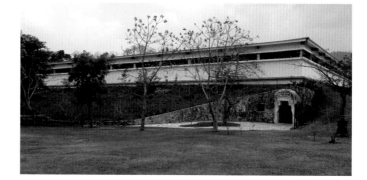

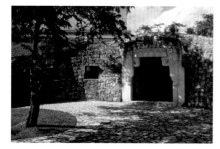

3. Close-up of tunnel entrance to the museum.

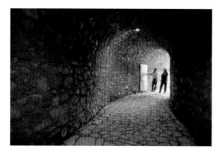

4. Tunnel leading into the museum.

reconstructed from jumbled piles of stone fallen from temples at the ruins. The exhibits represent the best-known examples of building façades and sculptural achievements from the ancient kingdom of Copan, now available to the public for the first time in more than a thousand years.

Architecture and its sculpture were inseparable to the ancient Maya. Like their counterparts in many other early cultures, including those of Egypt, Mesopotamia, and Southeast Asia, Maya rulers and architects planned and constructed temples and their supporting structures as microcosms of their worldview. Often they embedded calendrical and astronomical information in the alignments and proportions of these important structures. Vibrant sculptures decorating the outside walls further illustrated Maya concepts of the world and their place in it. In their most divine aspects, the major temples represented sacred mountains, nexuses from which godlike rulers could traverse paths to supernatural realms, communicate with their ancestors, and influence the forces of nature. Some were funerary temples, honoring important rulers and ancestors. The freestanding monuments, or stelae, were erected to record historical information about the rulers while emphasizing the celestial importance of commemorated events such as births, accessions, calendrical cycles, marriages, warfare, and deaths.

One of the beauties of the Copan Sculpture Museum is that it is an on-site museum, keeping the preserved art as close as possible to its original context. Visitors to the archaeological site of Copan retain fresh images of the ruins and their surroundings as they contemplate the sculptures and buildings reconstructed inside the museum. The museum's proximity to the ruins also reduced the complicated logis-

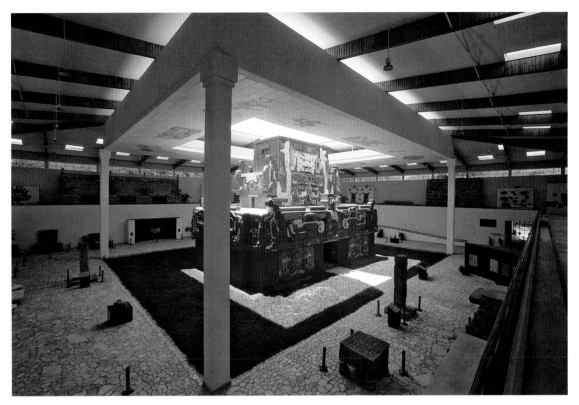

5. The museum's centerpiece, a reproduction of the temple called "Rosalila."

PHOTOGRAPH BY RICK FREHSEE, 1996.

tics and risks that would have arisen in moving immense sculptures over greater distances. Because the museum is situated on a former airstrip cleared in the mid-twentieth century, no danger existed of further destroying major archaeological remains in its construction.

During the planning of the sculpture museum in 1990, it was recognized that the building would become an imposing addition to the Copan archaeological zone. The design team did not want the structure to overwhelm the ruins themselves. With the ancient Maya worldview in mind, the profile of the 45,000-square-foot museum was kept as low as possible, and its lower level was designed in the form of an earthen platform or "mound" like the remains of ancient edifices all over the Copan Valley. Trees hide the exterior (**2**), and the entrance is the stylized mouth of a mythical serpent (**3**), symbolizing a portal from this world to the past world of the Maya.

The entrance leads dramatically into a serpentine tunnel passageway that symbolically transports museum visitors to another

place and time (**4**). It was also designed to give visitors the feeling of passing through the tunnels that archaeologists dig to reveal the earlier constructions buried inside later buildings. The tunnel's darkness and curves, interrupted only by soft illumination, resemble the mythical snake; the humid soil smells like the underground excavations.

Finally, the silent tunnel opens suddenly onto a breathtaking vista—the museum's centerpiece, a magnificent, brilliantly colored sixth-century-A.D. temple replicated in its entirety. This is "Rosalila," so named by Ricardo Agurcia Fasquelle, the Honduran archaeologist who discovered this masterpiece of Copan artistry. It is the most intact building uncovered at the site to date, and its facsimile adorns the center of the museum, surrounded by companion monuments. In its role as the sacred mountain, Rosalila rises from the underworld (the museum's first floor) through the middle world (the second floor) and reaches toward the celestial realm (**5**). The sculpture themes on each floor of the museum are organized to reflect these three levels of Maya cosmology. The building's accent colors reinforce the cosmological sense, with dark earth colors on the lower level, and on the second level, red to symbolize the blood of life.

The museum is a four-sided building oriented to the cardinal points (see inside back cover). It reflects the fact that the four directions and the sun's yearly path are fundamental aspects of the Maya world. Four is also the number associated with the Maya sun god and the parameters of a cornfield, or *milpa,* the foundation of settled village life in Mesoamerica.

Natural light has illuminated the monuments and buildings of Copan for centuries, so every attempt was made to use natural light in the museum without sacrificing preservation. Skylights and a compluvium—an opening at the center of the roof that admits light and rain—allow the sun, in its yearly movements, to highlight some exhibits more than others at certain times or on certain days of the year, just as it does at the archaeological site.

In the words of Angela Stassano, the museum's architect: "Everything [in the museum] has a supernatural quality; it becomes a blend between the past, present, and future. Inside, the ramp with its stylized skyband and the museum itself grow upward to the sky. It has a movement of vertical ascension. . . . There is no other museum like it; that is the heart of its beauty. This was our offering to our culture and to the world. The majority of museums try to stand out, to impose themselves, but not this one; this one attempts to appear invisible

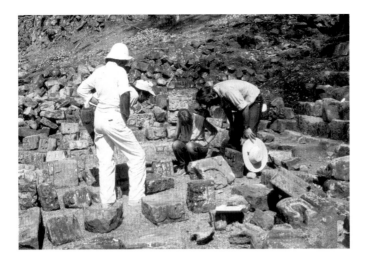

6. Members of the Copan Mosaic Project at work in the ruins, 1985. The author and Bill Fash are on the right.

PHOTOGRAPH BY REINA FLORES.

and humble, just showing the beauty and glory of our past and ancestors."

Creating the Copan Sculpture Museum was an extraordinary project that involved many people from all walks of life, people who shared a vision and forged strong bonds in making it happen. At the highest levels, the museum was a collaboration between the Presidency of the Republic of Honduras, the Instituto Hondureño de Antropología e Historia (Honduran Institute of Anthropology and History, or IHAH), the nonprofit Asociación Copán, and a U.S.-based project funded by the United States Agency for International Development (USAID). The building is an original design by Honduran architect Angela M. Stassano R., working in collaboration with Ricardo Agurcia Fasquelle, William L. Fash (my husband, hereafter referred to as "Bill"), the architectural restorer C. Rudy Larios, and me.

Before the three years it took to design and build the museum—from 1993 to 1996—came years of investigation into Copan's sculpture by a huge team of students, professional colleagues, and volunteers working on projects that Bill and I co-directed (**6**). In 1984, after the two of us had enjoyed some success piecing together the sculpture fallen from the façade of a building known as 9N-82C, or the Scribe's Palace (later restored by Rudy Larios), we began going to the ruins on weekends with some of our co-workers to probe the sculpture piles for motifs we could recognize and reassemble. The following year we proposed what we called the Copan Mosaics Project as a rescue operation to support IHAH in conserving and analyzing the

sculptures that were deteriorating in these piles at the ruins. We started the project by cataloguing and studying the sculptures associated with Copan's ballcourt.

In 1988 we broadened the scope of the mosaics project, and it became one branch of a research and excavation project for the entire Copan Acropolis, the huge mass of superimposed buildings at the core of the ancient city. This endeavor was called the Proyecto Arqueológico Acrópolis Copán (Copan Acropolis Archaeological Project, or PAAC). Rudy Larios came on board with the project, directing all aspects of restoration operations. Linda Schele and David Stuart, both art historians and epigraphers—scholars who study ancient inscriptions—also joined the project and transformed our understanding of the recorded history of the ancient city, the lives and times of the rulers, and the iconography of the sculptural monuments. The Copan Mosaics Project is ongoing today, dedicated to the study and conservation of the tens of thousands of sculpted stone blocks that once adorned the building façades of Copan. My role has been that of project co-director, artist, and sculpture co-coordinator, supervising the cataloguing and contributing to the interpretive analysis of more than 28,000 component pieces of sculpture.

7. Architect Angela Stassano serving as a human scale as the ruins are photographed during planning of the museum, 1993, and (inset) at her desk in San Pedro Sula.

PHOTOGRAPH BY THE AUTHOR; INSET BY EMILY DOTTON.

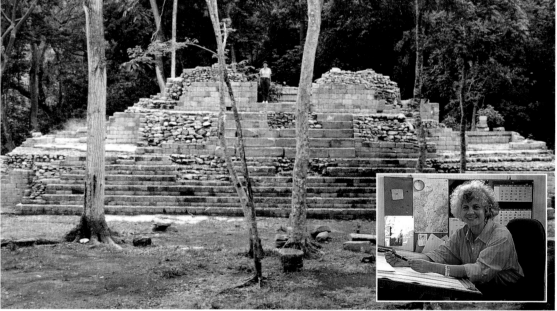

The museum project began as a joint effort between Bill and me and our closest colleague, archaeologist Ricardo Agurcia, executive director of the Asociación Copán and twice director of IHAH. The idea for a museum to preserve and display the sculpture of Copan germinated in our conversations after work during the Copan Acropolis Archaeological Project, often as we watched sunsets over the valley. In 1990 Ricardo and Bill founded the Asociación Copán, a nonprofit organization dedicated to preserving the Copan ruins and disseminating the results of investigations at the site. Through the Asociación, Ricardo hired architect Angela Stassano, who had recently renovated the anthropology museum in San Pedro Sula, Honduras, to design the building. Starting in 1991, Ricardo, Bill, and I, along with our talented friend and colleague Rudy Larios of Guatemala, who served as PAAC's restoration director, met with Angela many times to lay out the core ideas for the museum and initiate the design concept. Angela and I conferred about everything from overall layout to details of iron grille decoration. The two of us even set about the ruins to measure the façades of the buildings we wanted to reconstruct inside, and Angela served as a human scale in our photographs (**7**).

The museum would never have materialized without the vision and support of two Honduran presidents, Rafael Leonardo Callejas and Carlos Roberto Reina. President Callejas, a staunch supporter of preservation of the ruins and the cultural heritage of Honduras, visited Copan only four weeks after he was inaugurated in 1990, and we soon pitched our idea to him in the capital. He quickly gave us his wholehearted approval to move ahead with the plans and generously committed U.S.$1 million to the construction of the building from his presidential funds.

Once the museum plans were finalized, it took over a year to line up a construction firm, and we watched our plans stall in the mire of government bureaucracy. To jump-start the process, Ricardo made a case for administering the presidential construction fund through the Asociación Copán rather than the central government. When this was approved, construction surged ahead. But because of the late start, the museum was not finished during Callejas's term, and it fell to President Reina's administration to complete and inaugurate the museum. Reina gave his full support to the project, saw to its completion, and presided over a grand-opening ceremony and celebration in August 1996. Today a bronze plaque at the entrance to the

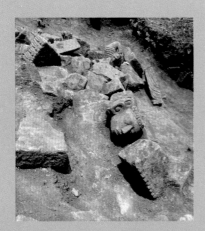

Pieces of sculpture fallen from the façade of Structure 9N-82, during excavation.

PHOTOGRAPH BY WILLIAM L. FASH, 1981.

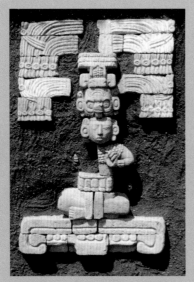

Sandbox reconstruction of a figure from Structure 9N-82.

PHOTOGRAPH BY WILLIAM L. FASH, 1981.

Plan of the distribution of sculptures fallen from Structure 9N-82.

REPRODUCED BY PERMISSION FROM W. FASH 1989.

RECONSTRUCTING COPAN'S SCULPTURE MOSAICS

How does one go about reconstructing the sculptured façades fallen from Maya temples and palaces? Paying careful attention to the patterns in which the sculpture pieces fell from the buildings provides a wealth of information.

First excavation units are laid out and the fallen pieces drawn in their locations within the units. A catalogue number is assigned to each piece and its number recorded on the grid map before it is lifted. Later, we join the maps of all the excavation units into one large map of the entire structure or excavation. With this map we can study the full distribution of the fallen sculpture.

Each numbered piece is drawn, photographed, and catalogued in a file and entered into the database at the Centro Regional de Investigaciones Arqueológicas (CRIA). We then separate them into motif groups, a main element or theme that is repeated on a building's façade. Motifs include things such as feathers, human figures, shields, masks, and plants. Data from the sculpture catalogue have been computerized in recent years for easier access, sorting of motifs, and recognition of building associations. Storage areas at CRIA are lined with shelves to keep the sculpture organized and out of harm's way.

Photographs and drawings are invaluable aids in reconstructing overall façades. Large quantities of sculpture require huge spaces and a lot of heavy lifting if they are spread out for analysis and refitting. Photo mosaics allow us to work on a tabletop or, now, on a computer with less cumbersome images. Ultimately, though, the refittings have to be checked against the actual pieces, because shadows and other details in photographs can be misleading and result in false matches. When the motifs have been refitted, they are reassembled in a large sandbox that Bill Fash designed for this purpose.

At Copan we are fortunate that the sculptors carved the details of the façade stones after they were in place on the building. In most cases this allows us to determine exactly which stones were carved together. Commonly, buildings have identical motifs that repeat around them several times. Yet because of carving techniques, only one true set accurately matches its companion pieces.

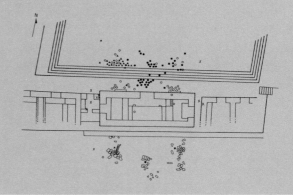

museum heralds the contributions of both presidents, who have become icons for their respective political parties (see pp. 172–173).

By the time we began the museum project, Bill was already an accomplished archaeologist and project director, a successful grant writer, and a seasoned navigator of bureaucracy. While he wrote letters and proposals and gave tours and public lectures, Ricardo made the 14-hour round-trip drive to the capital, Tegucigalpa, almost weekly, carrying paperwork from one government office to the next. He met with construction firms, engineers, and local officials while untangling bureaucratic snags. Quite the dynamic duo, they each had a special charm that won the trust and confidence of both the Honduran and U.S. government officials they engaged along the way. In the end, the construction contract was awarded to Pedro Pineda Cobos, with Raul Wélchez V., an engineer from Copán Ruinas, as project manager. Ground was broken at last in 1993.

Besides the Presidency of the Republic of Honduras and the Asociación Copán, the Instituto Hondureño de Antropología e Historia played a vital role in making the museum a reality. The project would not have survived for long without IHAH's Copan regional director, Oscar Cruz Melgar, who was on hand locally to coordinate the IHAH components of the project. "Profe," as he was known—short for *profesor*—had been with IHAH since 1976 and had long championed the study of Copan's sculpture. As the museum construction progressed, Profe arranged meetings, loaned vehicles, sent people on supply missions to San Pedro Sula, and facilitated the transfer of sculpture between the ruins and the museum site, always with a calm, steady hand and prudent advice.

Long before the museum building was completed, our team began planning and preparing its exhibits. Indeed, the genesis of many of them, like the genesis of the museum itself, lay well back in the Copan Mosaics Project. At the start of that project, piles of loose sculpture—jumbled pieces that had tumbled from the ancient buildings over the centuries—dotted the open spaces and temple staircases around the ruins (**8**). We gave numbers to these heaps and, together with Honduran staff, university students, and Earthwatch volunteers, sorted and catalogued many of them.

In time we were able to distinguish repetitive designs, motifs, and styles, which gave us insights into the themes illustrated on different buildings. Understanding those themes in turn helped us reassign countless stray sculptures to specific buildings of ancient

8. Sculpture from collapsed building façades placed in a pile at the ruins, prior to the work of the Copan Mosaics Project.

PHOTOGRAPH BY THE AUTHOR, 1986.

Copan. Much of the detective work involved excavating previously untouched portions of the structures, which allowed us to match pieces of sculpture that we knew came from a certain building with loose pieces found in the confused surface piles. What had seemed to be a giant jigsaw puzzle (without a box-top guide) proved to be a window onto the artistic masterpieces commissioned by Copan's rulers to showcase their power and impress the city's growing population.

Bill, Ricardo, Rudy, and I wished for these varied and meaningful mosaic sculptures to be reassembled, displayed, and appreciated for centuries to come. As professionals, we follow the international treaty dating to 1964 known as the Venice Charter, which lays out strict reconstruction codes that prohibit overrestoration of original buildings at archaeological sites. IHAH and all other parties engaged in scientific research at Copan abide by these codes, restoring only walls that are found intact. So until the idea of the sculpture museum emerged, it appeared that the once glorious, now fallen temple façades would be forever hidden away in storage areas. Fortunately, international standards do allow for didactic reconstructions in museums, away from the existing archaeological remains.

Since 1977, it had always been part of Copan archaeology projects to incorporate and train Hondurans, especially "Copanecos," as people from Copan refer to themselves, in skills needed to work at the ruins. Once the museum was under way, several key Copaneco staff members shared responsibility with me for the exhibit installa-

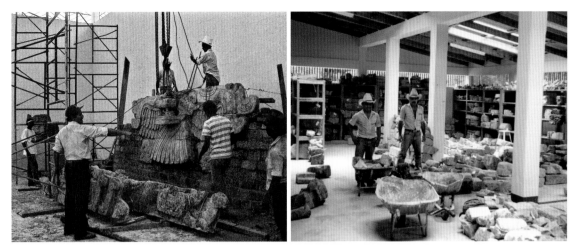

9. Juan Ramón Guerra (left) supervising exhibit installations, 1995.

PHOTOGRAPH BY THE AUTHOR.

10. Francisco ("Pancho") Canán (left) and Santos Vásquez Rosa in the early stages of organizing pieces of sculpture in storage, 1988.

PHOTOGRAPH BY THE AUTHOR.

tions. Foreman and chief enthusiast was Juan Ramón ("Moncho") Guerra, whose Herculean efforts routinely made the impossible possible (**9**). We had no high-tech equipment, so Moncho's ingenuity and improvisations with an old winch and pulley system were vital as he supervised the cushioning and moving of all the sculpture, facing stones, and several-ton stelae by dump truck into the completed museum building. Using humor to energize the workforce, he oversaw the setting up of equipment and scaffolding, the building of the foundation for the Rosalila replica, and the hoisting of cast sections of Rosalila into position.

Meanwhile, Copanecos Santos Vásquez Rosa and Francisco ("Pancho") Canán, archaeological excavators and veterans of the Copan Mosaics Project, used their expertise in masonry and the recognition of sculpture motifs to reassemble the pieces of the building façades we chose to exhibit. Years earlier, Santos and Pancho had heaved and carefully placed all the catalogued sculpture into safe storage at the Centro Regional de Investigaciones Arqueológicas (CRIA) under Bill's and my supervision (**10**). Now, as they worked on each exhibit, we moved all the pertinent sculpture for it into the museum, organized by catalogue number to coincide with my key plans. I worked side by side with them when I could, but as a mother of three, with a job at the Peabody Museum at Harvard University, I had to travel to and from Boston every two months for two-week stints once the exhibit installation was in full swing. Before departing for Boston I would leave Santos and Pancho my detailed drawings,

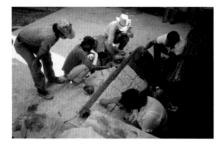

11. Rudy and Leti Larios (upper right and lower right, respectively) with technical staff, creating a cast of Stela 63, 1989.

PHOTOGRAPH BY THE AUTHOR.

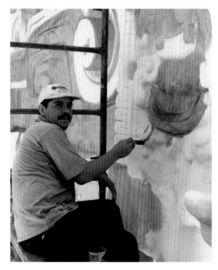

12. Marcelino Valdés, 1996.

PHOTOGRAPH BY WILLIAM L. FASH III.

13. Jacinto Ramírez, 1996.

PHOTOGRAPH BY WILLIAM L. FASH III.

plans, and photographs. They used these as guides to raise the complete façades. Each time I reappeared we pored over the reconstructions, often taking some parts down and reassembling them to make minute corrections in structural details that we had not anticipated when the pieces were on the ground. We often spent hours searching for just the right size facing stone to fill in a gap or developing the perfect mortar mix.

In the end, the three of us, aided by Bill and Rudy at crucial moments, were able to reconstruct the original sculptures for seven complete façades, combining them with faced stones also excavated from the original structures. Still, the reconstructions are meant to be seen as works in progress. We used the structural and iconographic clues available to us at the time to reconstruct the façades to the best of our ability, but we expect that new information will come to light that will advance our interpretations and alter some of the reconstructions now exhibited. For this reason we built all the exhibits using a reversible earth, sand, and lime mortar. This will enable future researchers to change or add sculptures to the exhibited façades in the event that new information or more pieces become available.

In a very few instances we made replicas of sculptures and used them in reconstructions to complement existing motifs or to present a more comprehensive example of a particular image. For example, at Copan's Structure 32, only one human portrait head was found during PAAC excavations in 1990, although the bodies of six human stone figures were uncovered. The other five carved heads had already disappeared in antiquity. To enhance the overall presentation in the museum, we made a replica of the one extant head and installed it with one of the figures in the exhibition. In other instances we used information from identical motifs on a building to reconstruct parts of severely broken sculptures. An example is the reconstruction of the tips of the macaw beaks in the ballcourt façade.

The single greatest challenge in preparing the museum's exhibits was creating the complete replica of the ancient temple called Rosalila. There the team benefited from the experience and expertise brought by Rudy Larios, who designed and supervised the building of Rosalila's foundation structure. With his wife, Leti, he also trained staff and oversaw the molding and replication of many of the other monuments now on exhibit (**11**). Rudy's countless talents and boundless energy made everyone believe that things never before

attempted could be done. His cheers of "Fabuloso!" still ring in the museum halls.

To replicate in clay the stucco designs decorating the original façades of the Rosalila temple, we began with my composite scale drawings, which were derived from accurate technical drawings of exposed sections done by José Humberto ("Chepe") Espinoza, Fernando López, and Jorge Ramos. Chepe had been drawing and carving wooden sculpture replicas before I ever arrived in Copan. Working on many archaeological projects over the years, he had mastered the illustration of ceramics and other artifacts and trained younger artists to work alongside him. Fernando, a skilled topographer, brought a keen spatial understanding of the construction phases of the buried architecture that we were about to reproduce. Jorge had started as a young archaeologist's assistant, excavating with Ricardo Agurcia, and went on to earn a Ph.D. at the University of California, Riverside, in 2006. As of 2007 he was back in Copan, co-directing a project with Bill and me that would teach yet another generation of Copanecos about sculpture analysis and conservation.

14. Marcelino Valdés (foreground) and Jacinto Ramírez modeling the clay replica of Rosalila, 1994.

PHOTOGRAPH BY THE AUTHOR.

Working from my drawings, stone carvers Marcelino Valdés (**12**) and Jacinto Abrego Ramírez (**13**), both superb artists, set out to model Rosalila's spectacular façades in clay. From the clay models, which I checked to maintain accuracy, they made molds that were later cast in reinforced concrete sections. Working as a team, it took us three years to complete the job. I remember how, when the first façade bird was finished, we sat down and revised our calculations of how long it would take to complete the entire structure. We all chuckled in disbelief at what we faced. But despite relentlessly sore backs and the plague of hungry mosquitoes, Marcelino and Jacinto had the time of their lives reproducing that amazing work of art (**14**).

With the concrete façade replicas at last completed, Moncho Guerra had each section hoisted by rope onto the fortresslike framework designed by Rudy Larios and Fernando López. Moncho saw to it that the sections were seamlessly joined in their proper positions, no easy feat on the highest parts of the building (**15**).

The ancient Maya painted their buildings in brilliant colors, and we wanted to replicate the colors as precisely as possible on the reproduction of Rosalila. We needed a paint that would not peel and would resemble the original paint. Finding it was no easy task. Luckily, a chain of helpful referrals led us finally to the Keim Company of Germany, which produces a special mineral paint frequently used in

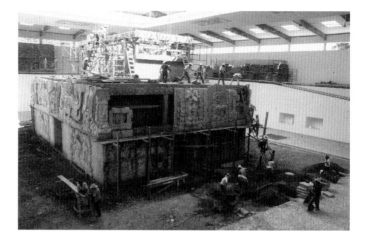

15. Assembling the cast concrete sections of the Rosalila exhibit, 1995.

PHOTOGRAPH BY THE AUTHOR.

outdoor conservation. When mixed with a silicate dilution, the paint petrifies with the cement matrix to which it is applied, creating a long-lasting adhesion that resists the growth of mold and mildew for years. Obtaining the paint, shipped from its American distributor, was not easy, either. It required many long-distance telephone calls, faxes, and e-mails on both ends to track down shipments and negotiate their release through Honduran custom agents. Meanwhile, our colleague Karl Taube, an anthropology professor at the University of California at Riverside, spent hours crawling about the Rosalila tunnels in 1996 to help unravel the complexities of the temple's elaborate color scheme. The vibrant colors seen on the replica today are a direct result of his Sherlock Holmesian efforts.

The Keim Company's paints promised to hold up on some stelae and architectural replicas made for outdoor placement as well. During the museum planning, IHAH sought to bring some original monumental sculptures, still in place at the site, indoors to ensure their long-term preservation. Eight were chosen for display in the museum: Stelae A, P, and 2, Altar Q, the doorway of Structure 22, the skulls on Structure 16, a ballcourt bird-head marker, and the lower niches from Structure 9N-82. The replica team cast copies of them in cement reinforced with iron rods and painted them in colors as close to the original as possible. Signs identify the replicas, which were erected in place of the originals among the Copan ruins, where visitors see them today.

The installation of the exhibits in the sculpture museum took four years to complete. But besides them, the museum building itself

16. Detail of iron railing with skyband designs.

PHOTOGRAPH BY THE AUTHOR, 1994.

needed appropriate architectural accents and finishing touches. In an effort to respect the ancient motifs and not add modern ones, we used simplified features inspired by Maya designs. For example, repeating celestial symbols taken from carved Maya skybands form the iron railings encircling the second level of the museum building (**16**). The serpent body markings on Rosalila are mirrored in the grille work over the contiguous windows. Architect Angela Stassano wanted the serpent motif to convey the sense of its body embracing the viewer as it wraps around the museum.

One of the largest decorative painting jobs to be done was that of the museum's drop ceiling, which hovers above the Rosalila replica. Angela asked me to come up with a design for a painting on the vast white background, and Rudy suggested a celestial theme. I chose the figures from the carved bench of Copan's Structure 8N-66C, excavated by archaeologists from Pennsylvania State University in 1990, and the carved peccary skull from Tomb 1, found during a Peabody Museum expedition in 1892. At night, Moncho would set up a projector for me, and using projected slides of my drawings, I would trace the outlines on the still-unassembled ceiling panels to be painted the next day. I later learned that the workmen thought I had some incredible gift because it seemed that I arrived in the morning to a blank white surface and just started painting. They could not make out my fine pencil lines from the evening before and simply saw images appearing like magic from my brush (**17**).

Among others who helped with the ceiling painting was Luis Reina, an adept draftsman and sculpture cataloguer who had worked

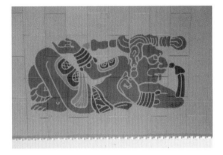

17. Figure of the night sun god painted on the drop ceiling.

PHOTOGRAPH BY THE AUTHOR, 1995.

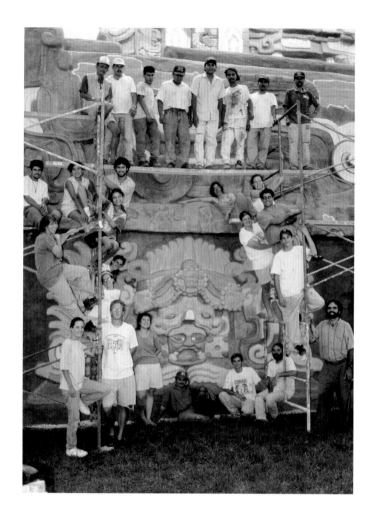

on the PAAC and other excavations. Luis learned every paint recipe for colors on the Rosalila replica and exhibits. He was also responsible for the acrobatic reassembly of the painted panels in the ceiling, for which he risked life and limb on shaky scaffolding that Michelangelo would probably never have set foot on. When the museum opened, IHAH named Luis the museum's manager.

The final painting of Rosalila and the other museum replicas took place in the last month before the museum's opening. To complete it in time it required a cast not of thousands but at least of dozens. Sculptors Marcelino Valdés and Jacinto Ramírez and their Copaneco assistants all stayed many late hours to finish the job, together with Bill and me and our three sons. The students in the 1996 Harvard

19. View of the northwest corner of the museum. Stela P is at right foreground, Altar Q stands at center, and a portion of the stairway of Structure 16 is in the left background, on the lower museum level.

PHOTOGRAPH BY RICK FREHSEE, 1996.

Summer Field School in Maya Archaeology painted too. Many of them stayed for an extra week on their own dime to help finish the job, racing ahead of the rain that would enter through the compluvium, working twelve hours a day, painting away to the booming accompaniment of Bob Marley (**18**).

At times it seemed incredible that with only perseverance and ingenuity, a strong dose of willpower, a few sections of scaffolding, some worn-down wheelbarrows, threadbare wood scraps, and one strong winch we were able to erect all the exhibits in the museum and accomplish the job (**19**). In an interview about the museum videotaped in 2005, Angela Stassano reflected on the team spirit: "It is a source of great pride for everyone that the work was completed, that it was accomplished with the efforts of everyone working together. Especially, the people from the *pueblo* feel proud, and the workers, both those of the construction crew and the exhibition crew . . . because there were employees of all levels working in unison with top professionals, and that was beautiful, because you do not often have the opportunity to bring together and foment that sort of unity." And throughout it all, we continued to be awed by what the Maya of Copan had accomplished 1,300 years before with nothing but stone age technology and people power.

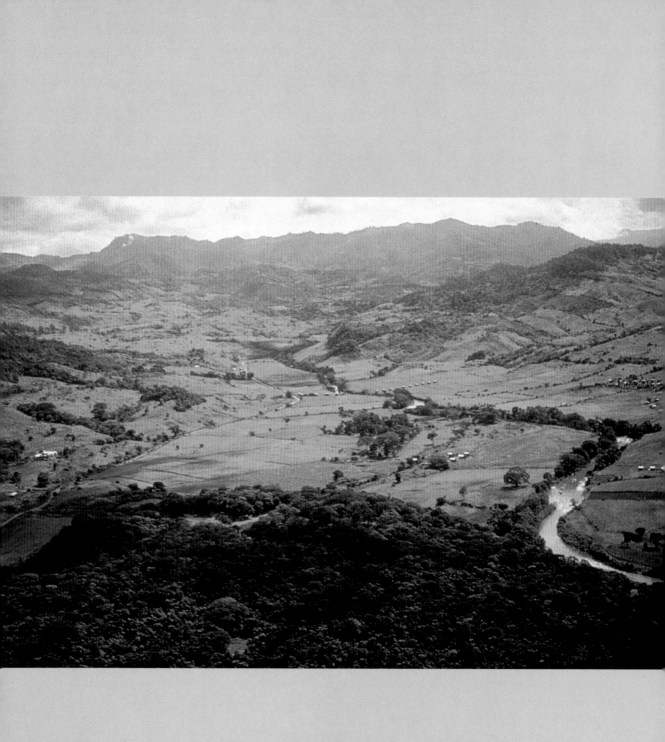

Copan and Its History of Investigation

Copan, the southernmost city of the ancient Maya world, rose to power in a fertile valley carved out by the Copan River, surrounded by verdant mountains rising to about 3,280 feet (1,000 meters) above sea level (**20**). The city's residents enjoyed a subtropical climate with an average yearly temperature of 78 degrees Fahrenheit (25 degrees Centigrade) and two marked seasons—a dry one from December to May and a wet one from May through November.

Like their counterparts throughout the Maya area, which stretched as far north as the Yucatán Peninsula and west to the Pacific Ocean, the people of Copan interacted with members of neighboring Mesoamerican cultures, especially those of central and southwestern Mexico and El Salvador (**21**). They also allied, traded, and intermarried with people from other Maya cities, such as Calak-mul, Palenque, and Tikal, all of which are mentioned in inscriptions on monuments at Copan. Archaeologists find that Maya urban centers often reflect their cosmopolitanism with trade goods from many places, written scripts in a mixture of languages, and distinctive blends of architectural and art styles. What made the ancient Maya remarkable were their highly developed writing, art, urban planning, astronomy, and monumental architecture.

Today, more than 6 million people speaking 26 surviving Mayan languages reside in the same area as their ancestors. Scholars believe that Mayan languages shared a common proto-Mayan ancestor around 2000 B.C., from which branches emerged as groups broke off to settle new areas. Copan was part of the Chol-speaking region. Chorti is still spoken in Maya settlements along the Guatemala

20. The Copan Valley, 1978.
PHOTOGRAPH BY THE AUTHOR.

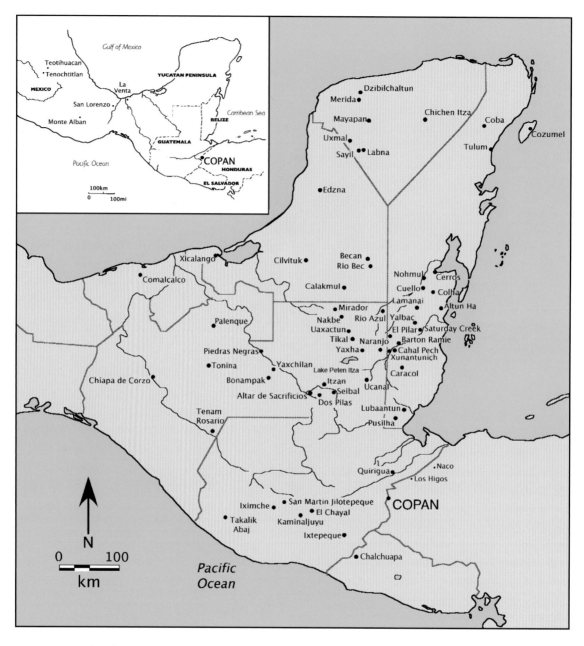

21. Mesoamerica (inset) and the Maya area.

MAP DRAWN BY THE AUTHOR ON THE BASIS OF W. FASH 2001:13 AND LUCERO AND FASH 2006:5.

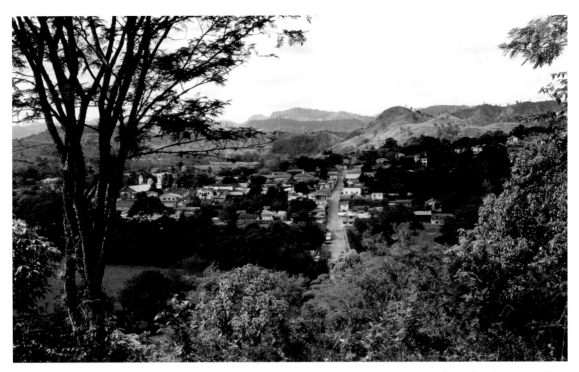

22. The modern village of Copán Ruinas, 1989.
PHOTOGRAPH BY THE AUTHOR.

border and is slowly moving back into Honduras. When the Spaniards arrived and conquered the Maya regions, between 1524 and 1697, they faced many independently ruled kingdoms that fought hard to hold onto their way of life. The Spaniards introduced the Roman Catholic religion, alphabetic writing, and many new diseases during their subjugation of the Maya people. Despite it all, the Maya survived and today carry on many of their ancient traditions, often blended with modern ones. Although Maya hieroglyphic writing and many other practices were lost, the people's distinct identity endured. Revivals of languages, culture, and history in the last century testify to the Maya's beliefs and determination.

The Copan Valley is covered with the ruins of ancient households, often clustered around reliable water sources. Archaeologists completed a survey of the valley in 1980 and mapped more than 3,400 visible house remains, or mounds (see inside front cover). Excavations suggest that at least as many more buildings lie invisible beneath the surface, bringing the total count closer to 6,000 dwellings. Some of these ruins date as far back as 1400 B.C., during the Preclassic period (1800 B.C.–A.D. 200), when small groups of

23. Quarry Hill rock outcrop, one source of the volcanic tuff from which the people of Copan fashioned their buildings and monuments.

PHOTOGRAPH BY THE AUTHOR, 2006.

horticulturists settled in the valley, farmed, and performed religious rituals in sacred caves in the nearby mountains. The population grew considerably until the ninth century A.D., toward the end of the Classic period (A.D. 250–900). Then the ruling dynasty collapsed, and the population diminished. Disease, natural disasters, political unrest, warfare, and environmental degradation all played roles in the decline of this great Maya center. In the sixteenth century, Spanish conquistadors invaded the valley and found the remaining population reduced to a handful.

The modern *pueblo,* or village, known today as Copán Ruinas, was founded in 1870 and named "San José de Copán" for its patron saint (**22**). It lies less than a mile (1.5 kilometers) west of the portion of the ruins known as the Principal Group. The village is built over an ancient ruin that was still visible in 1935. Copán Ruinas has grown considerably since the mid-twentieth century and is now home to more than 6,000 people. To modernize the *pueblo* and improve residents' standard of living, government projects in 1979 made water and electricity available to everyone living in the town proper. The old dirt road to Copán Ruinas, dusty and traversable only by mule in 1938 and later by automobile in the dry season, has been paved since 1980. Hotels, restaurants, and souvenir shops await visitors on many streets, and the municipality expanded public education through the high school level in 1995.

To the north of the Principal Group lies an outcrop of volcanic tuff, the source of the stone from which the ancient people of Copan

erected their buildings and monuments (**23**). From 134 million to 64 million years ago, the valley began to take shape geologically through the deposition of limestones and siltstones. Later, volcanic explosions deposited tuff, a powdery ash that solidifies into porous rock, in thick layers over the valley. The Copan River and its tributaries carved courses through both the tuff layers and the limestone beds, depositing soil and building river terraces and alluvial fans as they traveled. The remains of the oldest houses attest that early farmers settled in the valley, drawn by the fertile soils in which they grew maize and other staples. As the population grew and a complex Maya culture arose, people found the tuff ideal for buildings and sculptures. All but one sculpture exhibited in the Copan Sculpture Museum was carved from this local volcanic tuff. Other quarries of the same stone are still used today for construction in Copán Ruinas and the surrounding area.

The ancient Maya sculptors had no metal tools. Their main carving implements were hard greenstone celts—tools shaped like chisels or ax heads—in a variety of sizes. For finer incising, their tool kit contained sharpened bones and chert and obsidian points. The greenstone, or jadeite, was probably imported from a source in the Motagua Valley, about three days' walk to the east, and obsidian was brought from an outcrop at Ixtepeque in what is today Guatemala, some 50 miles (80 kilometers) distant. Chert was mostly mined locally, but some came from sources traced to modern-day Belize.

The Copan one sees today is dramatically different from the Copan experienced by early foreign visitors to the valley. In the sixteenth century the valley was covered in subtropical forest, and spider monkeys swung in the trees. Wild peccaries roamed the foothills, macaws squawked overhead, and deer abounded. The first written account of the archaeological site came from Diego García de Palacio in 1576, writing to King Phillip II of Spain. He described the stelae of the Great Plaza, which were still standing, and the sculptures on building façades, which had not yet collapsed. He reported that the village near the ruins was called Copan, and the ruins have been called by that name ever since. It is possible that the name derived from that of the native chief Copan Galel, who valiantly defended the district against Spanish invaders in 1530.

The ruins were all but forgotten for the next 250 years until, in 1834, the government of Guatemala sent an archaeological expedition to Copan under the direction of Colonel Juan Galindo. Galindo,

24. The fallen Stela C.

ENGRAVING BY FREDERICK CATHERWOOD, FROM STEVENS
1841:155.

FALLEN IDOL.

who had excavated at other Maya ruins such as Palenque in Mexico, drew public attention to the ruins through books published in London, Paris, and New York. He wrote and drew at Copan for several months and excavated a tomb chamber in the East Court that contained pottery vessels and human bones. Four years later, the famous U.S. diplomat and explorer John Lloyd Stephens, accompanied by the English artist Frederick Catherwood, embarked on a Central American journey that began with a lengthy stay in Copan. The two chronicled their travels in the well-known book *Incidents of Travel in Central America, Chiapas, and Yucatan.* Stephens's lively account and Catherwood's magnificent illustrations awakened Western interest in all of Central America, especially Copan (**24**).

The Englishman Alfred Percival Maudslay undertook the next significant exploration of Copan, in 1885. Traveling on his own, Maudslay conducted the first scientific excavations and recording of monuments at Copan, the results of which were published in London in 1889–1902 in the six volumes of his work *Archaeology* in the series *Biologia Centrali-Americana.* Maudslay was the first to describe the Maya corbelled vault, to create a nomenclature for the monuments and buildings (for example, Stela A and Altar Q), to take extensive photographs at the site, and to supervise the making of drawings and plaster casts of stelae and altars. The six archaeology volumes contain his detailed descriptions and sharp photographs along with superb drawings by artists Annie Hunter and Edwin Lambert. These depictions are treasured today, together with the

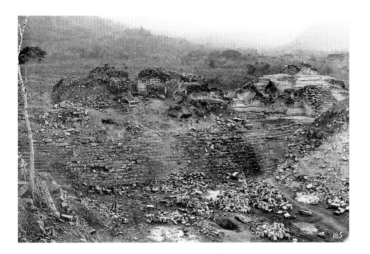

25. Peabody Museum excavations at Copan, including Structures 22 and 21 in the East Court, 1892.

casts, because many Copan monuments have suffered erosion in the past century. Maudslay's maps and descriptions of Temples 20 and 21 are the only reliable records researchers have of these buildings and their sculpture, for both buildings washed into the Copan River in the early 1900s. Maudslay transported the plaster casts and a substantial inventory of Copan sculptures, including the carved figural and hieroglyphic step from Temple 11, to the British Museum, where they remain today.

With an edict from the Honduran President, the Peabody Museum of Archaeology and Ethnology of Harvard University undertook expeditions in 1891–95 and 1900, focusing its efforts on Copan's Acropolis. The Peabody's work was important for the discovery of nine stelae and the excavation of the Hieroglyphic Stairway of Structure 26, whose glyphs compose the longest pre-Columbian text known in the Americas. The museum's teams also worked on the Reviewing Stand of Temple 11 in the West Court, on some East Court buildings, and at the royal residential area south of the Acropolis, known as El Cementerio because of the many burials unearthed there. Marshall Saville led the first of the four Peabody expeditions, in 1891–92 (**25**). John Owens, the second expedition director, fell ill with a tropical fever and died in Copan in 1893. He was buried in front of Stela D in the Great Plaza, where a weathered plaque now marks his grave. Alfred Maudslay was persuaded to head the excavations in 1893–94 and was followed by Owens's assistant, George Byron Gordon, who later published *The Hieroglyphic Stairway, Ruins of Copán*. Gordon also explored the caves north of the village along

26. Sylvanus Morley in Copan with the Carnegie Institution of Washington expedition, ca. 1912.

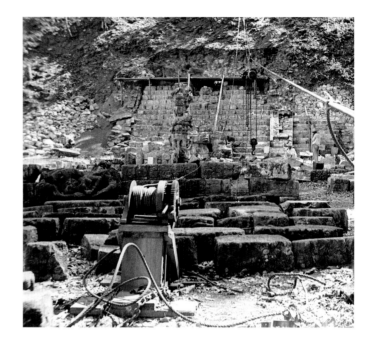

a stream known as Quebrada Sesesmil. As part of its contract with the Honduran government of the time, the Peabody Museum obtained a collection of more than 600 casts of Copan sculptures and approximately 300 pieces of original sculpture, including a seated figure and 15 random glyph blocks from the Hieroglyphic Stairway.

Early in the twentieth century, several scholars made important contributions to our knowledge of Copan. Herbert J. Spinden wrote *A History of Maya Art: Its Subject Matter and Historical Development,* a complete analysis of the style, content, and meaning of Maya art, using copious examples from Copan. American scholar Sylvanus G. Morley made many visits to Copan between 1910 and 1919 (**26**). He took hieroglyphic decipherment to new levels in his massive 1920 book *The Inscriptions at Copán* by calculating the dates of all the known monuments. Morley's personality and enthusiasm endeared him to the townspeople of Copán Ruinas and to the Honduran government. His resourcefulness and diplomacy enabled the Carnegie Institution of Washington, which hired him as field director for its Central American Expedition in 1915, to carry out an extensive archaeological study at Copan in conjunction with the Honduran government. The amicable and capable Morley, who participated in Carnegie projects until 1946, set the tone and the standards for foreign collaboration with Central Americans in future scientific endeavors.

During the later Carnegie years at Copan, 1935–46, after a lapse in fieldwork following World War I, a new team of workers restored many of the buildings and monuments of the Principal Group, including Ballcourt A, Temple 11, the temple at the top of Structure 22, the Hieroglyphic Stairway of Structure 26, and the stelae of the Great Plaza (**27**). Gustav Strømsvik, field director for the Carnegie's later expeditions to Copan and a legendary figure in Copán Ruinas—known locally as "don Gustavo"—directed or personally carried out the great majority of this reconstruction work (**28**). He also used his practical engineering skills to oversee the building of the archaeology museum and fountain on the village square in Copán Ruinas, and he supervised the rechanneling of the Copan River away from the Acropolis, where it had caused severe damage.

Morley, working more in Yucatán at this point, also arranged for the Carnegie team to hire the accomplished architect Tatiana Proskouriakoff to execute reconstruction drawings of the architecture of Copan and other Maya sites (**29**). Proskouriakoff had graduated from Pennsylvania State University and caught Morley's attention while she worked for a University of Pennsylvania expedition. Her beautiful

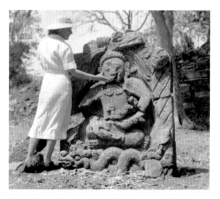

29. Tatiana Proskouriakoff at Copan with the Carnegie Institution of Washington expedition, 1938.

COURTESY PEABODY MUSEUM OF ARCHAEOLOGY AND ETHNOLOGY, © PRESIDENT AND FELLOWS OF HARVARD COLLEGE, NO. 58–34–20/74139.

30. Reconstruction painting of Copan's Principal Group and Acropolis by Tatiana Proskouriakoff, 1943.

COURTESY PEABODY MUSEUM OF ARCHAEOLOGY AND ETHNOLOGY, © PRESIDENT AND FELLOWS OF HARVARD COLLEGE, NO. 50–63–20/18487.

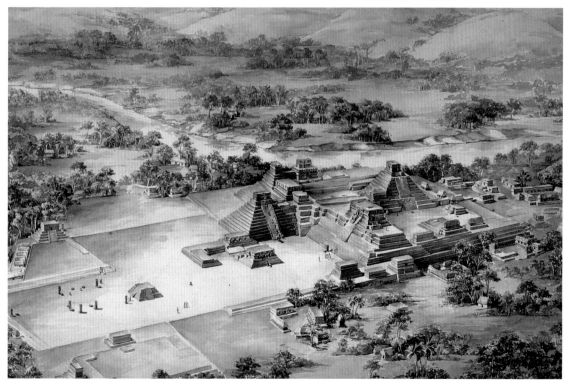

31. Jesús Núñez Chinchilla photographing façade sculpture, ca. 1950.

32. IHAH staff at Copan, 1989. Left to right: Miguel Rodríguez, J. Adán Cueva, Manuel de Jesús Cueva, Oscar Cruz, Victor Cruz, Ricardo Agurcia.

watercolors of Copan, now at the Peabody Museum, are frequently reproduced and admired for their accurate and insightful glimpses into a grand ancient city (**30**). Proskouriakoff's keen observation of the abundant fallen sculptures around Copan allowed her to produce some remarkable reconstruction drawings that reincorporated the fallen blocks into the once-existing façades. Her pioneering work formed the foundation upon which the ongoing Copan Mosaics Project and the Copan Sculpture Museum were built.

In 1952 the government of Honduras took steps to establish the Instituto Hondureño de Antropología e Historia (IHAH) under the direction of Jesús Núñez Chinchilla (**31**). He continued the restoration work in the Principal Group and conducted excavations in the valley. Núñez Chinchilla had received training while working with archaeologist John Longyear, a staff member on the Carnegie expedition, excavating and sorting ceramics from ruins in the vicinity of the Principal Group. In his thorough study *Copán Ceramics* (1952), Longyear published the first detailed map of the ruins and house mounds in the valley, made by surveyor John Burgh. Under Núñez Chinchilla, IHAH set about to preserve as many loose sculptures as possible by bringing them to the Copan Regional Museum of Archaeology at Copán Ruinas and to a small storage room at the entrance to the ruins. Although the exact proveniences of most of these pieces have been lost over the years, the sculptures were saved from disappearing forever into looters' hands. In 1971 IHAH built a fence to delimit the perimeters of the site core and to enclose and protect the Principal Group. The new fence was erected atop the foundations of a stone wall the Peabody expedition had constructed in 1895 to keep out cattle.

In the mid-1970s, another sequence of investigations commenced that has continued without pause to the present. At that time, José Adán Cueva, a Copaneco who had worked with Morley as a young man and whose father had assisted the earlier Peabody expeditions, directed IHAH (**32**). He proposed that the Honduran government fund investigations in Copan, and he invited Gordon R. Willey, Bowditch Professor of Central American Archaeology and Ethnology at Harvard University, to design a long-term program of research and preservation (**33**). Willey conferred with colleagues William R. Coe and Robert J. Sharer, of the University Museum of the University of Pennsylvania, before initiating an archaeological survey of the Copan Valley and preparing recommendations for future work.

Over the next three years, 1974–77, Willey directed a multidisciplinary project that focused on the residential areas in the valley around the Principal Group. Extensive mapping and household excavations by Willey and his students Richard Leventhal and William Fash (Bill) revealed new evidence about ancient Maya settlement patterns and socioeconomic history. The team combined this evidence with new data from geographers and geologists who worked at reconstructing the valley's ancient environment and agricultural history. Longyear's ceramic studies were updated, and Willey published the new studies in *Ceramics and Artifacts from Excavations in the Copán Residential Zone.* Bill, then a doctoral student at Harvard, wrote his dissertation about ancient Copan's rise to statehood. He arranged for me to come to Copan in 1977 to draw artifacts for the Harvard project. That year the excavations brought to light a hieroglyphic bench, which I had the privilege of drawing, and it set our future endeavors in motion.

This phase of Harvard research ended in the summer of 1977, and later that year the Honduran government began funding the Proyecto Arqueológico Copán (PAC). Claude F. Baudez, of the French Centre National de Recherche Scientifique, directed the first phase, PAC I (**34**). An international group of archaeologists and staff members completed and published Harvard's valley map, test-excavated habitation areas all across the valley, continued the ecological studies, renewed excavations in the Principal Group, resumed hieroglyphic and iconographic studies of the monuments, initiated a catalogue system for the loose sculpture, and constructed a modern archaeological research facility. Additionally, PAC I workers and researchers began to investigate the earlier levels of construction buried beneath the Acropolis and carried out the first scientific

33. Gordon R. Willey sorting pottery at Copan, 1977.

PHOTOGRAPH BY MURIEL HOWELLS, COURTESY PEABODY MUSEUM OF ARCHAEOLOGY AND ETHNOLOGY, © PRESIDENT AND FELLOWS OF HARVARD COLLEGE, DETAIL OF NO. 2003.14.89.

34. PAC I director Claude Baudez, 1979.

PHOTOGRAPH BY ISABELLE BAUDEZ, COURTESY IHAH ARCHIVES, COPAN.

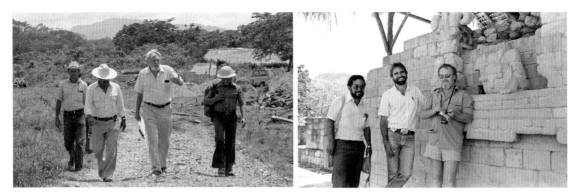

35. PAC II director William T. Sanders (center) during excavations at Las Sepulturas, 1981.

36. Left to right: Rudy Larios, Bill Fash, and visiting archaeologist Norman Hammond at Las Sepulturas, Copan, 1983.

mapping of the constructions exposed where the Copan River had cut through the ruins. The results of this ambitious project were published in 1983 in the three volumes of *Introducción a la arqueología de Copán, Honduras,* edited by Baudez. Continuing from the Harvard work as head project artist, I drew many stelae and the Hieroglyphic Stairway for studies of the sculpture and inscriptions under the supervision of Baudez, Marie-France Fauvet-Berthelot, and Berthold Reise. Monument recording continued through the second phase of the project, PAC II, and many of our sculpture drawings were published in Baudez's book *Maya Sculpture of Copan: The Iconography.*

PAC II began in late 1980 under the direction of William T. Sanders of Pennsylvania State University and kept its momentum for four more years. Sanders was especially interested in the economic and political growth of ancient Copan, so he directed extensive excavations in Las Sepulturas, the residential area east of the Principal Group (**35**). Although many of the ruins there dated to the Late Classic (A.D. 600–900) and "collapse" periods at Copan, the area also has dwellings dating back to Preclassic times, before A.D. 400. This research helped scholars reconstruct the domestic daily life of ancient Copan. The PAC II publications included the three-volume *Excavaciones en el área urbana de Copán,* edited by Sanders, and *The House of the Bacabs, Copan, Honduras,* edited by David Webster.

One of the large Late Classic structures excavated by Sanders's team, Structure 9N-82, revealed a fallen sculpture façade and hieroglyphic bench, which was unexpected at a residential group that distance from the main center. Bill excavated much of the fallen sculpture at rear of the structure, and together we studied the sculpture from all sides in 1982–83. This led us to consult with Rudy Larios, who was responsible for the architectural restoration of Group 9N-8,

of which this structure was a central part (**36**). As a result, some of the mosaic sculpture blocks were restored to their original positions on the front of the building. This work led directly to the formation of the Copan Mosaics Project, launched by Bill and me in 1985, which was conceived to preserve and study the façade sculpture from buildings throughout the Principal Group and the Copan Valley (**37**).

Together with the Copan Mosaics Project, excavations at the Principal Group and into the heart of the Acropolis have been the primary research undertaken at Copan in recent decades. In 1986 Bill secured funding through the National Science Foundation, Northern Illinois University (where he taught and led summer field schools for 7 years), USAID, IHAH, and other granting institutions to pursue the conservation and investigation of the Acropolis on a massive scale. He directed several contiguous projects that grew into the Proyecto Arqueológico Acrópolis Copán, or PAAC. PAAC incorporated several major subprojects headed by co-directors from Honduras, Guatemala, the University of Pennsylvania, and Tulane University. Building on the PAC II work in Las Sepulturas, Pennsylvania State University independently ran several seasons of excavations at Group 8N-11 in the early 1990s, for which I supervised the sculpture program. Since the conclusion of PAAC in 1995 and the inauguration of the Copan Sculpture Museum in 1996, Penn State investigators have continued to work on independent projects in the region and publish their findings. Bill and I, now returned to Harvard University, have run 11 more years of summer field schools at Copan, and Ricardo Agurcia devotes his time to research on Structure 16 in addition to directing the Asociación Copán.

In recent years IHAH has continued important conservation efforts at the Principal Group and salvage operations at ruins affected by modern construction in the Copan Valley. Although much is left to be discovered and understood about ancient Copan in the years ahead, the Copan Sculpture Museum underscores the importance of doing so responsibly, in conjunction with the conservation and careful management of Copan's scientifically and artistically priceless buildings, artifacts, and sculptures.

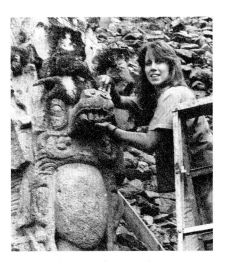

37. The author rematching a sculpture fragment to Stela M, 1986.

PHOTOGRAPH BY WILLIAM L. FASH.

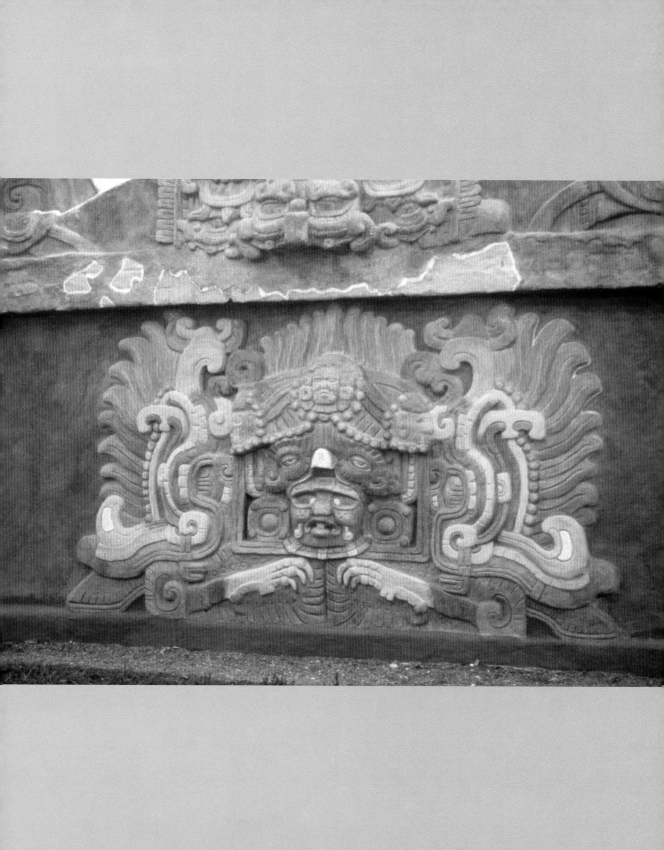

Honoring
the Founder

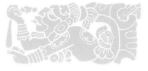

The Maya today, like people in many other cultures around the world, revere their ancestors. The ancient Maya believed their male rulers became apotheosized as the sun deity, and female rulers, as the moon deity. They held rituals to honor them at death, and they constructed massive funerary buildings and inscribed monuments to commemorate their reigns. At Copan, the founder of the royal dynasty, K'inich Yax K'uk' Mo', was the most important ancestor, and archaeologists have found several important structures and carved monuments dedicated to him. So central are they to understanding ancient Copan that the grandest of these commemorative monuments, the Rosalila temple and Altar Q, are presented as the first exhibitions visitors see in the museum (**38**).

K'inich Yax K'uk' Mo' established a royal line at Copan in A.D. 426 and reigned until 437. He was not the first person to rule over Copan; hieroglyphic texts mention even earlier rulers. But he is the pivotal figure whom the surviving historical records carved in stone claim as the founder of the Classic period dynasty. The 15 succeeding rulers all counted their numbered positions in reference to him. Archaeologists believe they have found the burial and tomb of K'inich Yax K'uk' Mo' in one of the earliest buildings on the Acropolis, nicknamed "Hunal." Bone chemistry analysis indicates that K'inich Yax K'uk' Mo' grew up in the central Maya area, and a hieroglyphic text pinpoints the site as Caracol, Belize. Altar Q records that later in life he traveled to central Mexico to receive his authority to rule, most likely from officials at Teotihuacan, the great city that was the central Mexican capital, and then made his way to Copan (**39**). A different

38. Museum reproduction of bird on north side of Rosalila.

PHOTOGRAPH BY THE AUTHOR, 1996.

Seven ceramic effigy lids of Copan rulers. K'inich Yax K'uk' Mo' is in the center with prominent rings around his eyes.

PHOTOGRAPH BY WILLIAM L. FASH, 1990.

COPAN'S RULING DYNASTY

The rulers of Copan were part of a dynastic succession lasting more than 400 years. Most of their names are known from their depictions on the famous monument Altar Q and from other inscriptions. Their phonetic names, if known, and the dates of their reigns are as follows:

Ruler number	Name	Dates of reign (A.D.)
1	K'inich Yax K'uk' Mo'	426–437
2	(Undeciphered)	437
3	(Undeciphered)	455
4	K'altun Hiix	465
5	(Undeciphered)	475
6	(Undeciphered)	485
7	Bahlam Nehn	500–545
8	Wi' Ohl K'inich	551
9	(Undeciphered)	551–553
10	"Moon Jaguar"	553–578
11	K'ahk' Uti' Chan	578–628
12	K'ahk' Uti' Ha' K'awiil	628–695
13	Waxaklajun Ubaah K'awiil	695–738
14	K'ahk' Joplaj Chan K'awiil	738–749
15	K'ahk' Yipyaj Chan K'awiil	749–761
16	Yax Pasaj Chan Yopaat	763–810

Source: Revised from W. Fash 2001:80.

posthumous monument at Copan makes reference to his performing a ceremony in A.D. 416, so it is possible that he came to Copan even before his trip to Teotihuacan.

EXHIBIT 1

The Rosalila Temple

The magnificent temple discovered during tunnel excavations at the site and nicknamed Rosalila was chosen to be replicated as the centerpiece of the Copan Sculpture Museum. Brilliantly painted in red, yellow, green, and white, the building greets awed visitors as they enter the museum, just as the original must once have done in the ancient city. The inhabitants of Copan built the temple to honor K'inich Yax K'uk' Mo', whose tomb lay in an earlier building beneath it.

Of all the grand buildings on the Copan Acropolis, only three—Structures 11, 16, and 26—are known to have antecedents dating back to the beginning of the dynastic rule. Later rulers respected the location of each building as, over time, they had masons raise subsequent edifices, one on top of another, in the same spots. Eventually, neighboring buildings filled in the spaces between the original ones. From Gustav Strømsvik's probes in the 1930s, later generations of archaeologists

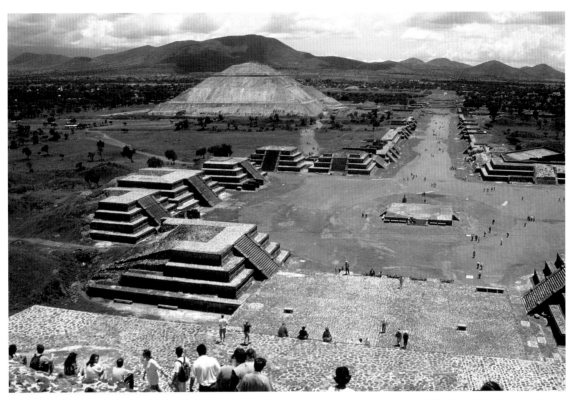

39. Overview of the site of Teotihuacan, Mexico, with the Sun Pyramid in the distance.

PHOTOGRAPH BY WILLIAM L. FASH, 1996.

could see that an intricate sequence of buildings spanning the history of the Copan kingdom lay beneath the site surface.

In 1989, Bill Fash, who was already directing excavations beneath Structure 26 and its Hieroglyphic Stairway, asked Ricardo Agurcia to direct new excavations at Structure 16, the highest structure on the Acropolis, as part of the Proyecto Arqueológico Acrópolis Copán (PAAC) (**40**). Part of this new investigation involved digging tunnels into the interior of Structure 16. As a result, we now understand that a sequence of superimposed buildings ending with Structure 16 was constructed over the tomb of the dynastic founder, K'inich Yax K'uk' Mo'. His tomb, discovered by Robert Sharer and colleagues while digging the earliest and lowest levels of the Acropolis, lies inside a structure named Hunal, at the start of the sequence (**41**). To Copan's inhabitants this became perhaps the city's most sacred location, at the heart of the Acropolis. Several other of the early buildings that followed in the sequence—called Yehnal, Margarita, and Rosalila— were decorated with the founder's motifs in painted modeled stucco.

40. Ricardo Agurcia excavating the central room and altar of Rosalila under Structure 16.

PHOTOGRAPH BY THE AUTHOR, 1992.

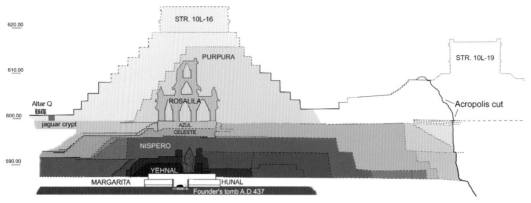

41. The construction sequence of the Structure 16 pyramid, including the Rosalila temple.

DRAWING BY THE AUTHOR AFTER A DRAWING BY RUDY LARIOS.

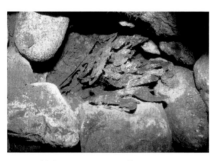

42. Rosalila's termination cache.

PHOTOGRAPH BY RICARDO AGURCIA, COURTESY IHAH ARCHIVES, COPAN, 1991.

Because they are in fragile condition, these decorations can be displayed in the museum only as replicas. Yehnal and Margarita were not fully revealed until after the Copan Sculpture Museum was designed, and it is hoped that replicas of them, too, will be made and displayed in the future.

The most remarkable architecture to emerge from the excavations beneath Structure 16 was the intact Early Classic temple that Ricardo named Rosalila. Throughout Mesoamerica, people's customary pattern of construction was to build up pyramids in stages, or layers, so that to archaeologists they resemble onions with layers to be peeled off. At Copan, ancient masons usually partially demolished an old building, filled it in with the debris, and then constructed a new building over and beyond the ruins of the previous foundation. Rosalila, however, was special: it was deliberately "entombed" inside the next structure in the sequence. No other building has been found so carefully preserved below the surface of the Acropolis or anywhere else in Copan. Rather than demolish the building, the ancient Maya whitewashed it with a thick coat of stucco and then surrounded it with a layer of packed clay before the next phase of construction. They buried nearly the entire structure intact, including its roof crest, an architectural feature never before seen preserved at Copan.

Apparently they also conducted elaborate "termination" rituals at Rosalila. Among other things, they placed a special offering in the temple's central chamber—nine "eccentric flints" wrapped in blue cloth and cached near the front doorway (**42**). Flint objects found at many Maya sites were knapped into intricate abstract figures and shapes, which earns them archaeologists' designation as

"eccentric." Copan's eccentric flints often took the form of sacred lance points with numerous profile heads. Clearly, this termination offering and the careful burial of the external decoration signals that the Rosalila temple was a sacred structure honoring the memory of K'inich Yax K'uk' Mo' and his tomb. The ancient inhabitants could not bear to see it destroyed, so they buried and preserved it with the utmost care.

Ricardo and his assistants excavated Rosalila until 1996, meticulously uncovering the fragile stucco designs that embellished the structure. They employed conservation measures such as injecting fissures and separations with a lime solution and applying a mixed lime and consolidant paste to seal and reinforce broken edges, to ensure that the decorations deteriorated no further. Working closely with the draftsmen who recorded the exposed areas in detail, I compiled the drawing segments into a composite image in order to complete the reconstruction of Rosalila's façade that is presented as the museum's centerpiece. This work guided the excavations, and because identical designs were repeated on multiple sides of the building, in many cases Ricardo and I jointly deemed only minimal uncovering of the fragile stucco to be necessary.

The color scheme of Rosalila's plaster decoration was ascertained slowly over time. Initially, stucco technician Fidencio Rivera and I conducted micro-probes beneath the surface of the thick termination layer of stucco, using the soft points of wooden and bamboo implements to reveal the details of carving hidden underneath (**43, 44**). In the upper registers of the temple, the colors were only sparsely preserved, probably because of weathering and intense sunlight. Karl Taube and I later had to examine the stucco painstakingly to find traces of pigment revealing the painting scheme on these levels. By 1995 Ricardo had discovered an unwhitewashed bird motif on the north side of the structure (**45**). The expansion of an adjacent building in ancient times had covered this portion of the stucco design before the termination coating was applied to the rest of Rosalila. This accident of preservation left the colors clearly visible on the stucco bird, which served as the primary color guide for the bird figures on the lower register of the museum replica.

Many people are curious about how Rosalila got its name. Sadly, we do not know what the ancient Maya called the structure, for its name is unrecorded in the inscriptions that have been found so far at Copan. Before PAAC, archaeologists had given numbers to the

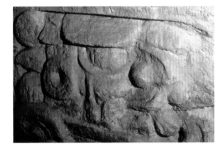

43. *Yaxk'in* motif in stucco on Rosalila before removal of the termination layer.

PHOTOGRAPH BY THE AUTHOR, 1994.

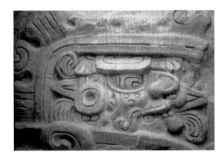

44. *Yaxk'in* motif in stucco on Rosalila after removal of the termination layer.

PHOTOGRAPH BY THE AUTHOR, 1994.

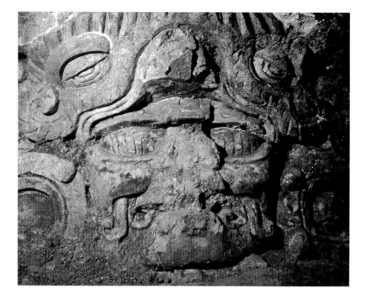

45. Original bird showing paint colors on Rosalila's north side, ca. 1993.

PHOTOGRAPH BY RICARDO AGURCIA, COURTESY IHAH ARCHIVES, COPAN.

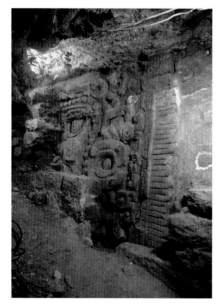

46. Original substructure mask on Rosalila, 1992.

PHOTOGRAPH BY JUSTIN KERR, COURTESY IHAH ARCHIVES, COPAN.

buildings they found to distinguish them from one another. Rather than use a cumbersome and potentially misleading numbering system, for PAAC it was decided that pyramidal bases, or substructures, would be given color names, and buildings and temples, or superstructures, would receive bird names. For example, other early Acropolis substructures were called Purpura (purple), Esmeralda (emerald), Yax (blue-green), and Azul (blue). Superstructures included Águila (eagle), Perico (parakeet), and Loro (parrot). Even this system became modified. When the first decorated stucco façade of Rosalila was uncovered, it was assumed to be the façade of a substructure, because no well-preserved temple with stucco decoration had previously been found at Copan. Hence the color designation Rosalila, or rose lilac. If we had a chance to change the temple's designation to a bird name now, perhaps Templo K'uk' Mo' (quetzal macaw) would be more appropriate.

The design of the museum replica was based on the knowledge we had for Rosalila in 1990. Two excavation seasons later, Ricardo penetrated the plaster floor that was in use during the final years of the temple's life and discovered that an elaborately decorated substructure lay buried beneath it. On this substructure, two well-preserved masks flanked a grand central staircase leading up to the temple (**46**). The staircase bore a hieroglyphic inscription dating the

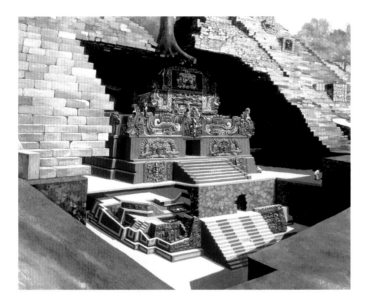

47. Artist's reconstruction of Hunal, Yehnal, Margarita, and Rosalila with its substructure masks and stairway added.

PAINTING BY CHRISTOPHER KLEIN, © NATIONAL GEOGRAPHIC SOCIETY (IMAGE ID 562714).

structure to the reign of Ruler 9, around A.D. 550. By the time of the new discovery, it was too late to change the design of the Rosalila replica—and if we had added to its height, it would no longer have fit into the museum. In any case, the replica is faithful to what visitors to the Acropolis saw of Rosalila in the final years of its life, when the substructure was covered by the plaster floor and no longer visible (**47**).

To create the Rosalila replica, local artisans Marcelino Valdés and Jacinto Abrego Ramírez first made clay versions of the stucco designs based on scaled enlargements of my reconstruction drawings and the visible stucco originals. For close access to the original, they worked in a specially roofed area on the low, flat expanse on top of Structure 14, directly opposite Structure 16 at the site. Although stone carvers by choice, the two soon came to appreciate and even prefer the versatility of clay for rendering the large, complex designs of the façade (see **14**). Before we made latex molds of any section from the clay model, I checked its accuracy by carefully comparing it with photographs and the original stucco. The latex molds, backed by fiberglass resin countermolds, were then cast with reinforced cement and transferred from the work area to the museum site.

Relying on detailed measurements of the original temple, Rudy Larios planned and oversaw the construction of the replica's

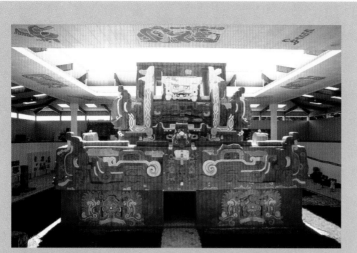

PHOTOGRAPH BY THE AUTHOR, 1996.

THE ROSALILA REPLICA

Rosalila's central iconographic theme is that of the worship of royal ancestors as solar deities and as birds that serve as supernatural avatars. In keeping with millennia-old (and still current) Maya belief systems, the whole temple represented a sacred mountain where the souls of the ancestors resided. Deity images in the form of mythical birds with outstretched serpent wings encircle all four sides of the structure in the register above the doors. They appear to be alighting on the building as they arrive with their messages. Lower on the structure is a repeating avian deity with green feathers and a quetzal bird head above its old man visage. Karl Taube determined that these characteristics, together with the yellow beaks of the macaws in the serpent wings and the lidded macaw eyes, mark the image as a *k'uk'-mo'*, or quetzal-macaw. It is believed that these images represent K'inich Yax K'uk' Mo', the founder of Copan's ruling dynasty, apotheosized as the sun god, here conflated with the aged and wizened deity Itzamnaaj in the guise of an avian messenger.

Fire is also a central part of the Rosalila imagery, and researchers believe that rituals involving fire took place inside the temple. The Maya used fire offerings for conjuring up and communicating with the dead, and evidence of burning was found with censers *(incensarios)* and artifacts in the central room of Rosalila. Open vents on all levels allowed smoke from the burning of incense inside the building to billow outward, creating a mystical scene. Rosalila was something like an enormous censer covering the tombs—the symbolic offering bowls—of the revered dynastic founder and his family.

reinforced interior structure, onto which the cast sections were secured (see **15**). On the lower level, the masons were actually able to cast the birds directly onto the structure's support beams and walls. On the upper levels, the slices of cast sculpture sections were painstakingly hoisted onto the building with a cable and secured in place. Each overall section took three to six months to complete, and constructing the entire building was a three-year endeavor. On opening day, the building was vibrant with fresh paint, barely dry.

Rosalila's sculptural message can be understood only in terms of the history of its ancient building site. Excavations have revealed that the temple was built directly above several earlier structures that were also embellished with stucco designs. The three best preserved are known as Margarita, Yehnal, and Hunal, the earliest, which dates to the time of the founder of the dynasty, K'inich Yax K'uk' Mo'. Elaborate royal tombs housed in these earlier structures are believed to be those of the founder himself and a related royal woman, thought to be his wife. Emblazoned on the exteriors of Margarita and Yehnal were colorfully painted emblematic names related to K'inich Yax K'uk' Mo' and the founding events of his dynasty (**48, 49**). The same sym-

bolism was carried forward to embellish Rosalila on an even grander scale. It is clear from studies of the art and architecture at Copan that this historical figure, K'inich Yax K'uk' Mo', became the city's most honored ancestor. His burial at this spot transformed it into a sacred place for all eternity.

Rosalila was one of the last buildings with a stucco façade to be visible on the Copan Acropolis. In the temple's heyday, a courtyard filled with other dazzling, stucco-decorated buildings surrounded it. But slowly these buildings were replaced, covered by new temples that had stone rather than modeled stucco sculpture decorating their exterior surfaces. The stones were tenoned into the buildings' façades, and their visible surfaces were carved. They were then coated with a thin whitewash of lime and were painted, producing the same visual effect as the earlier modeled stucco. This shift in technology took place around A.D. 600 and was gradually perfected in the following centuries. Stone sculpture had been in use for the larger free-standing monuments at Copan for centuries, but not until this time did it come into extensive use on building façades. My colleagues and I speculate that the ancient builders tired of the constant maintenance required by the fragile stucco and looked for a more durable substitute. Stone

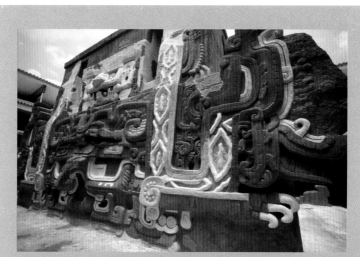

PHOTOGRAPH BY RICK FREHSEE, 1996.

MOUNTAIN AND SKELETAL MASKS ON THE ROSALILA REPLICA

The east and west sides of the upper story of Rosalila are each emblazoned with the face of a mountain deity, from whose forehead sprout scrolls of yellow corn kernels. The image evokes the myth of the sacred mountain where maize originated. Above the mountain deity is a skeletal head representing death and rebirth in the form of an enormous censer. In Maya religion, death was followed naturally by rebirth, just as the sun is reborn each day, maize regenerates every year, and Maya children are believed to be the regenerations, or *k'exol* (replacements), of their grandparents and ancestors. Elaborate termination rituals for one building were precursors for the dedication rituals of the next. The avian solar deities on the temple are fiery images of K'inich Yax K'uk' Mo' being resurrected from the underworld, transporting the sun rising in the east. *Yaxk'in* signs carried in the wings of the second-level bird represent the rising sun, reinforcing this interpretation.

Serpents flowing from the skeletal head have been variously interpreted as symbols for the sides of the sky, smoke produced by the burning of incense to attract dark clouds and the precious water they shower upon the earth, and representations of *chijchan*, serpents still revered by the nearby Chorti Maya. *Chijchan* are believed to burst forth in the form of streams from the mountains every rainy season. Karl Taube suggests that the serpents are hanging from branches of a sacred tree rising out of the censer head, as they do on the famous sarcophagus resurrection scene on the tomb of the ruler Pacal' at Palenque. One can also see their similarity to the double-headed serpent bars that rulers carry on stelae at Copan. On Rosalila they function in a similar way; the deified ancestors emerge from them, called forth by the fire rituals and sacrificial offerings that took place in the temple.

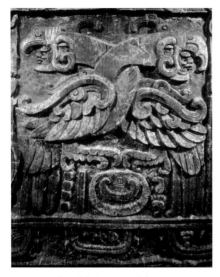

48. Original modeled stucco of the structure called Margarita.

PHOTOGRAPH BY THE AUTHOR, 2000.

49. Stucco design of the Yehnal structure.

DRAWING BY THE AUTHOR AFTER ANN KIM.

carving provided Copan sculptors with new possibilities for monumentality and symbolic expression on the exteriors of buildings.

Another motivation behind this shift may have been that preparing the lime for the stucco matrix was costly and time consuming. Limestone had to be quarried and carried from its source, and many trees had to be felled for fuel to heat the limestone during processing. As the landscape became increasingly deforested, stucco preparation became a greater challenge. Although architects continued to use massive amounts of lime stucco for the roofs and floors of their buildings, with the introduction of tenoned stone sculpture they were able to cut back on consumption for the decorated façades.

Even with the advent of the new technology, Rosalila and its neighboring structure, "Ani," were preserved for many years as relics of the older style. As new buildings crept up around them, the two appear to have been tended and revered until the last. Yet in time even these lone stucco survivors on the Acropolis were engulfed by new buildings. Rosalila was eventually covered several times, the final phase of construction taking place during the reign of Ruler 16, Yax Pasaj Chan Yopaat. Historic buildings succumbing to fresh waves of architectural construction—how often have we seen this happen in our own modern cities?

EXHIBIT 6

Altar Q

In the hieroglyphic inscriptions carved on stone monuments at Copan lies a wealth of information about rulers and events in the life of the city. The single most informative stone is Altar Q, so named by Alfred Maudslay in 1886. This famous, monolithic, square altar honors K'inich Yax K'uk' Mo' and his dynastic successors, displaying on its sides carvings of all 16 rulers in the Copan dynasty (**50**).

In the early twentieth century, Herbert Spinden proposed that the altar's inscriptions referred to an astronomical conference and that the seated figures depicted on it were attendees. By the 1970s, epigraphers had begun to understand that the hieroglyphs on the top of the altar recounted historical events involving the Copan dynasty, and the 16 human figures, 4 on each side, composed a chronological list of kings who ruled Copan from A.D. 426 to 775. Beginning with K'inich Yax K'uk' Mo', who holds a burning torch,

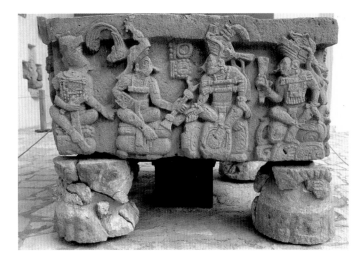

50. Altar Q after its transfer to the Copan Sculpture Museum.

PHOTOGRAPH BY RICK FREHSEE, 1996.

each ruler sits above a name glyph and holds an unlit paper torch in his hand. The fire and torches symbolize the transfer of authority from the ancestral founders of Tollan, the "place of the bulrushes," the mythical origin place for the ancient people of Mesoamerica. Authority over Copan appears to have been conferred upon K'inich Yax K'uk' Mo' at Teotihuacan, where sacred "New Fire" ceremonies and the granting of kingship for many Mesoamerican cities is recorded to have taken place for centuries.

Altar Q was erected in A.D. 763, the first year of the reign of Ruler 16, Yax Pasaj Chan Yopaat. It was set at the base of the grand staircase climbing Structure 16, the central pyramid of Copan's Acropolis and the final building in the sequence covering Rosalila and the

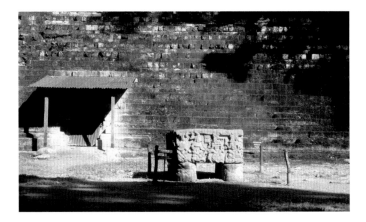

51. Replica of Altar Q at the site.

PHOTOGRAPH BY THE AUTHOR, 1996.

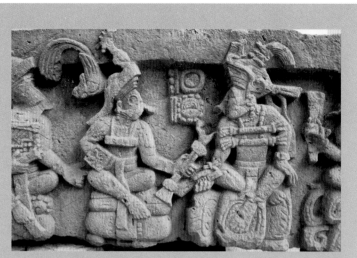

PHOTOGRAPH BY RICK FREHSEE, 1996.

K'INICH YAX K'UK' MO' AS DEPICTED ON ALTAR Q

On the west side of Altar Q, at center stage, the first and last rulers of Copan face each other in a mythical meeting and transfer of authority. Between them are glyphs for the date of the scene being commemorated, 6 Kaban 10 Mol, or July 2, 763, the day Ruler 16, Yax Pasaj Chan Yopaat, acceded to the throne. They are assisted by the other 14 rulers, shown in chronological order around the four sides of the altar. The ruler facing Yax Pasaj Chan Yopaat has been identified by David Stuart as the founder of the Copan dynasty, K'inich Yax K'uk' Mo'. He is depicted wearing a warrior costume that signals his affiliation with the central Mexican capital, Teotihuacan. The costume consists of Tlaloc, or storm god, goggles over his eyes, a square shield with a war serpent motif, a feathered mantle, and a headdress. Headdresses in Maya sculpture often contain attributes of a person's name, and here the founder actually wears his name in his headdress in the form of a combined quetzal *(k'uk')* and macaw *(mo')*, or *k'uk' mo'*. His shell diadem contains two other parts of his name, the signs for blue-green *(yax)* and sun *(k'in)*.

founder's funerary temple. In 1996 the altar was transferred to the sculpture museum for preservation and exhibition, and a reproduction was left in its place at the site (**51**). An earlier plaster cast of the altar, made in 1892 by the Peabody Museum expedition, remains on display in Cambridge, Massachusetts.

Altar Q measures 6 feet (1.85 meters) on each side and 4 feet (1.22 meters) high. Originally it sat on four carved cylindrical stone pedestals, but as the centuries passed, the pedestals gave way under the altar's weight. To early visitors such as Juan Galindo in 1834, they appeared to be merely circular stones propping up the altar from the ground. In 1990, Ricardo Agurcia excavated around the altar to find the floor on which it rested and discovered the lower sections of the pedestals. The fallen pieces were painstakingly reassembled by assistant Carlos Jacinto, student and sculptor Barbara Gustafsen, and me, and they are part of the museum exhibit today. Unfortunately, the carvings on the pedestals are mostly eroded beyond recognition. What little can be seen are masks on two of the cylinders and portions of dates on the other two—perhaps the date 6 Kaban 10 Mol, on which the altar was dedicated (see p. 53 for more on the Maya calendar).

In 1999, the founder's tomb and funerary slab, supported by four cylindrical supports, were discovered buried in one of the earliest phases of Structure 16. Altar Q and its bases, dating some 340 years later, could then be understood as a replication of the funerary bed of K'inich Yax K'uk' Mo'. The altar testifies to the strong memory of historic events kept alive by the ancient people of Copan through written records and visual symbols and undoubtedly through spoken histories and legends as well. Placed in front of the pyramid housing the founder's tomb at its core, Altar Q not only paid tribute to K'inich Yax K'uk' Mo' but also served to legitimate Yax Pasaj Chan Yopaat, Ruler 16, within the dynastic line.

DRAWING BY STUART 1991.

HIEROGLYPHIC INSCRIPTION ON THE TOP OF ALTAR Q

The top of Altar Q is carved with an inscription of 36 hieroglyphs, a historical narrative that commemorates the rulers in the dynastic line. To read the text, one starts in the upper left corner and proceeds downward in paired columns of glyphs. David Stuart has made the most comprehensive decipherment of the inscription, which begins with the Maya date 8.19.10.10.17, 5 Kaban 15 Yaxk'in, or September 6, A.D. 426, when the protagonist, K'uk' Mo' Ajaw (A3, green), receives the *k'awiil*, or divine charter of rulership in the *ch'am-k'awiil* ritual (A2). The event takes place at an Origin House, or Wite'naah (literally "tree-root house") (B2, brown). Bill Fash, Alexandre Tokovinine, and I believe this may be a reference to the Adosada platform and Sun Pyramid at Teotihuacan, described by Postclassic people as the place where rulers received the insignia of office. Three days later, on 8.19.10.11.0, 8 Ajaw 18 Yaxk'in (B3, A4), or September 9, 426, the ruler's name changes to include *yax* and the title *k'inich*, or "sun-faced ruler" (B5, green). The glyphs record that five months later he arrived at Uxwitik ("three *witik*") (D5), Copan's ancient name, to establish a new political and dynastic order. On 9.17.5.0.0, 6 Ajaw 13 K'ayab (December 29, 775) (C6, D6, E1, F1), 340 years later, the altar was dedicated to K'inich Yax K'uk' Mo' (F2, green) by Ruler 16, Yax Pasaj Chan Yopaat (F3, E4, F4). Finally, a date 64 days thereafter—9.17.5.3.4, 5 Kan 12 Uo (March 2, 776)—may correspond to a period of ceremonies surrounding the dedication of Altar Q. Stone-lined crypts discovered behind the altar in 1988 contained the bones of 15 jaguars and pumas and several macaws, perhaps sacrificed and deposited during these rituals.

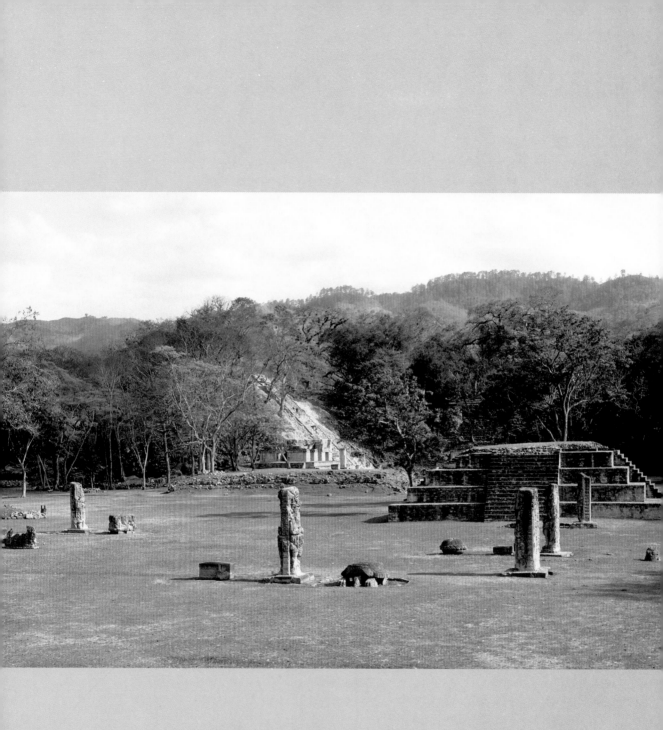

4
Stelae

Copan has long been esteemed for the spectacular, freestanding stone statues, or stelae, that grace its ruins (**52**). The first European explorers in 1576 marveled at the Copan sculptors' artistic creativity and their skill at carving in the round, which was unparalleled at any other Maya site. Gustav Strømsvik, who reerected many of the fallen stelae in the 1930s and 1940s for the Carnegie Institution of Washington, called them the "crowning glory of Copan" (**53, 54**). The Copan Sculpture Museum displays three of the site's original stelae: Stela P (exhibit 3), Stela 2 (exhibit 9), and Stela A (exhibit 15).

The Latin word *stela* (plural *stelae*), from the Greek *stêlê,* describes a shaftlike stone monument set upright in the ground. David Stuart has deciphered the ancient Maya name for a stela in the hieroglyphs as *lakamtuun,* or "great stone." An earlier reading of the glyph, which has been discarded, was *te' tun,* translated as "stone tree." Epigraphers were initially intrigued by the word local people today use to refer to such monuments in Copan, *te tun te,* which Stuart believes is a modified form of the Nahuatl word for stone, *tetontli.* The modern word, however, does not correspond to the phonetic signs in the ancient Maya glyphs (**55**).

The freestanding stelae at Copan inspired the artist Frederick Catherwood to record them in meticulous drawings in 1839, which helped set the art of the New World on equal footing with that of ancient Egypt and the Ottoman Empire. The English explorer Alfred P. Maudslay devised the system of number and letter designations for the stelae and altars that is still in use today (although it was later amended by Sylvanus Morley), and he took some of the most

52. Stelae in the Great Plaza erected by Ruler 13, Waxaklajun Ubaah K'awiil.

PHOTOGRAPH BY WILLIAM L. FASH, 1987.

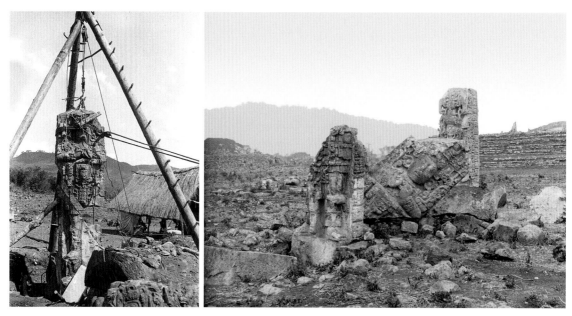

53. Stela C under repair by the Carnegie expedition, 1935.

54. Fallen Stela C as found by early expeditions, ca. 1892.

55. Glyph for *lakamtuun*, the ancient name for a stela.

DRAWING BY THE AUTHOR AFTER STUART 1996.

valuable and artful photographs of the stelae during his early exploration of the site. Plaster casts of the stelae made at the turn of the twentieth century were shipped to world's fairs and early museums for display. Many still stand in museum exhibition halls around the world, preserving details often eroded on the originals.

It was the Copan sculptors' good fortune to have soft, workable volcanic tuff as a medium in which to express their virtuosity at carving. Sculptors are known to have inscribed their names and titles on stone monuments at a few other Maya sites, but the practice was not followed at Copan. Stylistic clues hint at the hand of one sculptor or another, but it is likely that many people worked on a monument in concert under a single master.

Each stela was carved from one huge block of tuff quarried from one of the outcrops in the hills nearby. Once hewn from the outcrop, the monolith was probably rolled on logs to the spot where it was to be erected. Each stela was given a long, smooth tang, about half again the length of the carved portion, that secured it upright in the ground. A hole was dug and formed into an offertory cache box, usually cruciform, and a supporting base of large stone slabs was laid on the ground surface, securing the underground shaft. In this vault, people placed offerings such as pottery vessels, shells, jade beads,

and stalactites. Then the monolith, still uncarved, was lowered into the hole and offering box using ropes and wooden scaffolds. The act of erecting the stela was conceived of as an act of planting *(ts'ahp).* Hieroglyphs on three stelae at Copan, including Stela A in the museum, record the event using the phrase *ts'ahpaj lakamtuun,* "the great stone was planted."

To keep the stone moist for easier carving, workers probably built a temporary roof over it. Once the carving was completed, the stela was painted red using an iron ore or cinnabar pigment. Many stelae, such as Stela P and 2 in the museum, Stela C at the archaeological site (**56**), and Stela 12 in the foothills overlooking Copan (**57**), still show traces of red paint.

For many years researchers speculated about whether the figures carved on stelae at Maya sites represented deities or historic personages. In 1961 Tatiana Proskouriakoff identified the names of Maya rulers in stelae inscriptions at the site of Piedras Negras on the Guatemala-Mexico border, and since then researchers have widely accepted that the figures on Maya monuments are portraits of the semidivine rulers who held sway over the cities' fortunes. Names and historic events recorded in the hieroglyphs on stelae and on some altars give us dynastic sequences and events linked to rulers' reigns for many lowland Maya sites, including Copan. Some rulers, and in rare instances deities, are named as the "owners" of stelae in the inscriptions.

Twenty-four stelae stand today in the Copan Valley, and another 39 broken and fragmented ones are kept in storage or in the Copan Regional Museum of Archaeology for safekeeping (**58**). Most of the fractured stelae were early monuments that were buried under later architecture. Several have come to light through archaeologists' tunnel excavations into the pyramidal bases of major structures. It seems that before the long reign of Ruler 11, K'ahk' Uti' Chan, from A.D. 578 to 628, it was customary to destroy and bury one's predecessor's monuments. K'ahk' Uti' Chan and his successors, K'ahk' Uti' Ha' K'awiil and Waxaklajun Ubaah K'awiil, broke with this tradition. They not only left their ancestors' monuments intact but sometimes even built around them.

The rulers of Copan often erected stelae to mark the completion of a time period in the cyclical Maya calendar. The stelae's inscriptions, however, usually start with a date in the linear Long Count reckoning, which anchors the cyclical dates in absolute time.

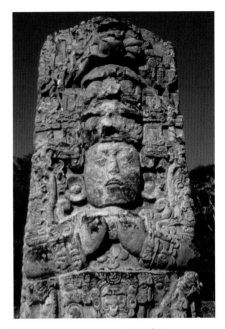

56. Detail of Stela C at the site of Copan, showing traces of the red pigment with which the statue was once painted.

PHOTOGRAPH BY WILLIAM L. FASH, 1985.

57. Stela 12 (Piedra Pintada), in the eastern foothills overlooking the Copan Valley.

PHOTOGRAPH BY WILLIAM L. FASH, 1984.

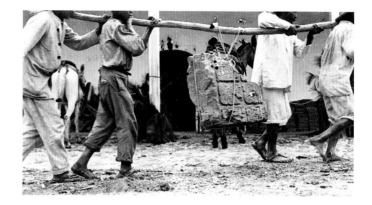

58. A fragment of Stela 24 being transported from the site to the Copan Regional Museum of Archaeology, 1918.

59. Glyphs for (a) *k'atun*, (b) *lahuntun*, (c) *hotun*, and (d) *ajaw*.

Throughout the Classic period, rulers erected and dedicated monuments every *k'atun*, a period equivalent to 20 years, and occasionally at subdivisions of the *k'atun*, the *lahuntun* (10 years) and the *hotun* (5 years) (**59**). The ruler's semidivinity was recognized in the carved texts through the title *ajaw* (lord), which signaled his transformation into the embodiment of sacred time. Astronomical events are also important parts of the texts on stelae and may refer to the ruler's spiritual journey into the supernatural world, a privilege restricted to rulers as semidivine beings.

Most of the rulers portrayed on stelae at Copan carry in their arms a double-headed serpent, which, by the Late Classic period, became stylized into a rigid bar. The serpents' mouths are opened wide to show emerging heads, representing the act of conjuring a deified being back into this world. Sacrificial offerings and bloodletting, generally from a person's ear, tongue, or penis, using sharp instruments such as thorns and stingray spines, were often parts of these conjuring rituals, a means of feeding the supernatural forces being called upon. In general, the serpents on stelae are death serpents, with fangs and fleshless mandibles.

The cruciform vaults over which stelae were usually erected at Copan symbolized the four directions and the four corners of the universe. The stela was placed where the four quarters of the vault met—at the center of creation. The ruler portrayed on the stela embodied this sacred axis.

Sometimes, stelae inscribed with texts and figures depicting rulers were paired with freestanding altars, the focal points of rituals carried out by rulers and priests to dedicate the two monuments and honor the passage of time. Although no altar is displayed with its

stela in the museum, they were the stones upon which to let blood, make sacrifices, and pour sacred liquids. Some altars and stelae are depicted, either on the altar itself or on ceramics and bones, as sacred time markers bound with tied knots, indicating that they were "bundled"—from the deciphered verb *k'altun* in the hieroglyphs, for the act of bundling. Sometimes the altars' proper names were inscribed on them, and these often included a reference to *k'antuun,* or "yellow/precious stone." Altars also recorded calendrical events and named personages. Sixteen stelae at Copan have associated altars, but most altars were carved as stand-alone monuments unrelated to a stela. These are often much smaller than those directly associated with stelae. Although much iconographic study remains to be carried out, Late Classic altars paired with stelae tend to depict supernatural beings that were perhaps particular to rituals involving the altars. Earlier altars often display a continuation of the stela's hieroglyphic text. Altars have been found purposely broken and cached under stelae or reused in architecture. Claude Baudez noted that in the eighth century, altars carved with complex scenes and hieroglyphic texts took on an importance nearly equal to that of stelae.

THE MAYA CALENDAR

Understanding the basic mechanics of the Maya calendar enables one to make sense of the dates on Maya monuments. The ancient Maya calendar was complicated, integrating several methods of reckoning time. The relevant methods for this book are what researchers call the Long Count and the Calendar Round.

The Long Count is a count of days elapsing from a mythical "zero" starting point that correlates with September 8, 3114 B.C., in the modern Gregorian calendar. It allows linear time to be calculated far into the past and the future. This is accomplished by using periods of time, or cycles, each multiplied a specified number of times. The cycles are summed to determine the total number of days to be counted forward from the starting date, 3114 B.C. The cycles are the following:

k'in	1 day
winal	20 *k'in,* or 20 days
tun	18 *winal,* or 360 days
k'atun	20 *tun,* or 7,200 days
bak'tun	20 *k'atun,* or 144,000 days

A Long Count date is written out as the number of each of the five kinds of cycles in sequence. A notation of 9.15.0.10.4, for example, means "9 *bak'tun* plus 15 *k'atun* plus 0 *tun* plus 10 *winal* plus 4 *k'in,*" or 1,404,204 days since the inception of the Long Count.

The Long Count date is connected to a date in the Calendar Round, a cycle that repeats every 52 years. Each year is exactly 365 days, for a total of 18,980 days. All Mesoamerican peoples, not only the Maya, used the Calendar Round, so it is thought to be much older than the Long Count. The Calendar Round has two interlocked components, a 260-day period (often considered to be linked to the human period of gestation) consisting of 20 repeating, named days, and the 365-day solar year of 13 months. The time it takes for a day and month combination to repeat in this linked cycle is 52 years. A sample notation might read "6 Kaban 10 Mol," or the sixth day of the tenth month. If this date appeared together with the Long Count date of 9.16.12.5.17, then one could calculate that it corresponded to the modern notation of July 2, 763 A.D. Without the Long Count notation to anchor the Calendar Round notation, the day-and-month date could be from any of the many past 52-year cycles.

SOURCE: THOMPSON 1971.

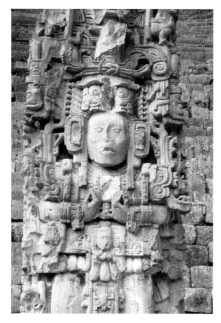

60. Detail of Stela N, a chronologically late stela carved in high relief.

PHOTOGRAPH BY THE AUTHOR, 1995.

In 1920, Sylvanus Morley grouped the stelae then known at Copan into three broad categories on the basis of their design layouts: hieroglyphic inscriptions on all four sides; inscriptions on three sides and a figure on the fourth; and inscriptions on two opposite sides, with back-to-back figural representations on the other two. Later investigators identified several new categories of design arrangements on stelae: inscriptions on three sides and the fourth left plain; two profile figures on opposite sides with no text; and a figure wrapped around three sides, his head turned in profile, with the fourth side inscribed in hieroglyphs. The most common stela presentation is Morley's second category, that of inscriptions on three sides and a figure on the fourth. The three stelae displayed in the Copan Sculpture Museum all fall into this category.

Scholars such as Herbert Spinden, Tatiana Proskouriakoff, and Miguel Covarrubias also classified the Copan stelae, using not just style but also chronology as a criterion. Each of them determined that the earliest, or archaic, monuments were carved in low relief and were purely textual. Over time, artists began to carve stelae in slightly higher relief and to portray human figures on them; Stela P in the museum is a good example. The stylistic sequence ends with ornate Late Classic monuments displaying fine carving in extremely high relief. These categories are useful for stylistic dating and have been substantiated by the hieroglyphic dates on the monuments. When excavators find only partial monuments, lacking inscribed dates, stylistic dating is a means of retrieving the otherwise lost chronology.

Influence from the Maya of the Guatemalan highlands and from lowland sites such as Tikal in the Petén helped shape the creative styles of the early Copan monuments. Brief inscriptions and portrayals of rulers in profile eventually gave way to Copan's lengthy texts and frontal poses. Studies indicate that the high-relief carving of the Late Classic period, which has become a hallmark for Copan stelae, evolved first on the city's elaborate temple façades. Designs on temple façades were already shifting from modeled stucco to stone carved in high relief by the end of the Early Classic period, or the seventh century, but stelae sculptors preferred more archaic styles into the eighth century.

Rulers are generally portrayed on the stelae as larger than life and heavily costumed (**60**). Elaborate headdresses with attached earflares, heavy belts with loincloths, and ornate sandals make up principal parts of the compositions. Epigraphers have deciphered

names for parts of the costumes, such as *tuup,* earspool, and *sak huun,* white headband. Later monuments such as Stela N at the Copan ruins show smaller figures and animals weaving in and out of the relief alongside the ruler. These may be ancestors, animal spirit companions, or mythical spirits in the supernatural world. Some of these additional figures are carved in extremely high relief, with cutaway areas giving a lighter, airier quality to the monument.

Originally, four stelae were chosen to be displayed in the Copan Sculpture Museum, representing a chronological sequence of earlier to later rulers. Stela N, one of the few monuments still standing when John Lloyd Stephens visited the site in 1839, was selected to represent the latest monument. Because of its high relief and cutout forms, however, it proved too challenging to replicate and was never moved into the museum. Still, the three stelae on display—Stelae P, 2, and A—allow visitors to trace the changing surface treatment and style of the monuments. These are some of the finest examples of their genre, highlighting the reigns of three important and long-lived rulers.

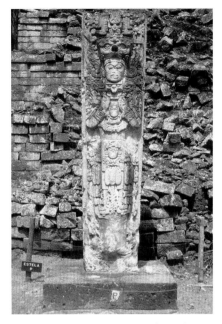

61. Stela P at the site before transfer to the museum.

PHOTOGRAPH BY THE AUTHOR, 1989.

EXHIBIT 3

Stela P

Stela P is a monument erected by Ruler 11 to glorify himself as well as to honor K'inich Yax K'uk' Mo', the founder of his dynasty (**61**). Ruler 11's name is read phonetically as K'ahk' Uti' Chan—Fiery Sky or Fiery Snake. It is written using glyphs for smoke followed by a sign for either sky or snake, which are homophones in Mayan. K'ahk' Uti' Chan was born in A.D. 563, acceded to kingship in 578, and died in 628 at the age of 65. The stela was dedicated on 9.9.10.0.0, 2 Ajaw 13 Pop, or March 21, 623—the ending of a *lahuntun,* or 10-year period—when the Rosalila temple was still in use. Archaeologists believe that Stela P was originally erected in another, nearby location, closer to Rosalila, and was relocated to a spot slightly northwest of Structure 16 in the eighth century, when the building's expansion necessitated its repositioning.

Stela P is one of the finest examples of the Early Classic style at Copan, a style that can be seen on several other early monuments at the site, including Stela 7, also erected by Ruler 11, and Stelae E and 2, raised by Ruler 12. The monument is wider at the top than at the bottom. Three of its sides are covered with glyphs, and its front

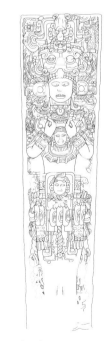

62. Drawing of Stela P.

DRAWING BY THE AUTHOR, 1981.

portrays K'ahk' Uti' Chan holding a two-headed serpent over his chest (**62**). The serpent's curving body, which looks natural and flexible on this and other early stelae and on later ones becomes a rigid bar, is often referred to as a ceremonial bar. From the open mouths of the serpent heads in profile emerge two human faces, also in profile. It has been suggested that they represent the old "paddler gods," a mythical pair who paddled a canoe through the underworld to the place of creation. They seem to personify the sun on its daily journey. On the back of the stela is a rare hieroglyph naming the ceremonial bar; it is a small version of the figural carving showing the two serpent heads back to back.

The ruler wears a jaguar pelt skirt with a loincloth draped over it and a heavily decorated ceremonial belt. Jade pendants dangle from twisted fabric, and youthful masks hang on the ruler's chest between the heads of the serpent bar and on the loincloth. A squirming serpent body with an eroded head can be seen alongside the ruler's legs on either side.

The jaguar pelt repeats in the upper background, perhaps representing the night sky. The Classic Maya and people of other cultures in ancient Mesoamerica believed that upon setting, the sun entered an underworld teeming with fierce jaguars and other creatures, and the stars in the night sky were like the spots on a jaguar's pelt. The ruler's ornate bird headdress is similar to that on the sun god on Rosalila; note that the beak is missing and would have been inserted into the extant cavity. A few objects from the Maya area that share many of the features of this headdress are clay *incensarios,* or containers for burning incense offerings, from Copan's sister city of Palenque in Chiapas, Mexico, and stucco masks from the site of Kohunlich, Belize. If this is the same sun god headdress associated with K'inich Yax K'uk' Mo' on Rosalila, then Ruler 11 might be dressed for a ceremony in which he portrayed both the sun god and the founding ruler. Some scholars believe this is a posthumous portrait of K'inich Yax K'uk' Mo' himself.

EXHIBIT 9

Stela 2

Stela 2, dedicated only 29 years after Stela P, bears a striking resemblance to its predecessor (**63**). Both are carved in the conservative low

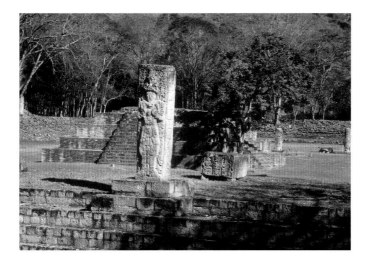

63. Stela 2 at the site before transfer to the museum.

PHOTOGRAPH BY WILLIAM L. FASH, 1987.

relief of their time, with hieroglyphs on three sides and a figure on the fourth. Although Stela 2 is shorter and wider than Stela P, the two are closely paired in symbolism. The ruler portrayed on Stela 2 has been identified as Ruler 12, K'ahk' Uti' Ha' K'awiil. Like Ruler 11 on Stela P, he is dressed in ritual attire to celebrate an important period ending in the calendrical cycle, in this case 9.11.0.0.0, or A.D. 652. It seems likely that the similarities between the two stelae were intentional, emphasizing that Ruler 12 is being compared to his predecessor on Stela P, with both performing period-ending rituals.

Ruler 12's elaborate costume helps us understand aspects of the ritual being commemorated (**64**). Like Ruler 11, he is shown holding a flexible, two-headed serpent. Out of the serpent's mouths emerge the heads of deities, identified as the jaguar solar deity (also known as the old "jaguar paddler"). The ruler wears sandals and a kilt and headdress made of spotted jaguar skin, appropriate ritual attire for bringing the jaguar solar deity to life again. He also wears a jaguar helmet (a departure from Ruler 11's bird helmet on Stela P) and two smaller masks with jaguar characteristics, one above the main helmet and the other below his chin. The square earflares, profile serpent heads, and braided cloth are other standard features of Maya rulers' headdresses. Vegetation sprouts from the upper headdress, and a curious hand emerges from a flowerlike petal. These may be aquatic plants, because the jaguar is affiliated with watery realms.

Stelae 2 also depicts the elaborate loincloth and belt, dangling polished celts, and shell tinklers that rulers wore to their ceremonies.

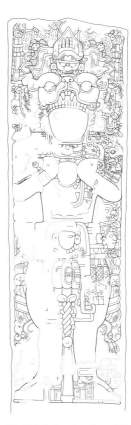

64. Artist's line drawing of the carving on Stela 2.

DRAWING BY THE AUTHOR, 1981.

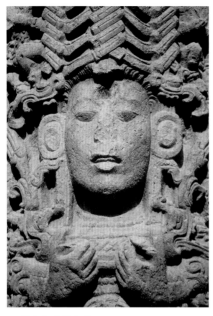

65. Detail of Stela A.

PHOTOGRAPH BY RICK FREHSEE, 1996.

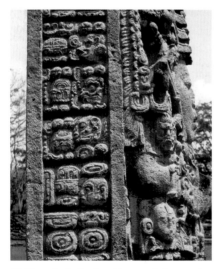

66. Hieroglyphs for four Maya capitals carved on Stela A.

PHOTOGRAPH BY WILLIAM L. FASH, 1984.

Although eroded here, small, youthful masks appear on his belt and his chest. In the background, snakes spiral from his elbow shields.

Like Stela P, Stela 2 appears to have been moved from its original location later in Copan's history. It was reset over a cruciform chamber in a platform overlooking the ballcourt, and the date of the platform is several *k'atun* later than the stela's dedication date. Initially, members of the Peabody Museum expedition in the late 1800s found the stela in two pieces on the ballcourt floor and set it up there. Later, the Carnegie expedition discovered the cruciform chamber in the platform and reerected the stela on that spot.

EXHIBIT 15

Stela A

Stela A is possibly the most popular monolith at Copan today because of its beautiful, high-relief carving and the fact that it is one of the few monuments with a preserved face (**65**). Serene Maya features were a trademark of Copan sculptors, especially during the reign of Waxaklajun Ubaah K'awiil, Ruler 13, from A.D. 695 to 738. The stela's dedication date is 9.14.19.8.0, 12 Ajaw 8 Kumk'u, or A.D. 731. Waxaklajun Ubaah K'awiil erected Stela A three *winals* (sixty days) after Stela H and directly across the Great Plaza. The text on Stela A uncharacteristically repeats some events also recorded on Stela H; these involve using sacred relics to recall deceased ancestors from the otherworld. Sometime in the nineteenth century a traveler to Copan carved the name "J. Higgins" into the border framing the glyphs on the back side. Despite this person's attempt to be immortalized, no one today has the slightest idea who the graffitist was.

Stela A was erected over a cruciform chamber to the north of Structure 4 in the Great Plaza. Strømsvik, who excavated the chamber, found it to contain pottery fragments, stalactites, and stone flakes. The hieroglyphic text on the stela mentions that the dedication offering took place in the Great Plaza. The altar in front of Stela A was also placed on the central axis of Structure 4, which highlights the importance of the altar and its offerings as the focus of the dedication ceremony, under the gaze of the ruler himself, carved in stone for eternity.

It is generally agreed that the figure carved on the front of Stela A is Waxaklajun Ubaah K'awiil. His name is mentioned in the text on

the monument, followed by the emblem sign for Copan, with its signature bat head. The emblem glyphs designating three other kingdoms, Tikal, Palenque, and Calakmul, appear on the south side of the monument (**66**). These three and Copan are believed to have been the four capitals of the lowland Maya world at the time. Each emblem glyph is paired with one of the four directional glyphs—those for north *(xaman)*, south *(nojool)*, east *(lak'in)*, and west *(chik'in)*—emphasizing the four-sidedness of the Maya worldview. New interpretations suggest that the emblem glyphs may refer to rulers or nobles from those cities who were visitors to Copan.

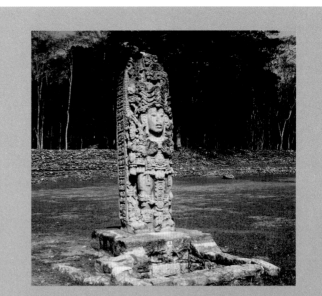

Stela A over its cruciform vault at the site of Copan before its transfer to the museum.

PHOTOGRAPH BY WILLIAM L. FASH, 1987.

STELA A

The semidivinity of Maya rulers allowed them access to hidden parts of the supernatural realm, empowering them to rule the city and to serve the ancestors, deities, and subjects alike. On Stela A, the divine authority of Ruler 13 (Waxaklajun Ubaah K'awiil) is emphasized by several design motifs, one of which—the woven mat or knot sign—is used repeatedly. In the headdress, whose four corners terminate with serpents' heads, strands of cloth are braided and tied to resemble a woven mat, a symbol of rulership. These rulership signs appear again on the ceremonial bar and belt. The three tied knots of cloth on his sandals, wristlets, background staff, and belt dangles, however, have been interpreted to signify sacrifice.

Also associated with sacrifice and death are the solar deities with elongated heads that emerge from the fleshless serpent death heads on the ceremonial bar. The heads (now missing) of the seated figures in the ruler's headdress once had solar characteristics as well; a fragment of one of these heads is in the Museo Etnografico Castello d'Albertis in Genoa, Italy. Sacrifices and offerings were paid to the ancestors and the celestial and earth deities in return for food and favors.

The images on Stela A can be understood in terms of the cycle of birth, life, death, and rebirth that is common to Mesoamerican belief systems. Like the sun, the souls of the deceased rise and set every day. A skeletal head at the very top of the stela sprouts vegetation, recalling the head on the roof crest of Rosalila. Both represent the repetitive growth cycle of plants such as maize, a powerful Maya symbol of death and rebirth.

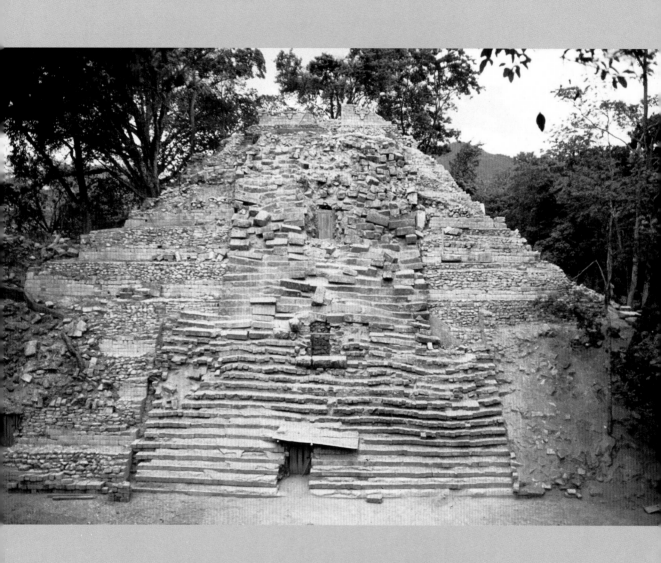

Underworld Symbolism

The Maya underworld, Xibalba, was a dark place inhabited by fearsome death figures that could emerge in the darkness of night. It was believed that when people died, their souls faced a journey through this treacherous place. If they succeeded in defeating the forces of death and evil during the journey, they were reborn into the heavenly realm, where the ancestors and celestial bodies dwelled. Monuments at other Maya sites show dead rulers dancing victoriously out of Xibalba to take their place alongside distinguished ancestors and preparing to guide their descendants still alive in the Middle World. In the event that someone died a violent death, his or her soul was believed to go straight to the heavens.

Like many other peoples around the world, the Maya had a myth to explain death and prepare people for this fearsome journey. A version of the story survives in the Popol Vuh, the sacred book of the K'iche Maya of the Guatemala highlands. The two protagonists are the Hero Twins, who descend to the underworld and defeat the gods of death after surviving a series of trials. Much of the underworld symbolism on Copan's structures recalls scenes from the Popol Vuh, and scholars suspect that versions of the myth were passed down from ancient times among many Maya groups. Certain buildings in the East Court have themes that appear to relate directly to the different houses in which the Hero Twins are said to have endured trials. The houses are described as abodes where sinister underworld creatures challenged victims with tricks and evil tactics. As I wrote twenty years ago, I believe these East Court buildings might have functioned as theaters for reenactments of the timeless tales.

67. Structure 16 as seen at the ruins during excavation of the west side, 1989.

PHOTOGRAPH BY WILLIAM L. FASH.

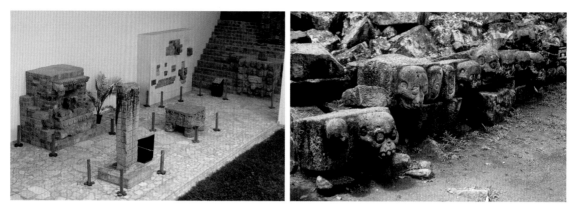

68. The Structure 16 corner in the Copan Sculpture Museum. Exhibit 4 is at left against wall; exhibit 7 stands at far right.

PHOTOGRAPH BY RICK FREHSEE, 1996.

69. Skull sculptures from Structure 16 at the site before relocation to the museum.

PHOTOGRAPH BY WILLIAM L. FASH, 1985.

Nine exhibits on the ground floor of the Copan Sculpture Museum include symbolism incorporating the underworld theme. Their placement on the lower level of the museum is meant to give the effect of being below ground, where the lords of death are said to dwell. The exhibits' dark accent colors further echo the somber underworld. Some sculptures are direct representations of underworld themes, and others are related to the conjuring of ancestors and spirits into the otherworldly and nightly realms.

The underworld journey begins with Structure 16 (exhibits 4, 5, and 7), a Copan building whose sculpture makes abundant references to death, warfare, and sacrifice (**67**). It continues with an exhibition of carvings of skulls and defleshed bones from Structure 230 (exhibit 8) and supernatural imagery from Structures 21A and 21 (exhibits 10–12). The journey concludes with a remarkable inscribed floor marker that once covered a tomb beneath Structure 26 (exhibit 13) and a menacing death bat *(cama zotz)* from Structure 20 (exhibit 14).

EXHIBITS 4, 5, & 7

Structure 16

The tallest structure on the Copan Acropolis was Structure 16, or 10L-16, using its precise Copan Valley map designation. It was the last pyramid built over the many layers of construction at this sacred place honoring and enshrining the founding royal ancestor, K'inich Yax K'uk' Mo', and his long-lived dynasty. The stairway on the west side of the pyramid, leading up to the temple at its summit, was punctuated by three decorated platforms. Their symbols represent,

successively, death and human sacrifice, the resurrection of K'inich Yax K'uk' Mo' as the warrior sun god, and an underworld mountain cave of origin. All three of these imposing features have been reconstructed and are displayed in the museum. Because of space limitations, the lowermost and middle platforms form exhibit 7, and the uppermost platform, the cave, stands apart in exhibit 4 (**68**).

Because these rectangular, blocklike platforms were outset from the steps, appearing as planar surfaces, most of the cut stones and sculptures that composed them collapsed over time and fell to the plaza floor. But the fallen blocks left clearly visible cavities in the intact stairway that revealed the platforms' original dimensions and placement. A few sculptures even remained in their original places, where they served as reference points when we began to reconstruct the platforms for display in the museum.

Reconstructing the stairway platforms was a challenge requiring many years and the work of many people. From 1988 to 1990, during the Copan Acropolis Archaeology Project (PAAC), student assistants Joel Palka and Donna Stone first catalogued and studied the huge sculpture blocks scattered about the base of Structure 16 (**69**). Rudy Larios and I recorded the blocks that were still in place on

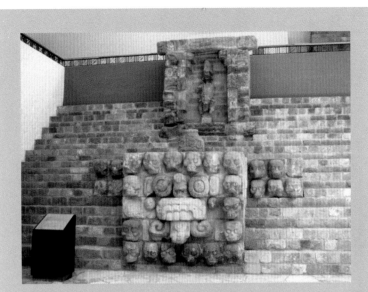

The lowermost and middle platforms on the west stairway of Structure 16.
PHOTOGRAPH BY RICK FREHSEE, 1996.

STRUCTURE 16 | EXHIBIT 7
STAIRWAY PLATFORMS

The lowermost platform on the Structure 16 stairway is a T-shaped panel composed of 30 large skulls and a central skeletal Tlaloc mask. Together they are obvious symbols of death, warfare, sacrifice, and the underworld. The carved platform is reminiscent of the much later *tzompantli* racks of the Aztec, on which the skulls of sacrificial victims were suspended on horizontal wooden crossbars in offering to their gods. The Tlaloc mask, so called because it has the characteristics of the central Mexican storm god of the same name, is surrounded by a block of 18 skulls, while the other 12 are recessed along either side. Karl Taube first noted the significance of the number 18, which denoted war and sacrifice in Teotihuacan. After the fall of Teotihuacan, many Late Classic Maya centers, including Copan, witnessed a florescence in the use of central Mexican imagery. Whether to reaffirm their power, claim descent, or exert a newfound freedom to use these icons, Maya rulers clearly legitimated their rule by linking themselves with images associated with one of Mesoamerica's greatest cities.

The Tlaloc mask is composed of large goggle eyes, a hooked, skeletal nose or beak, a mustachelike upper lip with protruding incisors, and a central "tongue" of bifurcating scrolls. Its earflares are circular disks with *k'an* cross designs and a single bead dangle. Twelve of the skulls were still in place but badly damaged on the stairway, so in 1995 they were transferred to the museum.

70. Construction of Structure 16 stairway platforms in progress, 1996.

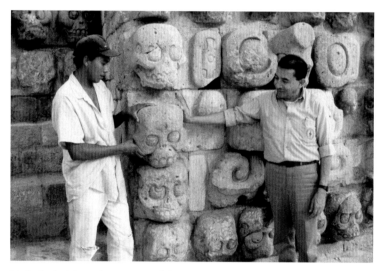

71. Carlos Jacinto and IHAH regional director Oscar Cruz check the match of a missing skull, 1998. One skull that was broken from its block on the Structure 16 staircase in the early twentieth century has been identified in the Museo Etnográfico Castello d'Albertis in Genoa, Italy. A cast of it seen here helped confirm that it matches the broken space.

the west staircase while its restoration was in progress. I made initial photographic and drawing reconstructions of these catalogued sculpture blocks. Later, Juan Ramón Guerra oversaw the transfer of the blocks to the museum and engineered their reassembly and installation there (**70**). Karl Taube assisted me in the final stage of the museum assembly work. He and Jorge Ramos analyzed the sculpture on the platforms, identifying and rematching many broken fragments and writing about the sculptures' interpretation. Carlos Jacinto, Hernando Guerra, Rufino Membreño, and Concepción Lazaro fit together the many broken pieces of sculpture that had become separated over the centuries before they were transferred from the site to the museum (**71**).

The three dramatic platforms can be seen as stopping points on the ascent up the staircase to the sacred temple honoring the founder. Through their symbolism, onlookers relived his mythical triumph over the underworld and his resurrection and rebirth as the warrior sun. K'inich Yax K'uk' Mo' emerges from the fiery solar realm to empower warriors to take captives in his honor and that of the storm god, Tlaloc. The sacrificial victims are present in the form of a skull rack and a captive in the mouth of the cave, which is visually located at a place labeled by *pu*

STRUCTURE 16
FIGURE IN SOLAR CARTOUCHE

The second of the three stairway platforms on Structure 16 features a solar cartouche. A human figure representing the warrior sun deity stands in a niche surrounded by a frame that may represent a shield. The shield is formed by a carved representation of braided rope and fringe framing the rectangular niche. The massive lowermost block with the braid motif had slumped only slightly from its original position on the staircase at the time of excavation. But like the skulls from the lower stairway platform, the rest of the blocks were scattered in piles along the western base of the pyramid and were reconstructed for the first time once they were brought to the museum. Each outside corner of the cartouche is cut away in a crescent shape, from which a skeletal centipede serpent's head emerges in profile. *Yax* signs appear on the sides of the frame, linking the symbolism to the rising sun, or *yaxk'in*. Centipedes figure in some Mesoamerican myths at the hearts of volcanoes as fiery symbols of the underworld.

Inside the niche is a human figure carved almost fully in the round. It took considerable effort to recognize and reassemble the pieces of this figure, which were weather worn and strewn about the sculpture piles in the West Court. The arms and legs are still incomplete, although after the museum opened, Karl Taube identified fragments of the missing feet, one leg calf, a lance point, a tied rope necklace, and other pieces belonging to the figure. Its eroded face is actually the countenance of the sun god, with large, squarish eyes and filed, T-shaped incisors. His headdress is a bird's head with macaw markings around the eyes and a quetzal crest similar to those depicted on Rosalila. Although broken, the three-dimensional figure appears to be dancing a victory war dance as he rises out of the underworld like the rising sun. He also looks poised to throw a lance he once held in his hand. My colleagues and I believe he portrays K'inich Yax K'uk' Mo' apotheosized as the warrior sun god, celebrating his bravery and virility. This is another version of the ancestor resurrection imagery that appears on Rosalila.

Solar shields or cartouches are often associated with ancestor worship. As frames with four directional heads at the corners, they place the ancestor in a central position and a powerful setting. Well-known examples come from elaborate carvings at the Maya site of Yaxchilan. Emerging out of the more common rounded cartouche, the ancestors appear to be conjured from the otherworld where they reside and represent the sun and moon. Solar cartouches appear on the façades of two other structures displayed in the museum, Structure 29 (exhibit 52) and Structure 8N-66C (exhibit 58). The sun symbols vary, as do the four directional elements in the corners.

The middle platform from the stairway of Structure 16.

PHOTOGRAPH BY RICK FREHSEE, 1996.

Reconstruction drawing of the face of the platform.

DRAWING BY THE AUTHOR, INCLUDING ADDITIONAL PIECES ADDED BY JORGE RAMOS AND KARL TAUBE.

Solar or ancestor cartouche from Yaxchilan.

DRAWING BY THE AUTHOR AFTER FIELD DRAWING BY IAN GRAHAM.

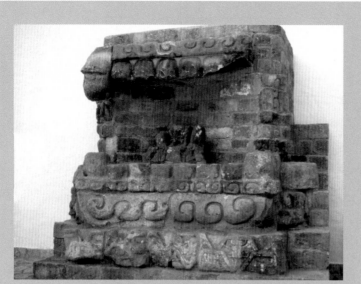

STRUCTURE 16 | EXHIBIT 4
UPPERMOST STAIRWAY PLATFORM

Culminating the procession up the stairs of Structure 16, the uppermost platform represents a captive seated inside the open mouth of a cave monster on a mountain. Portions of the sculpture from this panel were still in place on the stairway when excavations began in 1989, which helped in reconstructing the placement of the panel and its sculptural elements. Some of the blocks still in place were angular mountain signs that formed a base for the gaping mouth of an earth monster, the entrance of a cave portal to the underworld. Karl Taube noted that the mountains carried *pu* signs, which David Stuart has identified as signifying Tollan, the mythical, fertile place of origin, suggesting that these are the sacred mountains of Tollan. Undulating scrolls encircle the monster's open mouth and offset its enormous incisors and fangs, labeling it a "cloud serpent." Liquid, perhaps raindrops, flows from the corners of the mouth and drips over the steps. Alongside the mouth, a spotted serpent body blends into the staircase, giving the impression that the mouth belongs to a monster residing inside the pyramid. Of a human body that originally sat inside the open mouth, only the lower portion remains. It is bound with rope and seems to be that of a sacrificial victim being consumed by the cloud serpent.

signs, thought to signify Tollan, the mythical place of origin.

The pairing of the sun and storm gods is as old as Mesoamerican religion and finds its best-known expression in the twin temples of the Aztec, one of which was devoted to the worship of Tlaloc and the other to Huitzilopochtli, the Aztec's tribal war god, who was promoted to the status of sun god just as K'inich Yax K'uk' Mo' was at Copan. Bill Fash suggests that Structure 16 is an early example of a building combining these two forces of nature. The Copan rulers sought to legitimate their right to rule by aligning their ancestral warriors with a mythical place of origin and the most potent forces in their world. These imposing displays reinforced in the inhabitants of Copan the perception that the cult of ritual warfare was needed to appease the gods and ancestors, in order to perpetuate the natural world, especially the solar and agricultural cycles.

At the top of Structure 16, a person ascending the west stairway reached a two-story temple. Peering into its first-story chamber, the viewer saw an interior niche framed by a serpent's mouth, and inside the niche, a sculpture of the seated K'inich Yax K'uk' Mo'. The dramatic stairway, followed by the seclusion of the inner temple shrine, prepared vis-

itors for a momentous encounter with the spirit of the founder.

A photograph taken by Alfred Maudslay in 1886, during the first excavation of the temple, shows the inner chamber in its best-known state of preservation (**72**). The body of a human figure—an unusual one in which the person's crossed legs are covered with animal skin and claws, suggested to be from either a bird or a jaguar—is seen intact. Its long, rigid-looking upper body is decorated with a bar pectoral and a beaded collar (**73**). The costume represents an affiliation with an older warrior cult that was also followed in other Maya regions, as is attested by a ruler depicted in similar attire on Stela 16 from the site of Dos Pilas in Guatemala (**74**). It dates to A.D. 735, roughly 40 to 50 years earlier than Structure 16. The head in the Maudslay photograph, on the ground to the right of the torso, wears goggles over its eyes and may be the head to the figure, although Maudslay did not associate the two. If the two pieces are put together, the figure appears to represent K'inich Yax K'uk' Mo' wearing shell goggles, as he does on Copan's Altar Q (see sidebar, p. 46). The now broken torso and legs of the figure have been identified among the sculpture fragments at the Peabody Museum, while the head lies across the Atlantic in the

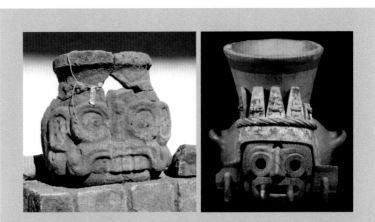

Stone *incensario* from Structure 16 in the form of a Tlaloc jar (with field tag attached).
PHOTOGRAPH BY THE AUTHOR, 1996.

Tlaloc jar from central Mexico.
COURTESY MUSEO NACIONAL DE ANTROPOLOGÍA, MEXICO CITY.

TLALOC IMAGES

A smaller version of the Tlaloc mask seen on the first staircase platform in exhibit 7 is carved on a stone jar that was found in several large fragments at the base of the Structure 16 staircase. In the exhibit it is placed above the skull panel. The object is similar to Tlaloc jars found throughout Mesoamerica and dating from as early as the Preclassic period into the Postclassic. This is the only known stone container, or *incensario*, from Copan carved with a Tlaloc mask. Elsewhere in Mesoamerica, ceramic Tlaloc jars were part of the rainmaking rituals associated with this deity. At Copan the censer might have been used for fire offerings involved in ancestor worship, in this case calling forth the spirit of K'inich Yax K'uk' Mo' from his burial crypt.

Outside of Teotihuacan, warrior factions that drew their inspiration from that city and its political ideology adopted the Tlaloc image as an emblem. The symbol was passed among cultural groups over the generations, and among the Maya it became associated with military power as much as with water and fertility. Tlaloc's appearance in the Maya area is generally associated with a cult of ritual warfare intended to procure sacrificial victims. The presence of the stone Tlaloc container suggests that rainmaking rituals associated with Tlaloc took place in the Maya area, but perhaps in the context of sacrifice. In Maya warfare, captives were taken and later sacrificed for various causes. The sculpture on Structure 16, heavily laden with themes of sacrifice and warfare, boldly confronts viewers with the power and purpose behind these ritual practices.

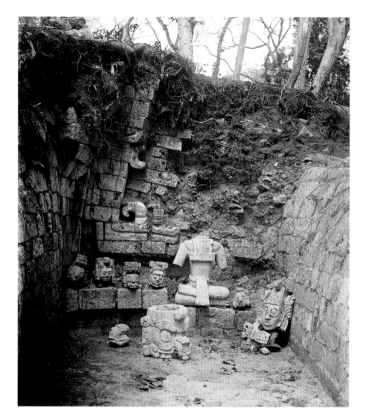

73. Hypothetical reconstruction of the niche in the inner chamber of the temple on Structure 16 (see **78**).

DRAWING BY THE AUTHOR.

British Museum. At some point we hope to rejoin them and verify the hypothesis. The split serpent framing the niche was badly damaged over the centuries, and by 1989, when Ricardo Agurcia reexcavated the temple, only portions of a few fangs and incisors were still intact.

Ancient Maya artists decorated the exterior of the temple on the summit of Structure 16 with an array of façade sculptures continuing the themes of ritual warfare, sacrifice, and ancestor worship. Some examples of these sculptures are displayed in exhibit 5 in the museum (**75**). Maudslay described small effigy heads still projecting from the cornice surrounding the inner room about 7 feet above the floor. Several of these were Tlaloc heads with knotted "Mexican year signs" in their headdresses. One that survived and was found during excavations in 1989 is displayed in the exhibit. Also in the display is an anthropomorphic Tlaloc brandishing a serpent shield (**76**) identical to the one K'inich Yax K'uk' Mo' carries on Altar Q. The human-like Tlaloc with shield was repeated four times on each side of the

temple façade. One example of a goggle-eyed owl mask surrounded by year signs is shown at the top of the exhibit panel. The owl, or *kuy* in Mayan, was considered the harbinger of death. The mask was probably originally connected to a binding or headband in the upper register of the building, possibly along the cornice molding.

Plain Tlaloc masks that flanked the doorways and decorated the corners of the lower register of the temple are partially restored at the site, directly on the temple's exterior walls (**77**). We were able to do this because in a few instances the excavation team found pieces still in place on the walls, giving us clues to the masks' exact locations. The curved faces of many elements of these masks indicate that some of them were intended for corners.

A striking design of interwoven bands with alternating *k'an* symbols, or equal-sided crosses, and heavy-lidded eyes may originally have been placed above the temple's doorways. A segment of this motif is reconstructed at lower left in exhibit 5. Other large *k'an* crosses (exhibit center), rectangular shields, and hieroglyphs forming the name K'inich Yax K'uk' Mo' formed part of the temple façade. When Structure 16 collapsed, the temple sculptures fell a great distance down the sides of the pyramid to its base. Because of this, we can only make educated guesses about the precise placement of most motifs on the façade. As of this writing, analysis is ongoing for other sets of sculptural motifs from Structure 16, including *witz* monsters, twisted rope, claws, and bands of feathers (**78**).

Taken as a whole, the amazing array of sculptures on Structure 16 reveals that this lofty pyramid and temple were constructed by the

74. Stela 16, Dos Pilas, showing ruler in a costume similar to the one worn by K'inich Yax K'uk' Mo'.

DRAWING BY LINDA SCHELE FROM SCHELE AND MILLER 1986.

75. Exhibit 5, façade sculptures from Structure 16.

PHOTOGRAPH BY BEN FASH, 2009.

76. Detail of Tlaloc warrior figure from exhibit 5.

PHOTOGRAPH BY BEN FASH, 2009.

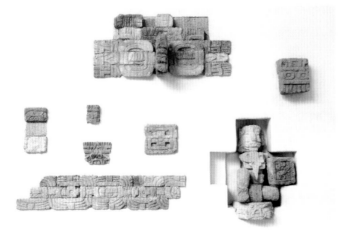

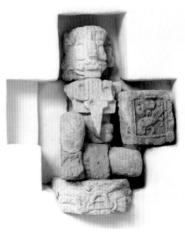

77. Partially restored Tlaloc masks (bifurcating tongues only) on Structure 16.

PHOTOGRAPH BY THE AUTHOR, 1991.

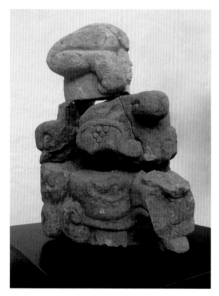

78. Stone *incensario* in the form of a *witz* (mountain) cave monster with a jaguar body, originally from the temple atop Structure 16. When Alfred Maudslay uncovered the temple room, he photographed this censer whole on the floor. Later it fell victim to vandals, and in 1989 archaeologists found pieces of it at the base of the stairway and scattered across the west side of Structure 16. The tail and hind legs of the jaguar are carved on the back.

PHOTOGRAPH BY RICK FREHSEE, 1996.

latest ruler or rulers of Copan as a sacred mountain to honor the founder of the dynasty, K'inich Yax K'uk' Mo', and to glorify him in his resurrection from the underworld as the sun god and archetypal warrior. The scenes on the three stairway platforms set the stage for the viewer's meeting with the statue of K'inich Yax K'uk' Mo' in the inner temple. The ancient people of Copan knew that the founder had been buried deep below the surface, many centuries earlier, in this exact place. The temple was a shrine consecrating this sacred spot, the *axis mundi* of a long-lived Classic Maya kingdom. Together with Altar Q, Structure 16 celebrated the power and glory of the rulers in the dynasty of K'inich Yax K'uk' Mo'. The multiple images of Tlaloc reaffirm the ruling dynasty's ties to the great capital of central Mexico, Teotihuacan. Through this symbolism the rulers legitimated their right to rule and gained power over life and death through practices of ritual warfare and sacrifice.

The size and grandeur of Structure 16 and its predecessors covering the sacred burial spot raise questions about both the rulers who sponsored the pyramids and temples and the workers who built them. Were the builders pleased and willing to honor the founding dynasty, or were they forced into submission through fear of the warrior cult? Were the ancient Copanec rulers proudly displaying their might to their contemporaries in surrounding regions? Or were they weak and fearful of revolt from within or conquest from without, now that Teotihuacan no longer existed to lend legitimacy to their

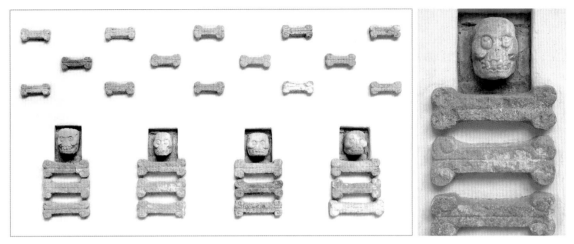

79. Sculpture from Structure 230 (exhibit 8).
PHOTOGRAPH BY BEN FASH, 2009.

80. Detail of skull and long bones from Structure 230.
PHOTOGRAPH BY RICK FREHSEE, 1996.

proclaimed right to rule? The sculpture alone does not answer these questions. Gathering and piecing together the archaeological data and deciphering the hieroglyphic texts may help provide insights into these enduring mysteries.

EXHIBIT 8

Structure 230

Structure 230 (or 10L-230), excavated in 1986, was built onto the south side of Temple 26 on the Acropolis. The majority of the sculptures from it that have been found are carved human long bones and skulls that were heavily disturbed after falling off the building (**79, 80**). For the Maya these motifs not only signified death but also implied the next step in a continuous cycle, rebirth. We know that the ancient Maya revisited the tombs and burial places of their deceased, because archaeological evidence shows that on these occasions they removed the bones or cleaned and then replaced them, sometimes adding a coating of red ochre or cinnabar to them. Rather than considering Structure 230 another building dedicated to sacrifice, I think this small structure was used for rituals involving the treatment of bones and the subsequent reburial of deceased rulers and perhaps their family members. Recalling an altar from Tikal where such a ritual seems to be taking place, my colleagues and I decided to display the skulls and bones in a similar stacked arrangement (**81**).

81. Ritual scene on an altar from Tikal, showing a stacked bone configuration similar to the Structure 230 motifs.
PHOTOGRAPH BY WILLIAM L. FASH, 1977.

EXHIBIT 10
Structure 21A

Not long before Structure 16 was completed, a small temple now called Structure 21A was built on the north side of the East Court as a small addition between two larger, neighboring buildings (**82**). A hieroglyphic stone bench found inside it dates to 9.16.12.5.17, or A.D. 763. It commemorates Yax Pasaj Chan Yopaat's accession as Ruler 16, making it one of his earliest works. The building façade was decorated with motifs related to rituals that conjured up supernatural beings carrying associations with both underworld darkness and celestial brilliance. The bench inscription, still in place at the site, consists of 16 glyphs separated by three star signs. The star signs and other cutout geometric shapes beneath the text may have been inlaid with a precious material such as obsidian, making this a reflective

82. Structure 21A, on the north side of the East Court of the Acropolis, ca. 1895. Structure 21A is to the left of and lower than Structure 21, at center. Structure 20 is half visible on the right. Structures 20 and 21 later collapsed into the river.

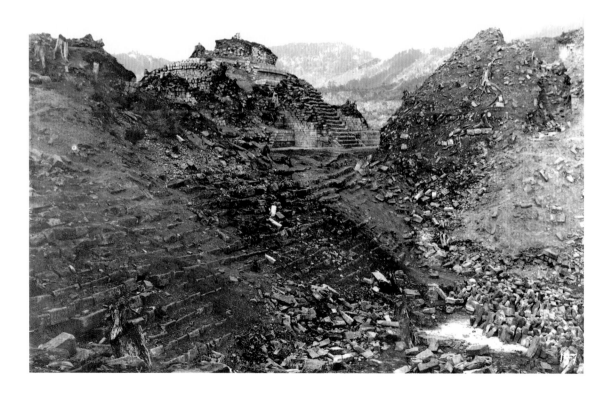

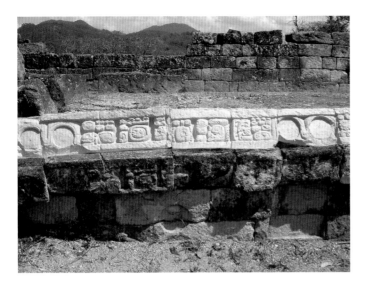

83. Cast of hieroglyphic bench inscription from Structure 21A, recast in 2004 from a plaster copy made in 1892, shown in comparison with the much eroded original at the site today.

PHOTOGRAPH BY THE AUTHOR, 2004.

display in a darkened room. The inscription records the act of placing the bench in the building and speaks of a ritual in which Yax Pasaj impersonated four patron deities, K'uy-(Undeciphered) Ajaw, Mo'witz Ajaw, Tukun Ajaw, and Bolon K'awiil, probably protectors that inhabited local caves, mountains, and springs. More than 100 years ago, members of the Peabody Museum expedition made a plaster cast of the inscription, which preserves many details now lost to erosion (**83**). In 2004 the Peabody donated a resin copy of the inscription, made from its plaster cast, for display in the Copan Sculpture Museum.

Structure 21A may have been one of the last buildings erected in Copan by Yax Pasaj Chan Yopaat. It pays homage to his accession to the throne and may even allude to the completion of the Copan dynasty. Studying the bench inscription and the temple's façade sculpture together yields a more complete idea of the building's message, which seems to refer to Yax Pasaj's ability to bring forth the ancestral patron deities through fire-drilling rituals. Fire-drilling was the ancient method of starting a fire by rapidly rotating a wooden stick, and it was often a sacred part of a foundation ritual. Perhaps the ritual calling forth the deities was carried out in the inner chamber and recorded on the hieroglyphic bench in an effort to ensure a prosperous reign for the sixteenth and final ruler and to bring light to a place of darkness. The similarity of the symbolism on neighboring Structure 21, discussed next, suggests that Structure 21A was Yax

Hypothetical reconstructions of roof decoration, serrated points, and a Tlaloc mask from Structure 21A.

PHOTOGRAPH BY THE AUTHOR, 1996.

STRUCTURE 21A | EXHIBIT 10
ROOF DECORATION

Excavations on the north side of Structure 21A uncovered a mass of plain geometric blocks directly below the building, on the second-highest substructure terrace. These sculptures looked similar to the plain Tlaloc masks on the lower register of Structure 16. Julie Miller and I reconstructed them to form goggle eyes and curling mouths with scrolls falling from them, but this is only one possible way in which they might be arranged.

Excavations also turned up more than 80 triangular pieces fallen from Structure 21A. After some deliberation it seemed that a plausible reconstruction was as a honeycomb arrangement on the roof, forming a roof crest. A small segment is reconstructed in exhibit 10. In this arrangement, the open spaces between the triangles create a repetitive, diamond-shaped pattern similar to those of slightly later Maya buildings in Yucatán. Reversing them to form stacked triangles in columns, as on other Yucatecan buildings, is another option.

Dominating Structure 21A were enormous, serrated dart points inset into the walls. Their tips formed freestanding parapets, a favorite way to mount decorative elements on the moldings and roofs of ancient buildings at Copan. All the blocks belonging to the points were found on the north side, or rear, of the building, suggesting that the points were visible only from that side, perhaps as part of a flying façade or roof crest. Originally thought to be depictions of stingray spines for bloodletting, they may actually have been the tips of staffs, which perhaps evolved into the much later Aztec *chicahuaztli*, a type of divining staff that aided in fire-drilling ceremonies and served as warriors' weapons. The pointed tips of the staffs relate to the tails of fiery shooting stars in the night, which pierce the ground or sacrificial victims.

Aztec *chicahuaztli* staff.

REPRODUCED BY PERMISSION FROM MATOS MOCTEZUMA AND SOLÍS OLGUÍN 2002.

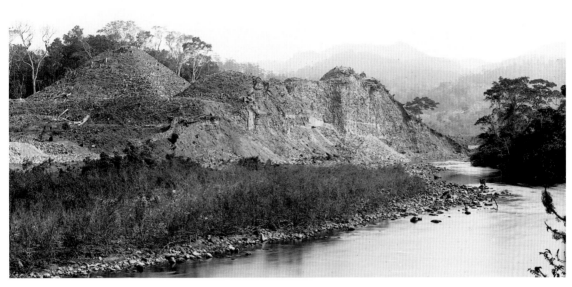

84. View of the cut in the Copan River, 1892.

Pasaj Chan Yopaat's addition to extend the earlier building.

Exhibit 10 shows a selection of motifs from the exterior of Structure 21A. Although the sculptures have almost no incised designs and seem rather plain to viewers today, it is possible that originally they were colorfully painted.

EXHIBITS 11 & 12
Structure 21

What remains of Structure 21, the towering temple to the east of Structure 21A, is only a fraction of

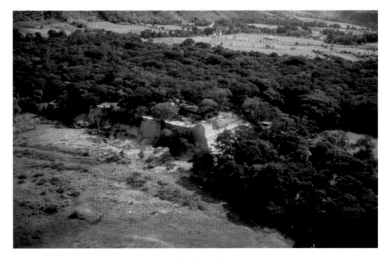

85. The Copan River cut and the Acropolis from the air, 1993.

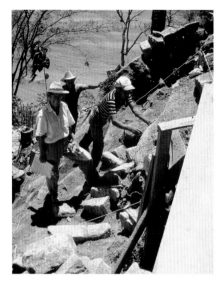

86. Julie Miller conducting excavations on the north side of Structures 21 and 21A, 1989.

PHOTOGRAPH BY THE AUTHOR.

87. Sculpture motifs from the façade of Structure 21 (exhibit 11). Left to right, top row: serpent head with obsidian eye, death head, small death head (now identified as having come from Structure 22), obsidian lancet; left middle: interwoven eye retaining obsidian disk; lower row: *pu* and sky sign, interwoven eyes with butterfly wings, bundles of wood or reeds.

PHOTOGRAPH BY RICK FREHSEE, 1997.

88. Star eyes and butterfly wings depicted on the roof of a building in the Codex Nuttall, an accordion-folded Mixtec book recording genealogies and activities of eleventh- and twelfth-century rulers in Oaxaca.

DRAWING BY THE AUTHOR AFTER NUTTALL 1975.

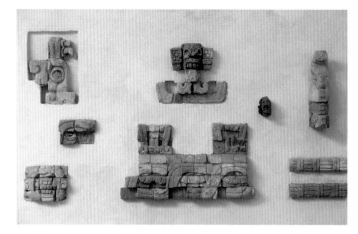

this once imposing building. Much of what we can reconstruct of the temple and its sculpture comes from photographs taken at the turn of the twentieth century, when Structures 20 and 21 still stood at the northeast corner of the East Court (**84**). In subsequent years, the Copan River took a course straight for the Acropolis. As it gradually ate away at the stone, mortar, and plaster built up over the centuries, the structures at the edge crumbled and were swept away. The Instituto Hondureño de Antropología e Historia and PAC I initiated stabilization of the river cut at its southern end in 1979, with funding from the Central American Bank for Economic Integration (CABEI). In 1989 the Proyecto Arqueológico Acrópolis Copán (PAAC) and the Asociación Copán procured funding from the Honduran Fund for Social Investment (FHIS) to resume further stabilization. Although much has been lost in the last hundred years, the river cut provides us with an unprecedented cross section in which to view the history of construction at Copan (**85**).

It is believed that Structure 21 was built after A.D. 715, possibly during the reign of Ruler 15, K'ahk' Yipyaj Chan Yopaat. It was once a marvelous temple brimming with dynamic sculpture. Considering that more than half the building was lost to the river, it is amazing that more than 1,000 sculpture blocks were uncovered during excavations, and in excess of 100 more were found in sculpture piles. PAAC archaeologist Julie Miller supervised these excavations during the 1989–91 field seasons and, not surprisingly, spent the majority of her time cataloguing sculpture (**86**). Much of the Structure 21 sculpture is from motifs and masks so huge that it is difficult to under-

stand the individual blocks, long since separated from one another. We have been able to reassemble only some motif elements that once composed a unified pattern covering this lofty structure. These make up exhibits 11 and 12.

Patient detective work in retrieving and piecing together motifs on the surviving sculpture has enabled us to propose tentative reconstructions for motifs from Structure 21 (**87**). The temple's abundance of obsidian and of cross-hatched signs, signifying black and darkness, coupled with lancets and warrior figures, suggests that it was a structure akin to the *chay-im na,* "obsidian knife house," one of the places in which the Hero Twins were kept during their underworld trials as described in the Popol Vuh. Vinelike serpents decorated with butterfly wings, with Tlaloc warrior figures emerging from their open maws, probably encircled the building. This supernatural creature, related to visions, sacrifice, and death, may be a Classic period representation of what became known in Postclassic Mexico as Itzpapálotl, or Obsidian Butterfly. Adorning the corners of the temple were lancets labeled with cross-hatching as black or obsidian. Such lancets were used for ritual bloodletting, an act that enabled the spirits to awaken and emerge from their supernatural realm. Obsidian eyes glinted in the sunlight from the recesses of the twisted, umbilical-like serpent body. The droopy eyes are reminiscent of the half-opened eyes that represent stars hanging from the darkened sky in Maya books, or codices (**88**). The starry sky was thought to be the realm of the jaguar deity of the underworld.

The most common motif on the building was the interlaced eye design with attached butterfly wings (or "fans"). Several styles of wings and droopy eyes appear, one of which has an eye gouged into a deep circle. Amazingly, a pupil block was recovered with an obsidian disk still embedded in it, which we put on display. This fondness for inset disks of black obsidian to symbolize an underworld connection probably inspired the same technique on Structure 21A, and it occurs again on the upright, grinning dancing jaguars in the East Court.

The interlaced eyes may form sections of twisted vines or cords that lead into a split serpent head and open mouth, similar to Structure 16's serpent mouth. The serpent's large incisors, not on display, perhaps formed a base for the seated figure in exhibit 12 (**89**).

Another interpretation I propose is that the obsidian eyes are representations of seeds, and the butterfly wings are modeled after stylized flowers (**90**). Seeds from datura or morning glory plants were

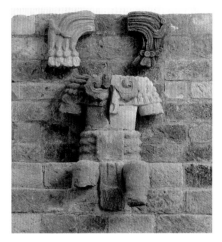

89. Seated figure from the façade of Structure 21 (exhibit 12). The figure wears a heavy rope waistband and has a bifurcating tongue. Liquid streams over his chest. Although the figure's head has never been found, it is possible that its features were similar to those of the Tlaloc figure on Structure 16 (see **76**) because the tongues and the liquid on the chests of the two figures are almost identical.

PHOTOGRAPH BY RICK FREHSEE, 1996.

90. Imagery of personified datura flowers on a vase.

DRAWING BY THE AUTHOR.

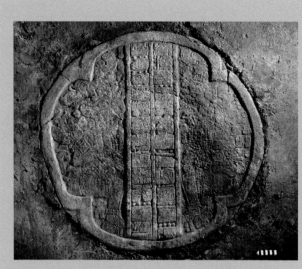

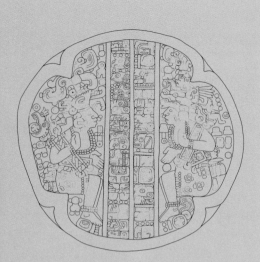

The "Motmot" floor marker while in place at the Copan ruins, 1992.

Line drawing of the floor marker.

Carved replica of the floor marker made for the museum by Jacinto Abrego Ramírez and Marcelino Valdés.

THE "MOTMOT" FLOOR MARKER

The irregular piece with a circular carving known as the Motmot floor marker has the lowest-relief carving of any monument in Copan, making it challenging to view or read. The carved scene shows two seated rulers facing each other, with a double column of hieroglyphs in the center. The rulers sit on a quatrefoil (four-lobed) border that frames the scene and tells us that the action is being viewed through a cave portal to the underworld. Each ruler wears his name in his headdress—K'inich Yax K'uk' Mo' on the left, and his son, the second ruler in the dynastic succession, on the right. Their name glyphs also appear in the central inscription. The rulers are dressed almost identically, and each carries a serpent bar. Below their feet are two hieroglyphs reading 7 K'an and 9 Imix, which are interpreted as referring to supernatural locations.

The text is inscribed in a very early style with an unusual structure and narrative. It starts with an introductory glyph followed by a date in mythological time. This is followed by the name K'inich Yax K'uk' Mo' and an early form of the Copan emblem glyph. Then a dedication event is recorded that involved a deer sacrifice at a 4 Chan (Sky) place, perhaps a reference to the Motmot structure. The next column continues with a reference to the period ending date 9.0.0.0.0 (A.D. 435), followed by the second ruler's name. Then a so-called distance number counts forward to an event that seems to be associated with a 5 (unknown) place and 4 Macaw place. The 4 Macaw place might be the early ballcourt adjacent to the Motmot structure, the façade of which was decorated with four stucco macaws. Bill Fash has suggested that the 4 Chan place was the Motmot structure just east of the marker and tomb, which had linear celestial motifs called skybands on its four corners.

91. Cosmic directional offering over the Motmot marker.

PAAC PHOTOGRAPH BY WILLIAM L. FASH AND RICHARD WILLIAMSON, 1992.

used for their hallucinogenic properties in Mexican warrior cults. After ingesting preparations of the plants, warriors felt invincible. Classic period costumes of warriors and related war imagery conflate a jaguar and a serpent with butterfly attributes in a creature Karl Taube calls the War Serpent. The symbolism appeared earlier at Teotihuacan and might have been related to militarism, the watery surface of the underworld, and fertility rituals. In central Mexico, warriors' souls were believed to be transformed into butterflies after death. Although there are no written accounts of this belief in the Maya area, the widespread use of butterflies and obsidian in warrior motifs at Copan and other Classic Maya sites lends support to the existence of a similar cult.

EXHIBIT 13

The "Motmot" Floor Marker

The fascinating and important Motmot floor marker, so called after its association with the building given that name, is unique at Copan. It is the oldest dated monument from Copan found still in its original place. It is also the only one carved in limestone, which came from a nearby mountain; all others were carved in the locally abundant volcanic tuff. When it was discovered in 1992 in a tunnel excavation beneath the Hieroglyphic Stairway of Structure 26, the carved circular surface of the marker was all that was visible, because

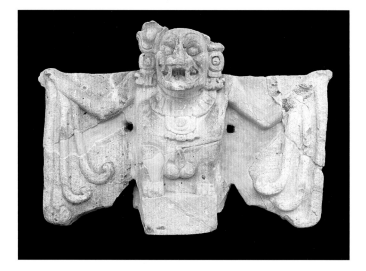

92. The largest bat sculpture from Structure 20 is one of five known from Copan. In exhibit 14, the killer bat is displayed on a panel painted with a quatrefoil symbol, which symbolizes the cave entrance to the underworld throughout Mesoamerican art.

PHOTOGRAPH BY BEN FASH, 2009.

the irregular part of the stone was embedded in the stucco floor. It was placed directly in front of a building that was given the field name Motmot, after the iridescent blue-green trogon bird species that abounds at Copan. The marker served as a tombstone for a circular crypt beneath it. The tomb was associated with one of the earliest temples (known as Yax) buried underneath the Hieroglyphic Stairway. The marker's hieroglyphic inscription commemorates the important calendrical period ending of 9.0.0.0.0 (December 10, 435) and the sealing of the tomb approximately seven years later.

The marker was covered by a dedicatory offering, the remains of which included charred feathers, seeds, and colorful areas of yellow and burnt umber alternating with spots of fine pinkish gravel (**91**). It is possible that the pigments in the offering constituted a design that became compacted and altered during the 1,500 years between its burial and its uncovering. It appears that the offering was laid out replicating the ancient Maya worldview. Four jadeite spools were placed in the four cardinal directions, and three stones symbolizing the three hearthstones were placed in the middle with a charred sacred bundle of material including feathers and woven elements.

Once the floor marker was lifted, a sizable offering of mercury and the remains of a sacrificed deer came to light. This confirmed the reference to a deer sacrifice recognized in the floor marker's text. Lower still was the circular crypt, which held the remains of a woman in her early twenties, accompanied by ceramic offerings,

jade, shell, a deer antler, and the skeletons of several animal companions. Three decapitated human heads were found in different levels of the burial. We do not know the identity of the woman or the beheaded victims, but she might have been a young shaman associated with three ballplayers who were sacrificed after losing a game commemorating the celebrated period ending. Cylindrical crypts were not previously known at Copan, but they are common at Teotihuacan. This raises more questions about the nature of interaction between Copan and Teotihuacan during the formation of the dynasty of K'inich Yax K'uk' Mo'.

The Motmot marker is also significant because it shows the earliest known portrait of the founder. In all later portraits he wears the central Mexican warrior costume and has goggles over his eyes. Here he is dressed in a more conventional Maya fashion. Two distinctly Teotihuacan features imply that K'inich Yax K'uk' Mo' did have ties with the ancient Mexican capital: this cylindrical tomb and the early building called Hunal, deep beneath Structure 16, that appears actually to hold the founder's remains. Hunal was built in an architectural style known as *talud-tablero* that was typical of Teotihuacan. Perhaps K'inich Yax K'uk' Mo' is being "Mayanized" in this portrait dedicated by his son and successor, who built many structures, including Motmot itself, in the lowland Classic Maya style.

93. The Copan emblem glyph, the leaf-nosed bat.

PHOTOGRAPH BY RICK FREHSEE, 1996.

EXHIBIT 14
Structure 20, Bat Sculpture

In the 1930s, the Carnegie Institution retrieved several bat sculptures from Structure 20, one of the large East Court Acropolis temples lost to the river cut (**92**). An underworld house of trials mentioned in the Popol Vuh is the Zotzi-ha, or House of the Killer Bat, the *cama zotz.* A curious feature of Structure 20 is its cord holders on the outsides of the rooms, by means of which doors or curtains were secured. This led to the idea that the building might have functioned as a jail, perhaps holding captives. Because the Hero Twins were locked inside the Bat House as one of their underworld trials, it is conceivable that the bats on the roof of this building label it as such a place. A leaf-nosed bat is also the main sign for Copan's emblem glyph (**93**).

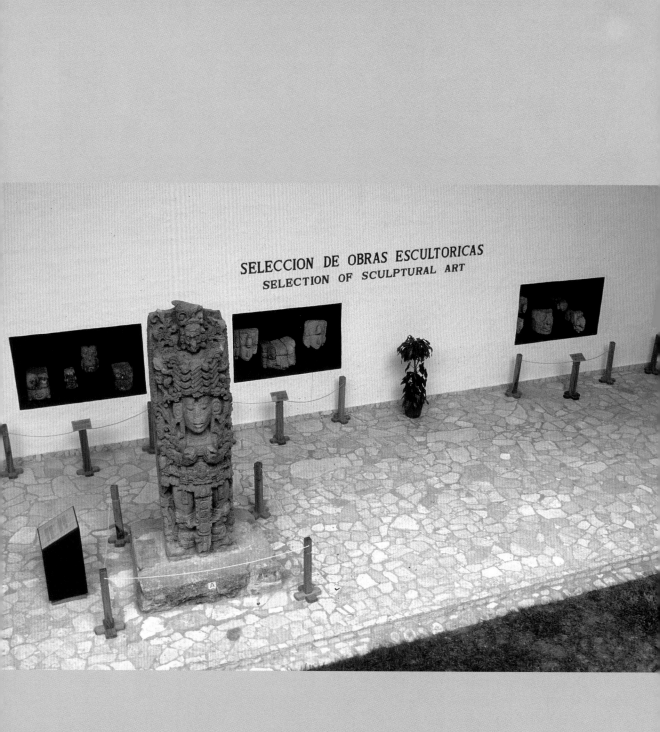

<div align="right">

6

Masterpieces
of Copan
Sculpture

</div>

Many of the sculptures of Copan stand on their own as exquisite works of art, even when separated from their original building façades and companion pieces. For display in one area of the Copan Sculpture Museum (exhibits 16–19), my colleagues and I selected a sample of works that we considered masterpieces (**94**). Their aesthetic quality, artistic attributes, and iconographic themes make them exemplary of sculptural artistry at Copan. As exciting new sculptures are discovered, the exhibited pieces may be rotated to accommodate them. Continuing beyond these four niche exhibits on the museum's lower level (exhibits 24–29), we placed other sculptures illustrating a variety of stylistic developments in Copan's history and highlighting the creativity of the sculpture genre in both form and meaning (**95**).

EXHIBIT 16

Collection of *Ajaw* Sculptures

Exhibit 16 displays examples of what is called the *ajaw* symbol, a sculptural facial motif found frequently at Copan and other Maya sites (**96, 97**). The word *ajaw* is a title for a ruler and also the twentieth day name in the Maya calendar. The symbol's appearance as a puffy face has been interpreted in many ways over the years. One early Western observer of these jovial faces described them as monkeys' faces. This seemed to fit with the hieroglyphic day sign *ajaw,* which occasionally appeared as a howler monkey within a cartouche. Other researchers suggested that *ajaw* motifs should be understood

94. The "masterpiece" area on the lower level of the Copan Sculpture Museum.

PHOTOGRAPH BY RICK FREHSEE, 1996.

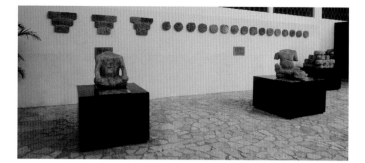

95. Exhibits 24–29, on the lower level of the museum.

PHOTOGRAPH BY RICK FREHSEE, 1996.

as bones, not as monkey heads. As more *ajaw* sculptures became known, sometimes as appendages on headdresses and borders, they clearly needed a reevaluation.

In the 1980s, phonetic decipherment of the hieroglyphs opened the way for another interpretation of the *ajaw* symbols. According to this line of reasoning, the *ajaw* face is derived from a flower sign, or *nik*. The sign *nik* is often coupled with the sign *sak*, meaning white. The combination *sak nik*, "white flower," is a known metaphor for "soul" among the Maya, so the *ajaw* sign may symbolize the soul. Flowers embody a spiritual force equated with the soul, and ungerminated maize kernels and fruit pits, the sources of plant regeneration, embody the unborn soul. These seeds are described as "little bones," or *huesos*, in many Mesoamerican cultures and, like bones, are perceived as containing the life force of animate beings. Perhaps the association between bones and souls explains the similarity the *ajaw* motif also bears to a skull.

Why would flower souls be depicted in grand scale all over buildings in Copan? The ancient Maya, like their modern counterparts, were concerned with the soul from before birth until after death. The souls of newborn babies were fragile and needed to be watched

96. An *ajaw* motif from Structure 22.

DRAWING BY THE AUTHOR.

97. *Ajaw* sculptures displayed in their museum niche.

PHOTOGRAPH BY THE AUTHOR, 1996.

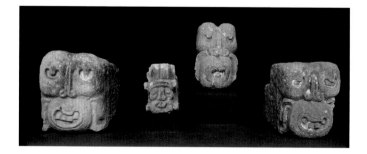

closely. The souls of ordinary people were at constant risk of being lost or damaged. After a person's death, beings in the supernatural world tended to the soul until it was ready to be reborn in another individual. The regeneration of plants, especially maize and fruits, paralleled the cycle of human life. The abundance of *ajaw* motifs on Copan's sculptural façades suggests that they were reminders of the life cycle and of the ancestors' souls waiting to be reborn.

The epigrapher David Stuart has suggested that *ajaw,* when used as the title of a ruler, means "he who shouts." The open, toothy mouths of many *ajaw* sculptures, as well as their monkey associations, lend support to that interpretation. Perhaps the word was used interchangeably for shouting rulers, howling monkeys, and the soul's outcry at the moment of rebirth.

EXHIBIT 17

Two Heads and a Monster Mask

Exhibit 17 displays two oversize, carved human heads and a grotesque mosaic mask (**98**). The nearly identical heads are each carved from a single stone, and each wears a zoomorphic headdress. Their serene countenances are typical of the carving style used during the eighth and ninth centuries at Copan. Sculptural patterns there suggest that these heads were parts of either torsos or full bodies that once adorned a prominent building façade. Unfortunately, no information exists about where or when, in the early twentieth century, they were collected and placed in storage. No other heads like them have appeared in excavations in the Principal Group, so perhaps they

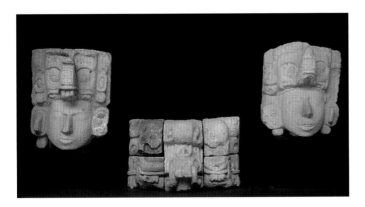

98. Niche display of two oversize sculpture heads and a grotesque mask.

PHOTOGRAPH BY RICK FREHSEE, 1996.

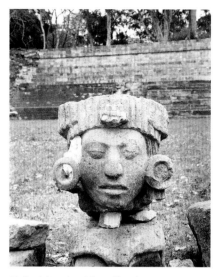

99. Sculpture head from Structure 20, 1942.

came from an outlying site in the Copan Valley. Their facial features, such as the prominent nose and chin and the shallow, slightly skewed eyes, are less refined than the Classic Maya features that typify sculptures from the Principal Group. A good example of the latter is a beautiful head from Structure 20, about the same size as the two heads in the sculpture museum, that is displayed in the Copan Regional Museum of Archaeology in Copán Ruinas (**99**).

The mosaic mask in exhibit 17 was excavated from the southwest corner of Structure 22. Whereas human forms at Copan were generally carved almost fully in the round and placed in roof crests or niches, this mask shows how extremely high relief was achieved within wall courses. Cut stones were blocked out in rough forms and placed in the walls during construction. Massive tenons on the backs of the blocks were needed to anchor them into the walls. Later, sculptors finished the images and added details. This practice enabled those of us studying the sculpture to match up the carved lines and rejoin the fallen pieces with certainty.

Skeletal features such as the fleshless nose and mouth on this piece indicate that it was a death mask. Possibly it served as an underworld support for a figure, much the way a similar carving does on a bench inside Structure 22. There, a skeletal death's head supports the supernatural sky bearers, or *bacab* figures, that hold a celestial monster arching across the doorway. Structure 22 was laden with mountain, or *witz,* masks on all sides, so this singular death mask was probably part of an isolated feature on the façade. Some much larger blocks with similar features were found during excavations at the rear of the building. These pieces have not been reassembled, but they might form a similar mask that had larger proportions and faced north.

EXHIBIT 19

Waterbird and Streams from the "Híjole" Structure

The amazing sculpture of a waterbird at the center of exhibit 19 is the highest-relief carving so far uncovered at Copan. It was unearthed along with what appear to be "water cascade" sculptures during tunnel excavations into the northeast corner of the pyramidal base of Structure 26 (**100**). A small, buried building was found at this spot and named "Híjole," an exclamation of surprise, because both the building and the flamboyant sculptures were completely unexpected. When

ancient people buried the Híjole structure, they placed these sculptures on or near a bench at the west end of the building's interior (**101**). All the sculptures were then partially broken or demolished, perhaps as part of a termination ritual for this and other, earlier buildings beneath Structure 26. Similar fragments of waterbirds were discovered during excavations on the exterior of the final-phase construction of Structure 22, to the northeast of Structure 26. The buried bird sculptures probably once adorned an earlier version of Structure 22, given the continuity of themes in each building complex. Structure 22 is considered a representation of the "First True Mountain of Creation," a place of fertility and the rebirth of maize.

The dramatic form of the bird, carved from a single stone, is a remarkable sculptural achievement. The soft volcanic tuff from Copan's hillsides lent itself to the sculptor's style of fluid carving with open contours. The Híjole pieces all exhibit multiple projecting elements that give the works an airy, naturalistic quality. Many other small, flaring fragments like these, broken at the time they were buried, have been excavated and restored onto the sculptures. The waterbird and cascades in exhibit 19 are part of a larger complex of water symbolism best represented on Structure 32 (exhibit 49), described in chapter 11.

100. Waterbird (center) and cascade sculptures from the "Híjole" structure.
PHOTOGRAPH BY RICK FREHSEE, 1996.

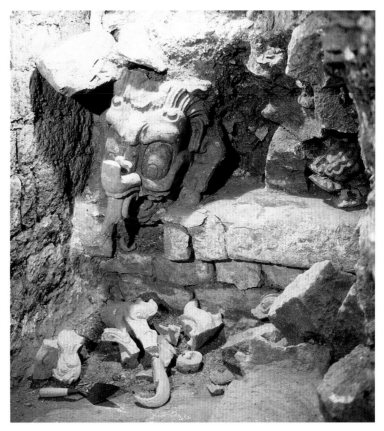

101. Sculptures inside the Híjole structure during excavation, 1989.
PHOTOGRAPH BY THE AUTHOR.

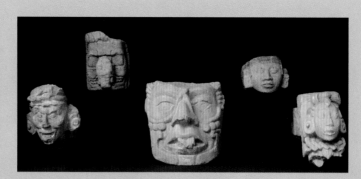

Sculptured heads displayed in exhibit 18.

PHOTOGRAPH BY RICK FREHSEE, 1996.

AN ARRAY OF SCULPTURED HEADS

Figural sculpture was a Copan specialty, and the heads shown in exhibit 18 demonstrate the imagination and skill of Copan sculptors. Buildings that displayed humanlike images often had six to eight human figures around their exterior walls and even larger ones in their roof crests. Over the last thousand years, many of the beautifully carved heads and delicate, gesturing hands have been lost to scavengers. Some of the remaining heads are distinctly human; others are imbued with supernatural features. The immense sun god head in the center of the exhibit is from Temple 11, and the head decorating a belt to the right probably came from Structure 20, but the other, smaller ones lack exact proveniences. The heads reveal a variety of distinctive expressions and hair treatments, which might someday help to identify their original locations.

Close-up of head from a belt decoration.

PHOTOGRAPH BY RICK FREHSEE, 1996.

Close-up of old man's visage.

PHOTOGRAPH BY RICK FREHSEE, 1996.

EXHIBIT 20
Toads

Toad sculptures were popular in rural areas around the Copan Valley, and it is thought that they were part of an early folk religion or fertility cult that flourished into the Late Classic period (**102**). The largest known toad sculpture in the city of Copan itself is one called El Rey Sapo ("the king toad"), which sits on the hillside site called Los Sapos, to the south of the Principal Group (**103**). It is carved into a natural rock outcrop along with other animals and a sculpture that seems to depict a person in the act of bloodletting by penis perforation. Although no date is carved into the outcrop, it is thought to be a Late Classic shrine on the basis of excavated material from the adjoining site.

Smaller toad sculptures have turned up from all parts of the valley but have lost their original proveniences over the years. The largest, most comical freestanding version, displayed in exhibit 20 with several others (but not illustrated here), was found in 1993 during excavations directed by E. Wyllys (Will) Andrews V, of Tulane University, in the residential compound of the last ruler of Copan, south of the Acropolis near Structure 86. Its whimsical smile and arms folded over a pudgy belly have endeared this toad to modern archaeologists and visitors as surely as they did to the ancient inhabitants of the ruler's compound.

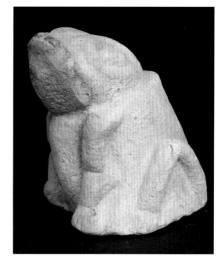

102. Toad sculpture from Copan.

PHOTOGRAPH BY RICK FREHSEE, 1996.

103. "Los Sapos," a rock outcrop shrine on the southeastern hillside beyond the Principal Group at Copan, 1938.

COURTESY PEABODY MUSEUM OF ARCHAEOLOGY AND ETHNOLOGY, © PRESIDENT AND FELLOWS OF HARVARD COLLEGE, DETAIL OF NO. 58–34–20/59716.

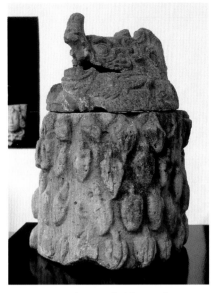

104. *Incensario* decorated with carved cacao pods.

PHOTOGRAPH BY RICK FREHSEE, 1996.

105. *Sak lak tuun* glyph from an *incensario*.

DRAWING BY THE AUTHOR AFTER STUART 1986.

EXHIBIT 21

Stone *Incensarios*

Archaeologists working at Copan have found many large vessels hollowed out of large blocks of tuff, which they have dubbed *incensarios,* or censers (**104**). Two of them are displayed in exhibit 21. Because these vessels show no direct evidence of having been used to burn incense, an alternative explanation is that they held offerings of liquids or foods during rituals. In contrast, the abundant clay *incensarios* discovered throughout the ruins—in burials and offerings, for example—do show evidence of burned substances. Some scholars suggest that clay censers were placed inside the stone containers, and smoke escaped through small openings, or smoke holes, in the larger vessels. The stone containers, many of them with elaborate lids, appear also to have functioned as portable monuments. Several of them have hieroglyphic inscriptions on either their walls or their lids. David Stuart has deciphered a glyph from these inscriptions that reads *sak lak tuun,* "white stone vessel," which he believes was the ancient Maya name for the *incensarios* (**105**).

Researchers believe that the great majority of the stone containers known from Copan were commissioned during the reign of Ruler 16, Yax Pasaj Chan Yopaat. Dates in the inscriptions generally refer to the creation of the vessel and its ritual dedication during the years of his reign. Many *sak lak tuun,* both whole and fragmentary, have been found sitting on the ground near buildings and platforms throughout the Acropolis, sometimes on or near a plain, circular, pedestal base. It is thought that they were left where they were used during ceremonies held at the Principal Group. Two platform buildings across the East Court plaza from each other on the Acropolis, Structures 17 and 25, were both heavily covered with the stone containers (**106**). Structure 18, abutting the Structure 17 platform on the southern edge of the East Court, was Yax Pasaj's funerary chamber, and the *sak lak tuun* might have held offerings left by visitors for the deceased ruler. I think Structure 25, on the opposite side, was a dance platform near Structure 22A, and the containers there might have been used for offerings or for serving food during the feasting associated with performances.

Some of the vessels have deep cavities, and others are relatively shallow. The shallow ones might have held clay censers in which rit-

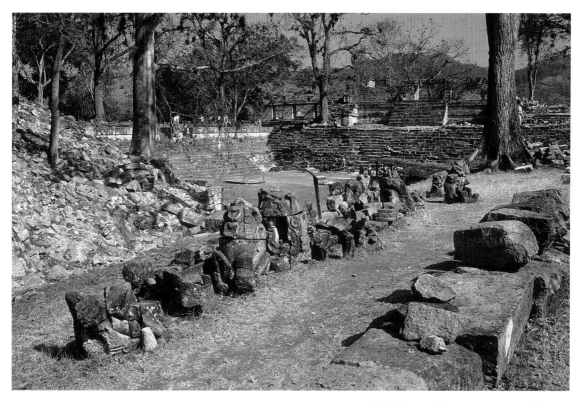

106. Platform of Structure 17, covered with *incensarios*, 1992.

PHOTOGRAPH BY THE AUTHOR.

ual participants burned offerings of copal, the resin of certain tropical trees. The containers with deeper cavities might have been those used for food offerings or storage. Some of the deep *incensarios*, including one of those displayed in exhibit 21, are decorated with cacao pods and have ornate lids carved to represent miniature cacao trees (**107**). This suggests that they were used to hold offerings of cacao beans or drinks made from cacao. Others, featuring maize plants and mountain effigies, might have contained maize beverages or kernels. The Maya ritually consumed both maize and cacao beverages and offered them to the gods. Epigrapher and iconography specialist Simon Martin identified the dried maize plant in Maya art as the regenerative fertilizer for fruit tree plantings, especially cacao trees. This relationship served to spiritually embody the soul of the maize god in chocolate drinks made from the bean. Mountains and caves were important places where humans could communicate with their ancestors and the supernatural world. Stone vessels incarnating cave or mountain deities created a

107. *Incensario* lid decorated with cacao tree and pods.

DRAWING BY THE AUTHOR AFTER LARA 1996.

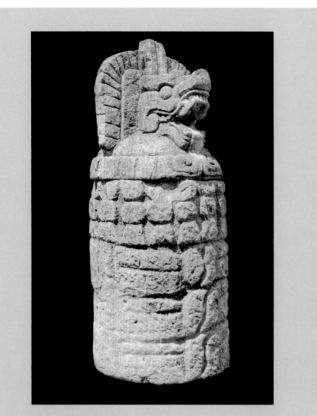

PHOTOGRAPH BY JEAN PIERRE COURAU, 1977.

INCENSARIO WITH INSCRIPTION AND KNOTTED BANDS

One of the containers displayed in exhibit 21 is from a pair that is thought to have been created for the ninth anniversary of Yax Pasaj Chan Yopaat's ascension to the throne of Copan, an anniversary that took place on 6 Kaban 10 Mol, 9.17.1.0.1, or January 2, 772. The date is recorded on the containers' lids as 10 Imix 13 Kumku (9.17.1.0.1). The other container on exhibit, independently produced, bears no inscription, so its exact date is unknown (see **104**). Encircling the base of this container are carved rows of beads with knotted bands. The lid is carved as the head of a beast with both jaguar and serpent attributes. The beast's mouth is the opening to the vessel, and from it emanates a bifurcated, scrolling tongue. Another, similar example records one of the latest inscribed dates at Copan, 3 Ajaw 3 Yax (9.18.15.0.0), or July 24, 805. Other sets of stone containers with inscriptions were carved during the reign of the thirteenth ruler, Waxaklajun Ubaah K'awiil. These earlier vessels were generally carved to represent *witz*, or mountain, deities.

portable sacred landscape for ceremonial and ritual offerings wherever they were transported.

EXHIBIT 22

Macaw Ballcourt Bench Markers

Copan's ballcourt is famous for its elegant architecture and setting (**108**). When people think of the Mesoamerican ball game, the Copan court and the famous court at Chichen Itza in Yucatán often come to mind. Unlike the Yucatecan version, with its stone rings for scoring, the Copan ballcourt featured stone macaw heads as side-alley, or bench, markers for points when players deflected the rubber ball. Three of the bird heads were placed on the sloping bench on either side of the playing alley, one at the center and one at each end, presumably for scoring purposes. They mirrored the whole macaws with outstretched wings that appeared on the building's upper façades (see chapter 8, exhibit 34).

The ballcourt underwent four renovations or stages of construction over time, which archaeologists have labeled Ballcourts I, IIa, IIb, and III. Ballcourt III is the version visible at Copan today. The earlier, buried versions of the ballcourt were found in the 1930s when the Carnegie Institution of

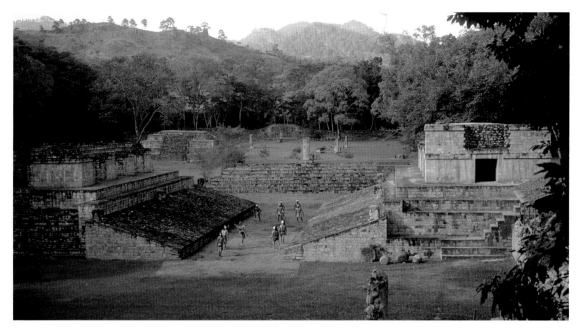

108. The Copan ballcourt, reconstructed in 1936 by the Carnegie Institution of Washington. Sinaloan ball players are shown being filmed for a National Geographic special, 1991.

PHOTOGRAPH BY WILLIAM L. FASH.

Washington began reconstructing the final-phase ballcourt. With each construction phase, a new set of macaw markers was carved and inset into the sloped playing benches, and the markers from the previous phase were removed.

It is possible that markers were sometimes broken during games and later replaced with similar but not always identical versions. However the sculptures became broken, the pieces were discarded and often thrown in with construction fill. In one instance, the tenon of a broken macaw head (not displayed) was found in a tunnel beneath Structure 26. The huge tenon was later hoisted over to another tunnel excavation and shown to fit into a hole in the early Ballcourt IIb bench, from which it had been removed in ancient times.

A macaw head game marker from each construction phase of the ballcourt is displayed in exhibit 22, showing the progression of styles and artistic skill during Copan's Classic period (**109–112**). The earliest versions are small and blocky; one has holes gouged in it to indicate the wrinkled skin of the macaw's face. The larger, more naturalistic heads are later and reflect the flamboyant carving style used during the reign of Waxaklajun Ubaah K'awiil, Ruler 13. With the exception of the one displayed in the museum, all the Ballcourt III

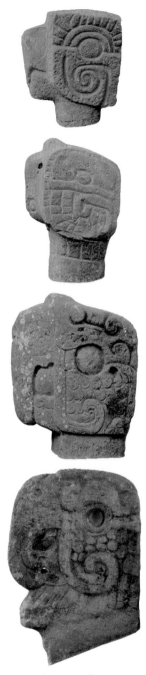

109–112. Top to bottom: Ballcourt macaw head bench markers from Ballcourts I, IIa, IIb, and III.

PHOTOGRAPHS BY THE AUTHOR, 2008.

macaw heads are visible at the site, restored in the 1930s to their original places along the playing walls. These enormous macaw heads have counterparts at only two sites near Copan, La Unión and Asunción Mita.

The head from Ballcourt IIb shown in exhibit 22 was one of two unearthed by the Carnegie expedition (see **111**). Until it was installed in the museum it had been lying underneath a large guanacaste tree across the plaza from the ballcourt and the Hieroglyphic Stairway. In 1986–87, Bill Fash and his students discovered other, earlier markers from Ballcourts I and IIa buried inside a room under the west side of Structure 26. The room was part of a structure nicknamed "Papagayo" that was built over during the reign of Waxaklajun Ubaah K'awiil. When Papagayo and the neighboring ballcourt were buried, the macaw heads were deposited inside the room, probably as part of the termination ritual (**113**). Stela 63 (exhibit 30), which had originally been erected at the rear of the room, and the upper surface of a hieroglyphic bench in front of it were also found broken and burned. One of the macaw heads on display was found on top of the burned stone bench and still has a chunk of carbon adhering to its beak. This evidence is left untouched for visitors to see as part of the archaeological record.

EXHIBITS 24 & 25

Structure 29, Head and Death Mask

Structure 29 at Copan is an L-shaped building in the royal residential area known as El Cementerio, or Group 10L-2, directly south of the Acropolis below Structure 16. It had nine interior niches, perhaps for offerings or statues, but no sleeping benches, the usual hallmark of a residential building. For this reason archaeologists refer to it as a shrine structure (**114**).

Excavators, students, and architectural restorers worked with me to reassemble the abundant sculpture fallen from the exterior façades of Structure 29 (see chapter 11, exhibit 52), revealing a pattern that repeated on all sides. Its motifs included 10 solar cartouches, each carried on the shoulders of a supernatural figure, 13 half-quatrefoil niches spaced along the molding between the cartouches, and numerous S-shaped scrolls representing clouds or smoke. The head of one of the supernatural figures is displayed in

the museum as exhibit 24, without the cartouche. The iconographic theme appears to be celestial; the 10 solar cartouches and 13 niches are relevant to the diurnal passage of the sun and the Maya belief in 13 levels of the heavens. Because solar cartouches often contain images of ancestors in Maya art, they may mark this building as an ancestor shrine.

Structure 29 rests on a low, broad platform with access by staircases on the eastern and southern sides. On the corners of the platform facing northeast and southeast, two large death masks, found fallen from their positions, marked the space as an abode of the deceased. One of these ominous creatures has been reassembled in exhibit 25 (**115**). Note the plain eyes, important pieces that could easily have been overlooked if they had not been carefully excavated as part of the group of sculptures forming this particular mosaic.

Human Figures in the Round

Depictions of the human form fully in the round are artistic as well as intellectual achievements in any society. Although examples are rarely found in the Maya area, many come from Olmec sites in Tabasco and Veracruz, Mexico, and from much later Aztec ruins in

113. Ballcourt macaw head markers as found in the Papagayo structure.

PHOTOGRAPH BY WILLIAM L. FASH, 1987.

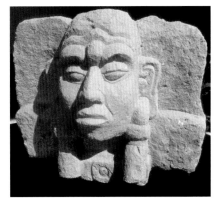

114. Supernatural personage from interior niche in Structure 29.

PHOTOGRAPH BY RICK FREHSEE, 1996.

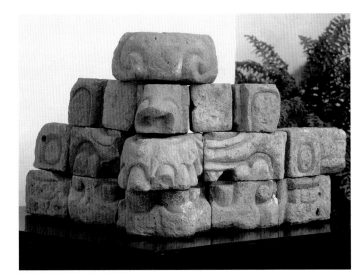

115. Death mask from a corner of the platform supporting Structure 29.

PHOTOGRAPH BY RICK FREHSEE, 1996.

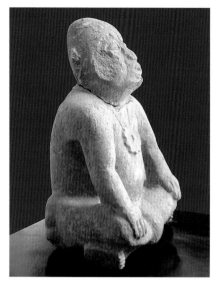

116. Earliest known sculpture from Copan of a human form fully in the round.

PHOTOGRAPH BY THE AUTHOR, 2009.

117. The "Man of Tikal" sculpture.

REPRODUCED BY PERMISSION FROM VALDÉS, FAHSEN, AND ESCOBEDO 1994.

the Valley of Mexico. Stylistically the handful of Copan examples are closely related to the Olmec carvings, even though the Olmec were geographically distant and flourished some 1,200 years earlier. Small jade statuettes, first carved during Olmec times but later made and prized by the Maya in the Preclassic and Early Classic periods, might have served as the inspiration for the life-size Copan figures. The rigidly seated figures, each carved from a single block, are frequently depicted crossed-legged, hands on or directly in front of their knees, sometimes holding objects in their hands. Scholars often refer to Olmec figures in similar postures as priests or "mediators"—those who communicate with the supernatural realm. The Olmec sculptures' realistic features illuminate the spiritual qualities integrated into the sculptures, which the renowned art historian Beatriz de la Fuente described as "the human form in which divine power has a seat."

Exhibit 26 shows the earliest representation of a seated figure fully in the round known at Copan (**116**). Ricardo Agurcia found it in a tunnel excavation beneath Structure 16 of the Acropolis. Stratigraphically it dates to about A.D. 550, although it could have been carved much earlier and buried only then. The piece is remarkable for the sculptor's attempt to carve in this style, but the genre seems still to have been in a formative stage. The figure's arms are noticeably short in proportion to the rest of the body, and the graceful pose and more naturalistic musculature of later versions are not in evidence. The body is covered in light red pigment, and the figure wears a sectioned shell pendant around its neck. Interestingly, the rigid arms and forward tilt of the torso reflect the characteristic posture for this category of figure dating back to Olmec times. Another Maya version from about the same time as the Copan image is the Early Classic seated figure referred to as the "Man of Tikal," from that ancient city in Guatemala (**117**).

In the plaza to the east of the Structure 29 ancestor shrine at Copan, two large, seated figures carved in the round once sat together in the grass (**118**). Broken limbs and missing heads, removed long ago, left them aesthetically unappealing to scavengers and scholars alike, so they went relatively ignored in modern times. Their posture, with crossed legs and pudgy bellies, led to their being compared to Buddha sculptures from Southeast Asia, although no direct connection exists. Carved at least 200 years after the statue in exhibit 26, they were two of the last seated figures left associated

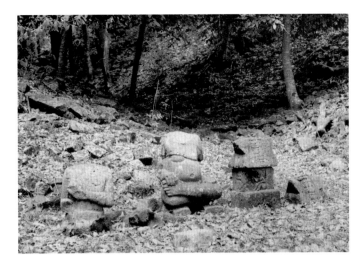

118. Seated figures in the grass in the plaza near Structure 29, 1977.

PHOTOGRAPH BY JEAN PIERRE COURAU, COURTESY IHAH ARCHIVES, COPAN.

with the shrine, too battered and heavy to merit being carted away. In 1990, don Daniel Lorenzo, an older workman from Copan, told us that in his youth, some 65 years earlier, people had called this area "Plaza de los Muñecos," or "Plaza of the Dolls," and it was littered with crossed-legged statues of all sizes.

One of the seated Structure 29 figures is displayed in exhibit 27, with a head next to the body but unattached (**119**). The head fragment was found during tunnel excavations beneath Structure 32, across the plaza from Structure 29. How the head found its way into that structure's fill is a mystery. As is the case with many sculptures from the Olmec area, the seated figures from Copan are almost exclusively found decapitated. The Maya saw decapitating a statue as a means of destroying its spirit, or *ch'ulel*. This is why we find many figures without their heads. Another example is the well-known *escribano,* or scribe, found with its body and head broken, each part buried separately at Group 9N-8, Las Sepulturas. It is now displayed in the Copan Regional Museum of Archaeology with its head reattached to its body (see **164**). In contrast, we decided not to reattach the head of the Structure 29 figure but to leave it separate as a testimony to this practice. Even so, the possibility that in other cases vandals removed the heads of surface sculptures in recent times cannot be ruled out.

If the seated figures are representations of powerful personages, then we can speculate that their strengths and skills were ritually killed when the figure, or part of it, was buried. This might have

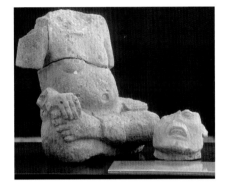

119. Seated figure with broken head from the platform of Structure 29.

PHOTOGRAPH BY RICK FREHSEE, 1996.

MEDALLION GLYPHS

In recent years, explorations of architecture at some of the larger residential compounds in the Copan Valley have yielded a fascinating array of sculptures. On occasion, fragments of hieroglyphic inscriptions and small altars have come to light, although generally the excavated sculpture is from the collapsed building façades. At the residential area known as Group 8L-10, or Salamar, a string of glyphic medallions was discovered fallen from the façades of one of the main structures, Structure 8L-74, during excavations by Wendy Ashmore in 1989. Subsequently, a few matching glyphs were identified in the IHAH storage rooms and sculpture piles.

It is rare to find small glyphs on an exterior façade, and the circular form of these examples also draws viewers' attention. The inscription records the date 8 Lamat 6 Tzec, or May 5, 738. This was a mere two days after the death of Waxaklajun Ubaah K'awiil, Ruler 13. His name and titles, combined with planetary information that seems to relate to the sun, the moon, and a star, also appear in the inscription. Although an *otoot* or house dedication glyph is part of the text, we can only speculate about why this inscription appeared when it did. Perhaps family members living in this compound felt compelled to commemorate his long reign or events that transpired in the days immediately following his capture and beheading at the hands of K'ahk' Tiliw Chan Yopaat, the ruler of Quirigua.

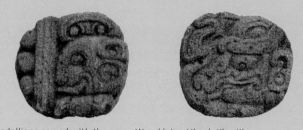

Medallions carved with the name Waxaklajun Ubaah K'awiil.
PHOTOGRAPHS BY RICK FREHSEE, 1996.

Glyphs with solar (LEFT) and lunar characteristics.
PHOTOGRAPHS BY RICK FREHSEE, 1996.

coincided with the death of the person it represented or with the death of the statue's owner. Perhaps someday we will understand whether the statues represented deceased ancestors, patron gods, or images of divine rulers or priests. It is even conceivable that intruders deliberately decapitated the sculptures in an effort to vanquish their enemies and destroy a source of their authority.

EXHIBIT 29
Tuun Elements from a Royal Residence

At Copan's royal residential compound, many household structures were adorned with mosaic sculpture façades. Structure 41 sits at the southern edge of the group, facing west onto Plaza B. Excavated in 1992 by Will Andrews and his students, it is a long building with several rooms, each having individual sleeping benches (**120**). By all evidence, the structure served as living quarters for a segment of the royal family. A mosaic façade once decorated the exterior of the central section of the building. The predominant motifs, presumed to be from the upper register, form stepped designs with beaded clusters in their centers. I interpret these stepped forms, refit by Jodi Johnson, as stylized representations of dripwater formations

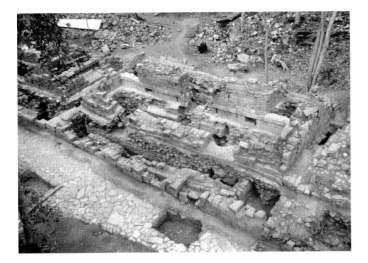

120. Structure 41, south of the Acropolis, after excavation, 1993.

PHOTOGRAPH BY E. W. ANDREWS V, COURTESY IHAH ARCHIVES, COPAN.

found in caves (**121**). The interior beaded clusters with wavy strands label the formations as "water-stones," or stalactites. They are read as either *witz* (mountain) cave symbols or glyphically as *tuun,* stone. Ethnographic accounts describe Maya people collecting pure water in caves for ceremonial use in foods, ritual beverages, and curing rites. The *tuun* signs on Structure 41 might have symbolically transformed the house into a cave dwelling. It is likely that the occupants collected water during the rainy season from the stone drains found in debris collapsed from the roof.

The roof ornaments on this building are also in keeping with the cave or mountain theme. Stone-carved maize sprouts set vertically into the roof would have appeared to be growing out of the structure. According to Maya myths, humans found the first maize kernels beneath a stone inside a mountain cave. The iconography on Structure 41 seems to recount the maize creation story in a diminutive version of Structure 22 (see also chapter 8, exhibits 39–41).

121. A stepped *tuun* motif, representing a dripwater formation, from the mosaic façade of Structure 41, 1996.

PHOTOGRAPH BY RICK FREHSEE.

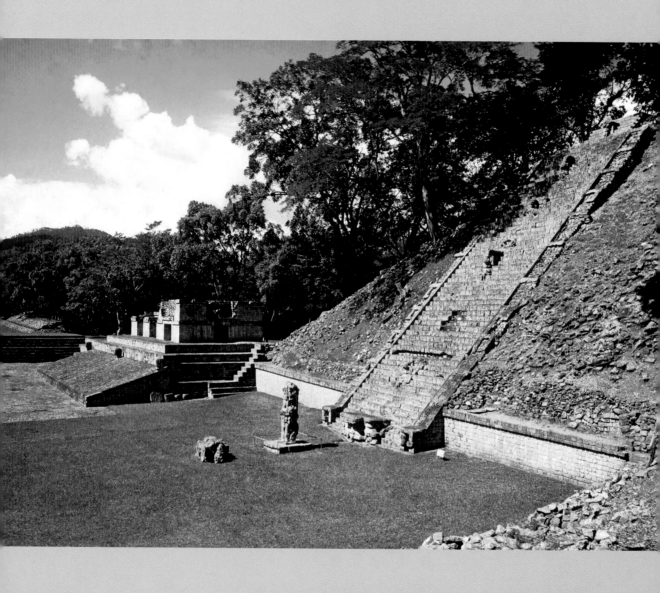

7
Warfare and Ritual

The histories of Mesoamerican peoples, like those of most peoples everywhere, are partly histories of warfare. The Mayan-speaking groups were no exception. Maya rulers launched raids or all-out battles against their neighbors and sometimes fought prolonged wars against rival kingdoms. They fought to acquire new land, force others to pay tribute to them, or fulfill ritual pacts made with supernatural forces. Often rulers started battles in order to secure captives. Although the Maya usually offered animals in sacrifice to the supernatural forces, some important rituals at urban centers also required the sacrifice of war captives. Preserved ancient carvings and paintings of battle scenes reveal that Maya warfare involved a great deal of pageantry and commotion. Banners and war standards evoked the mythical animal patron deities that accompanied warriors into battle for strength and protection. Warfare was often timed according to auspicious calendar dates or the movements of celestial bodies. Archaeological evidence suggests that warfare intensified as the authority and power of the Classic Maya ruling elites eroded and kingdoms increasingly competed over resources.

At Copan, evidence for warfare and its associated rituals comes from the iconography on several buildings and stelae. Rulers were depicted as robust warriors brandishing shields, lances, sacrificial implements, and ropes with which to tie captives. Their roles as powerful war captains became more important as outside forces pressured the stability of the Copan polity and as the need to carry out rituals in order to triumph over misfortunes increased. Rulers from neighboring areas threatened to overtake Copan and topple its

122. The Hieroglyphic Stairway and Structure 26 as seen in 1978.

PHOTOGRAPH BY WILLIAM L. FASH.

ruling dynasty, while population increases prompted environmental catastrophes such as deforestation and the spread of diseases.

Nowhere at Copan is the theme of warfare and war-related ritual inscribed more prominently in architectural sculpture than on Structure 26, the pyramid famous for the immense Hieroglyphic Stairway on its west side (**122**). Exhibit 30 in the Copan Sculpture Museum displays a stela discovered inside the structure called "Papagayo," buried beneath the Structure 26 pyramid. Exhibits 31–33 display motifs and inscriptions from the façades of the temple that once crowned the pyramid. Before turning to those sculptures, however, it is useful to know something of the history of Structure 26, its famous stairway, and archaeologists' exploration of them.

Alfred Maudslay was the first explorer to call attention to the Hieroglyphic Stairway, investigate the mound, and give the stairway the name by which it is still known today. John Owens conducted the first clearing and excavation of Structure 26 in 1891–93 as part of Harvard University's Peabody Museum expedition. After Owens died of a tropical fever and was buried in front of Stela D in the Great Plaza, his field assistant and subsequent director of the expedition, George Byron Gordon, carried on the work (**123**). Gordon was responsible for the initial reordering of the fallen steps of the stairway and the carvings of seated warrior figures that punctuate its ascent. He and others took photographs, which are archived at the Peabody Museum, and made molds of many of the carved risers. The photographs remain a trove of information, retaining details of the hieroglyphs now too eroded to make out. The Peabody Museum published Gordon's complete study of the Hieroglyphic Stairway in 1902, and his reconstructions and decipherments of the key dates in its text have withstood the test of time.

When the Carnegie expedition started fieldwork at Copan, its participants devoted much of their time to restoring the monuments and architecture. At the insistence of epigrapher Sylvanus Morley, one of the first buildings the team worked on was Structure 26. Members of the earlier Peabody expeditions had found the majority of blocks from the stairway dislodged and fallen out of position after centuries of plant growth, earthquakes, and rainstorms. The Carnegie team restored the two sections of steps that had remained in sequence together (see **27**). Subsequently, in the 1940s, Carnegie project members filled in the unrestored spaces with the remaining hieroglyphic blocks and seated figures. They added sequences of cal-

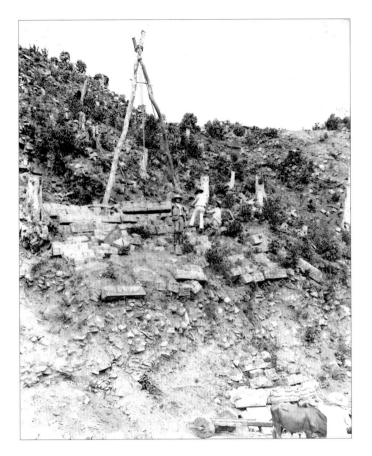

123. Excavation of the Hieroglyphic Stairway by the Peabody Museum in 1895.

COURTESY PEABODY MUSEUM OF ARCHAEOLOGY AND ETHNOLOGY, © PRESIDENT AND FELLOWS OF HARVARD COLLEGE, NO. 2004.24.361.1.

endrical dates, which were the only parts decipherable at the time, but made a jumble of the remaining blocks of the inscription.

In all, 63 steps and a decorative balustrade were reconstructed on the west side of the pyramid, and these are what visitors see today. In 1986, a sixty-fourth step was uncovered at the base of the stairway; it had been covered over when the plaster floor was refurbished in ancient times, probably to keep water from collecting at the base. Epigraphers have spent years studying the inscriptions carved into the steps, deciphering and reconstructing the many passages of the text in efforts to reconstruct its original order and message. Today they have succeeded in reconstructing 71 percent of the text.

The inscription presents an exceptional public record of local dynastic history, giving accounts of the lives and accessions of Copan Rulers 7–15, in effect to legitimate their places in the ruling dynasty. Significantly, although the founder of the Copan dynasty,

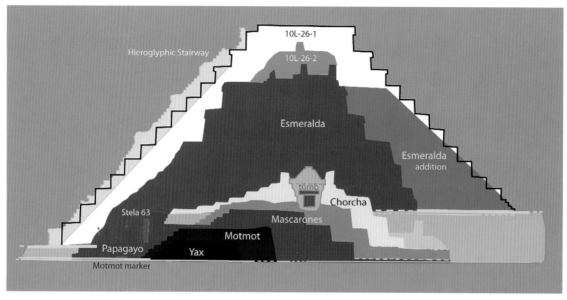

124. The construction sequence of the Structure 26 pyramid.

DRAWING BY THE AUTHOR AFTER A DRAWING BY RUDY LARIOS.

125. Lowermost seated figure on the Hieroglyphic Stairway, 1987.

PHOTOGRAPH BY JEAN PIERRE COURAU, COURTESY IHAH ARCHIVES, COPAN.

K'inich Yax K'uk' Mo', is named in several places in the inscription, the stairway particularly highlights the long reign of Ruler 12, K'ahk' Uti' Ha' K'awiil. Just as the tomb of K'inich Yax K'uk' Mo' lies beneath Structure 16, so the tomb of Ruler 12 lies at the heart of Structure 26, associated with an earlier building (**124**). Ruler 12's 67-year reign (A.D. 628–95) corresponded to the reigns of other powerful Maya rulers, such as K'inich Janahb' Pakal of Palenque and Itzamnah B'ahlam I of Yaxchilan. He consolidated power in the kingdom and ushered in the cultural florescence known throughout the Maya area as the Classic period.

Scholars believe that Copan's rulers built the Hieroglyphic Stairway in two stages. Ruler 13, Waxaklajun Ubaah K'awiil, sponsored the first stage on Esmeralda, three years into his reign, as a dedication to Ruler 12, which covered his earlier burial structure and ancestor shrine. Following the death of Waxaklajun Ubaah K'awiil at the hands of a ruler of Quirigua and the subsequent short reign of Ruler 14, their successor, K'ahk' Yipyaj Chan K'awiil, Ruler 15, rebuilt the stairway and temple. The final dedication date of the relocated stairway, its addition, and the entire final-phase pyramid is 9.16.4.1.0, or May 8, 755. Another important event recorded in the lengthy stairway text was a conflict with the neighboring city of Quirigua, which ended with the fateful capture and decapitation of Waxaklajun

Introductory glyph
(with patron of the month Ceh)

'It is recorded the
number tree'

ah li
('it is said')

Nine — Baktuns

Zero — Katuns

It'zat Ahau
('man of letters')

Zero — Tuns

u wa ha
('it was placed')

Zero — Winals

Zero — Kins

8 Ahau
(Tzolkin date) — Ninth Lord
of the Night

'Ruler 2'

Lunar Series
Glyph 'F' — Lunar Series
Glyph '9D'

Proper name
of monument

Lunar Series
Glyph 'C' — Lunar Series
Glyph 'X'

Lunar Series
Glyph '9A' — 14 Ceh
(Haab date)

yune
('child of father') — t. 157
verb?

Proper name
of monument

K'inich Yax K'uk' Mo' — K'inich Yax K'uk' Mo'

lak am tuun
('large stone')

DRAWING BY THE AUTHOR FROM W. FASH 2001:82.

EXHIBIT 30
STELA 63

Stela 63 is one of the earliest stelae known from Copan. Bill Fash and his team found it in 1988, broken in three sections inside the buried structure nicknamed Papagayo, beneath the Structure 26 pyramid. It had been carved to commemorate the 9.0.0.0.0 period ending on December 9, A.D. 435. This event was something like a modern turn of the century, except that it took place every 400 years. Importantly, it coincided with the start of the Copan dynasty founded by K'inich Yax K'uk' Mo'.

The lower portion of the stela was found in its original place at the back of the interior room, with the other two sections nearby. The back is flat and uncarved because it stood against the wall, but the inscription carved on the front is in low relief with exceptional detail. Especially interesting are the medallion glyphs on either side of the monument. They name Ruler 2 with a scribal title and as the *yune* (offspring) of the founder. Others designate the stela as a "number tree."

Because the stela was broken and ritually burned at the time of the structure's termination, many of the glyphs were damaged or are missing entirely. David Stuart has determined that the very last fragmentary glyph of the inscription shows the personal name of K'inich Yax K'uk' Mo', fol-lowed by what seems to be a place glyph reading "Uxwitza'," or "Three Water Hills," along with a *ch'ajoom* title, a toponymic title similar to *ajaw*, or "lord."

Uxwitza' is the place name for the Maya site of Caracol, Belize. Stuart believes its appearance on Stela 63 indicates that the founder was a Caracol noble who came to Copan to establish a new political order. Further evidence comes from analysis of the element strontium remaining in the bones buried in the Hunal tomb, which are thought to be the founder's remains. These findings indicate that the deceased spent his youth in the central Maya lowlands, not in Copan.

126. Sylvanus Morley's initial reconstruction of the Structure 26 temple inscription, 1937.

Ubaah K'awiil, Ruler 13. It seems that Waxaklajun Ubaah K'awiil began the stairway to honor his father, Ruler 12, and K'ahk' Yipyaj Chan K'awiil finished it essentially as a monument proclaiming the accomplishments of Copan's royal lineage and reaffirming its dynastic honor and warrior strength following Ruler 13's defeat. This would explain why portraits of the rulers as powerful warriors grace the central axis of the stairs and the temple's exterior façade (**125**).

EXHIBIT 31

Structure 26, Hieroglyphic Panel

The temple atop Structure 26 continued the war-related imagery established on the Hieroglyphic Stairway. The temple was in complete ruin long before archaeologists rediscovered it in the late 1800s. Members of the nineteenth-century Peabody expedition collected large quantities of scattered sculpture from the exterior façade and interior hieroglyphic inscriptions from the fallen walls. Some 25 blocks containing portions of a lively hieroglyphic text from the temple's inner room made their way to the Peabody Museum, whose contract with the Honduran government—written more than 100 years ago—stated that the museum could remove half of what it found. Another 20 blocks or so were taken to the Honduran National Museum in Tegucigalpa. During the Carnegie Institution's excavations in the 1930s,

127. Excavations behind Structures 22 and 26, 1987.

128. The Structure 26 temple inscription reunited and reconstructed in the sculpture museum.

PHOTOGRAPH BY RICK FREHSEE, 1996.

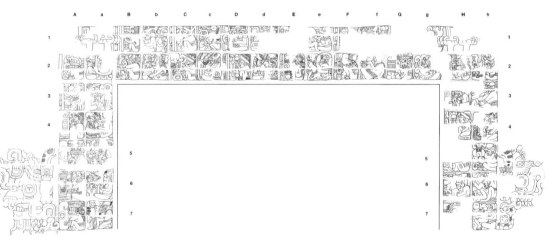

129. Drawing of the Temple 26 inscriptions showing parallel "fonts," Mayan and Teotihuacano. This inscription is one of the most beautiful carvings at Copan. Each hieroglyph is carved as a full figure, a more elegant and artful way of writing the words than the more commonly used phonetic and logographic elements. (Logographs are symbols representing entire words.) Most of the figures hold objects or crouch in profile and appear to be engaged in rituals or other interactions.

DRAWING BY DAVID STUART.

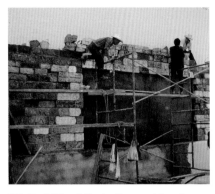

130. David Stuart, Santos Rosa, and Francisco Canán at work reconstructing the Structure 26 temple inscription in the Copan Sculpture Museum, 1996.

PHOTOGRAPH BY THE AUTHOR.

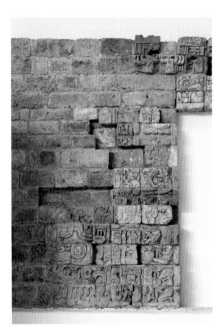

131. Detail of the left side of the Structure 26 temple inscription.

PHOTOGRAPH BY BEN FASH, 2010.

additional glyph blocks from the same panel inscription were found as workers cleared the structure for restoration. Morley catalogued and photographed the pieces and made the first attempt to reconstruct their order (**126**).

Later excavations of the terraces on the north and east sides of Structure 26 in 1986, by Bill Fash and other members of the Hieroglyphic Stairway Project, uncovered even more temple inscription blocks (**127**). Finally, in the 1990s, the Tegucigalpa pieces were brought to the lab at the Centro Regional de Investigaciones Arqueológicas (CRIA) and reunited with the Copan sections to prepare for their eventual reassembly in the Copan Sculpture Museum (**128**). David Stuart and I then reassembled a majority of the blocks in the sandbox, leaving spaces for the absent Peabody blocks. In 1996 I worked with conservation personnel at the Peabody to make paper molds of the inscription blocks in its collection. Transported to Copan, the molds were cast in plaster and rejoined with the rest of the inscription for the first time since the blocks fell from their positions on the temple walls. Finally, Stuart and I oversaw the reconstruction of this extraordinary hieroglyphic text in the museum (**129, 130**). We are still on the lookout for some of the missing pieces to fill in the gaps.

The temple's inscription actually forms the body of a two-headed beast with birdlike attributes, including talons at the top of each side (**131**). The entire form stretches across an expanse that we reconstructed as a solid panel, although conceivably it was a deeper niche with a wooden lintel. The text focuses on Rulers 11–15, with the accession date of Ruler 12 singled out for special recognition. This is not surprising, because his tomb was found in an earlier temple construction beneath Structure 26, and the grand Hieroglyphic Stairway was dedicated to him.

The inscription is most remarkable for being written in a unique double script. David Stuart first noted this intriguing feature when he realized that each phrase and ruler's name in Mayan glyphs in the inscription was mimicked by a glyph with Teotihuacan elements (**132**). The sets of glyphs appear in paired columns, with the central Mexican sign always on the left and the Classic Maya glyph on the right. The glyphs with Mexican attributes are so far unique to the Copan inscriptions. They imply that the sculptor was making reference to the distant and by then abandoned city of Teotihuacan and possibly to Copan's earlier associations with that great center. This is particularly informative because of the paucity of glyphs from Teoti-

huacan and scholars' poor understanding of them. Although the glyphs are not direct representations of Teotihuacan writing, the coupling of a Teotihuacan "font" with deciphered Mayan glyphs opens up possibilities for new decipherments of the earlier Teotihuacan writing system. Perhaps the foreign glyphs were an attempt to represent the secret, esoteric Zuyua language, which the Maya considered to be associated with Tollan, the mythical place of origin for ancient Mesoamerican cultures.

The text also harks back to the pilgrimage K'inich Yax K'uk' Mo' made to Teotihuacan's origin house, the Wite'naah, to be invested with the office of king. The inscription claims illustrious descent from the founder for the entire dynastic succession of rulers. Because Teotihuacan was a great metropolis of far-reaching influence associated with warrior-merchants, Ruler 15's decoration of Structure 26 and the Hieroglyphic Stairway with Teotihuacan warrior imagery, in addition to the dual-script temple inscription, honors a distinguished line of rulers as warriors empowered by the legacy of this powerful city in the wake of the death of Ruler 13.

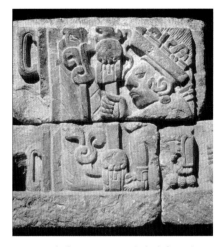

132. Detail of a reconstructed glyph from the Structure 26 temple inscription.
PHOTOGRAPH BY THE AUTHOR, 1989.

Structure 26, Temple Masks and Façade Sculptures

Documentation and analysis of the mosaic sculpture fragments associated with the temple on Structure 26 began in 1986 as part of the Hieroglyphic Stairway Project. During excavations, I helped reassemble motifs from the scattered piles of sculpture that matched fragments emerging from the ground (**133**). This exercise revealed that some of the same iconographic themes found on the balustrade and seated figures of the Hieroglyphic Stairway were repeated in the temple's façade sculptures and roof comb. As on other Copan structures, the main theme was ancestor veneration, with ancestral rulers shown in the guise of warriors.

High on the temple's roof comb, six seated warriors were repeated around the building (**134**). Their warrior costumes resemble those of the seated figures on the Hieroglyphic Stairway, and at one time they brandished shields and lances. Their attire includes elements of the Tlaloc warrior costume such as the interlocked year sign and supernatural owls in their headdresses and distinctive leg garters with trapezoidal elements.

133. Detail of fallen sculpture in excavations at the juncture of Structures 22 and 26.
PHOTOGRAPH BY WILLIAM L. FASH, 1987.

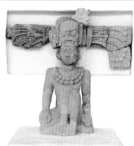

Other sculptural motifs from the façade of the Structure 26 temple (exhibit 33).

PHOTOGRAPHS BY BEN FASH, 2009.

Sandbox reconstructions of the six fringed eye motifs.

PHOTOGRAPH BY WILLIAM L. FASH, 1987.

SCULPTURAL MOTIFS FROM THE TEMPLE

It has long been known that numerology played an important role in Maya religion. The motifs carved on the temple of Structure 26 were found to occur in patterns of six—six warriors, six masks, six rectangular shields, and so forth—but it is unclear precisely what the significance of the number was in this setting. Perhaps six, or *wak* in Mayan, in this instance signified a connection to the ancient deity Wak Lom Cha'an—literally "six sky piercer," perhaps a supernatural warrior.

The motifs include a dangling heart, a rectangular shield, and a droopy-lidded, fringed eye with scrolls and a year sign. A roof ornament in the form of a stylized eccentric flint or obsidian lancet—a miniature version of the tongues of the war serpent masks on the temple façade—makes reference to acts of piercing. Another repeated motif is the small, seated figure with closed eyes, which may have represented deified ancestors or patrons of the warriors. Roof ornaments in the form of six stylized torches and six eccentric flints or obsidian lancets encircled the building. The upright torch signifies the New Fire ceremony traditionally held at Teotihuacan and continued by Mexican cultures over the centuries. Disks of stone that resemble the representations of *chalchihuites* ("precious stones") on temple façades in Mexico were likely placed on the roof crest or embedded in a flaring molding. These plain disks show signs of having been coated and inset in stucco. It is possible they were to appear as the goggle eyes of Tlaloc.

The inset altar at the base of the Hieroglyphic Stairway ties these symbols together. Karl Taube and David Stuart think the altar may represent an upside-down war serpent head; the balustrade outlines its centipede- and scorpion-like body. They also suggest that the war serpent, closely associated with obsidian in the Maya area, had its origins in Teotihuacan. Perhaps Wak Lom Cha'an was the Maya form of this deity, a precursor of Xuihcoatl, the meteor fire serpent of the Aztec. Certainly the stinging qualities of the centipede and scorpion could be likened to the piercing blows of a warrior's weapon, an obsidian blade, or bloodletting implement. If so, then it would seem that Copan's warriors drew their strength from this deity and from an affiliation with central Mexico.

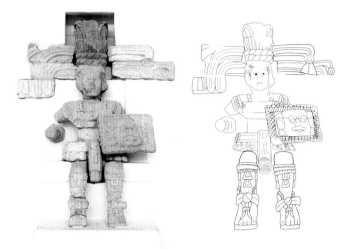

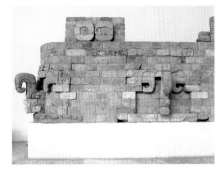

134. (LEFT) Photograph and drawing of ancestral warrior figure as reconstructed from the façade of the Structure 26 temple.

PHOTOGRAPH BY BEN FASH, 2009; DRAWING BY THE AUTHOR.

135. (ABOVE) War serpent masks reconstructed from the façade of the Structure 26 temple.

PHOTOGRAPH BY BEN FASH, 2009.

Six war serpent masks with proboscis-like lancet tongues formed niches along the molding of the temple's upper register. Along the sides of the war serpents' mouths, stylized butterfly wings were appended to droopy-lidded, starry eyes (**135**). These might have represented the warrior's soul, which in ancient central Mexican belief was transformed into a butterfly at death (**136**). Similar examples are found in painted Mexican codices showing star eyes along a celestial band, possibly another symbol for the warrior's soul.

The themes of warfare and sacrifice that predominate on this temple represent a departure from the sustenance themes portrayed on embellished façades of many earlier buildings at Copan. This shift may reflect the general atmosphere in the war-torn Maya lowlands of the Late Classic period and in Copan particularly following the death of Waxaklajun Ubaah K'awiil. After his defeat by the Quirigua ruler, the surviving nobles might have felt it necessary to make a strong political statement to exalt the ruling dynasty. The sculptural message on the temple was meant to instill confidence in the rulers' supernatural abilities and warrior skills.

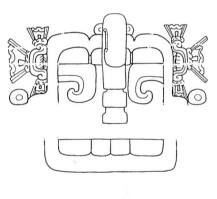

136. Reconstructed war serpent with butterfly attributes from Structure 26 (top) and butterfly symbol from the Codex Nuttall (after Nuttall 1975).

DRAWINGS BY THE AUTHOR.

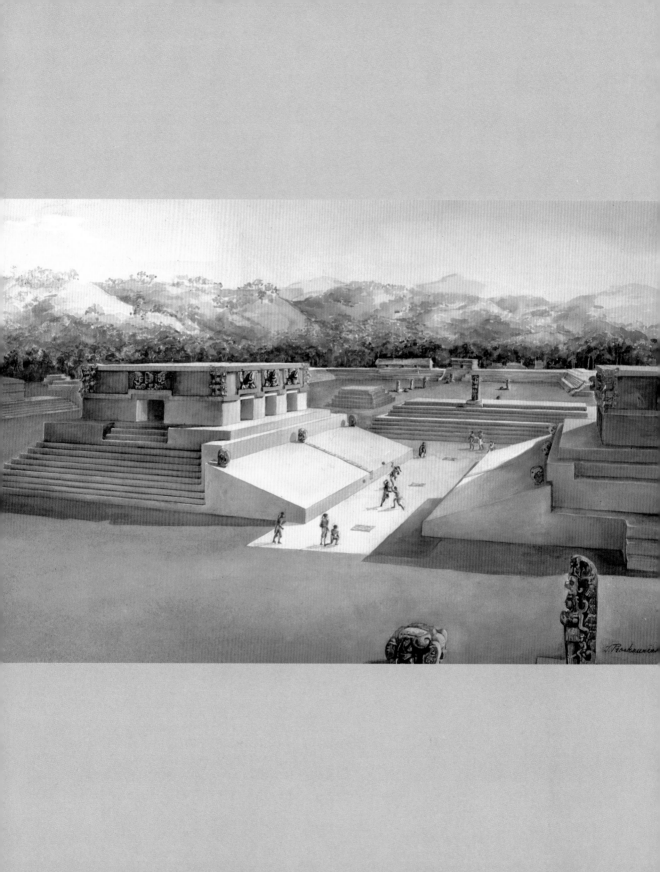

8

Fertility and Cosmology

The ancient Maya world revolved around concepts of creation. These concepts are still apparent in the spiritual practices of contemporary Maya, who carry on traditions that Spaniards witnessed in the sixteenth century and that Maya artists themselves recorded much earlier in inscriptions and paintings. Through covenants with deities and ancestors, rulers were empowered with divine authority to bring agricultural fertility to their people and to mediate with these supernatural forces on their people's behalf. Many of the important buildings and ritual caches re-created a four-part universe with a center point from which life arose. Through both public and private acts, rulers symbolically placed themselves at this center point to assert their role in re-creating and preserving the cosmic forces.

In exhibits 34 and 36–41, the Copan Sculpture Museum displays sculptures that exemplify the abundant symbolism of fertility and cosmology that the ancient Maya of Copan found meaningful. (Exhibit 35 had not yet been installed at the time of this writing.) Two exhibits come from the Copan ballcourt, for the Maya ball game was in part a ritual that reenacted the Maya creation myth to give rebirth to the sun and the maize crop (**137**). The ballcourt was not part of the Acropolis proper, but it was linked to the rituals carried out there and in the Great Plaza. It epitomizes the way Maya public art and architecture defined sacred spaces in which rituals were performed. Exhibit 34 is the reconstructed façade of Ballcourt III, the last of three phases of ballcourt construction at Copan, and Exhibit 36 is a replica of a giant bird carved in stucco from the earlier Ballcourts I and II. Sculptures that once decorated Temple 11 (exhibits 37 and 38)

137. Artist's reconstruction of the Copan ballcourt and its sculpture façade.

WATERCOLOR BY TATIANA PROSKOURIAKOFF, 1943. COURTESY PEABODY MUSEUM OF ARCHAEOLOGY AND ETHNOLOGY, © PRESIDENT AND FELLOWS OF HARVARD COLLEGE, NO. 50–63–20/18488.

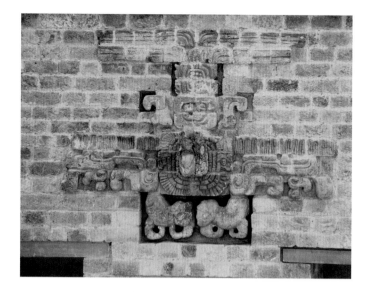

138. Reconstructed Ballcourt III macaw.

PHOTOGRAPH BY WILLIAM L. FASH III, 1996.

emphasize water symbolism and astronomical phenomena. Finally, the temple atop Structure 22 (exhibits 39–41) embodied the sacred mountain where maize first germinated and featured symbols of the Maya creation story.

EXHIBIT 34

Ballcourt III Façade

Copan's ballcourt is justly famous for its elegant form and corbelled arches. It is also special because its two parallel structures, Structures 9 and 10, were richly decorated with cosmic imagery. With its display of supernatural macaws and companion architectural sculptures, it illustrated the cosmological symbolism inherent in the game in a way no other known ballcourt in Mesoamerica did. The descending birds acted as messengers from the supernatural world as they alit on the façades, which were envisioned as their homes (**138**).

The embellishment of the Copan ballcourt signals the importance the game and its associated rituals held for Waxaklajun Ubaah K'awiil, Ruler 13, who commissioned the ballcourt in its final form. He was possibly a ball player himself, and some scholars have even hypothesized that his capture and sacrifice at Quirigua resulted from the loss of a ball game.

The game itself has been interpreted as a ritual reenactment of the sun's battle for survival and rebirth on its daily and annual journeys through the heavens and the underworld. A successful reenactment helped ensure fertility and the survival of humankind and life on earth. On the Copan ballcourt, the macaw was a messenger representing the sun and its link to the vital maize crop in the yearly agricultural cycle.

Ball-game iconography from many sources informs us that human sacrifices were associated with the ball game. At some Maya archaeological sites, such as Yaxchilan, the sacrificial victim is depicted rolled into a ball and thrown down a stepped false-ballcourt toward a defending player, usually a ruler. The sacrifices were part of the ritual deemed necessary to promote agricultural fertility and ensure the resurrection of the sun and the maize plant. This symbolism mirrors the concern with the agricultural and solar cycles also expressed on Structure 16, with its emphasis on Tlaloc and on K'inich Yax K'uk' Mo' as the sun (exhibits 1 and 4–7).

Throughout Mesoamerica, the macaw's bright plumage, regarded as the sun's costume, together with its power of flight, made it a logical substitute for the sun. In the Popol Vuh, the supernatural macaw Vucub Caquix (Seven Macaw) is portrayed as the sun's impersonator. Barbara Tedlock and Dennis Tedlock report that among the K'iche Maya, Vucub Caquix is said to be the constellation we know as the Big Dipper. He is eventually killed by the Hero Twins, but not before he has ripped off the arm of Hunahpu, one of the twins. Bishop Diego de Landa reported in the sixteenth century that the name of a prominent Yucatec Maya deity, K'inich K'ak' Mo', meant "Sun-face Fire Macaw." According to Landa, a temple at the town of Izamal was dedicated to K'inich K'ak' Mo', and it is still called by that name today. Maya codices portray macaws carrying torches, a probable symbol for drought brought on by the sun.

Number symbolism revolving around fertility is also evident on the structures that make up the ballcourt. The macaws that dominate their façades are repeated eight times on each structure, to represent the cardinal and intercardinal directions on each building. The number eight is associated with the maize deity in Maya belief, and its divisor four is associated with the sun and the four-sided *milpa,* or agricultural field. The imagery reinforces the interpretation that the agricultural cycle and journey of the sun gave meaning to the game played out on the court.

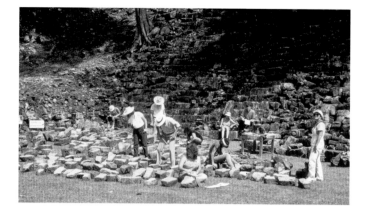

139. Students and volunteers sorting sculpture blocks in ballcourt pile 1, 1985. The author is standing at center left.

PHOTOGRAPH BY WILLIAM L. FASH.

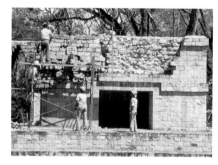

140. Test of macaw mosaic reconstruction on the Ballcourt III façade at the ruins, 1989.

PHOTOGRAPH BY THE AUTHOR.

It was at the ballcourt that the Copan Mosaics Project in 1985 initiated its attempts to reconstruct the fallen sculptures in the Principal Group of Copan. Pieces of ballcourt carvings were strewn about in five surface piles (**139**). After several years of motif analysis at the site, a hypothetical reconstruction of a flying macaw mosaic was temporarily restored as a test on the west façade of Structure 10, the easternmost of the two ballcourt buildings (**140**). Later, IHAH replaced it with a cast, which remains there for visitors to see. The original sculptures were transported to storage at the Centro Regional de Investigaciones Arqueológicas (CRIA) until four of the best-reassembled groups could be reconstructed in the museum.

In the 1940s, Tatiana Proskouriakoff painted a reconstruction of the Copan ballcourt showing eight macaws adorning the upper register of each of the two buildings flanking the playing alley (see **137**). As we worked on reconstructing the actual sculptures, we found that she was right about the number of birds, but new information led us to alter her hypothetical placement of the macaws. Whereas Proskouriakoff depicted all the macaws on the frontal planes of the façades, we discovered that four of the eight birds on each building were originally on its corners. We determined this from the wedge-shaped tenons on the birds' collarpieces. When fitted together in the back, the wedge-shaped stones caused the front carved faces to form rounded corners rather than 90-degree angles (**141**). Our proposed composition, displayed in exhibit 34, has outstretched wings flanking a beaded jade collar beneath the macaw's unmistakable head. The wings and an upright tail both signal that the bird is in flight but in the process of alighting on the building (**142**).

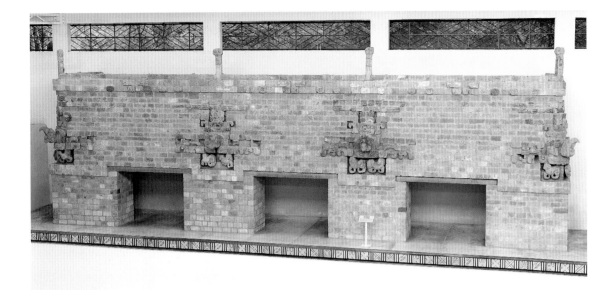

The wings of the ballcourt macaws are composed of stylized serpents' heads with short feathers flaring from the tops, forming a variant of the common Maya "serpent-wing" motif. Birds with such wings are identified as divine beings having either celestial or underworld associations. The model for the Copan macaw sculptures was the royal macaw (*Ara macao*), a bird once common in the subtropical forests of the region. Although macaws no longer live in the wild around Copan, today visitors can see protected birds at the entrance to the ruins. On the ballcourt sculptures, a pattern of raised bead shapes encircles the macaws' eyes, representing the white, wrinkled skin around an actual macaw's eye.

Several other motifs reconstructed on the ballcourt façade associate the sun-impersonating macaw with maize and with the sun's nightly journey through the underworld. We found components of maize configurations, which during reconstruction were set along the upper molding between the birds (**143**). Another maizelike element seems to be part of the macaws' tails (**144**), along with an *ak'bal* sign (**145**), a sign associated with darkness, caves, and the earth's interior. The maize plant sprouting from this *ak'bal* sign may refer to the rebirth of maize from the earth's interior. It was natural to pair these motifs with the macaws because they also occurred in groups of sixteen.

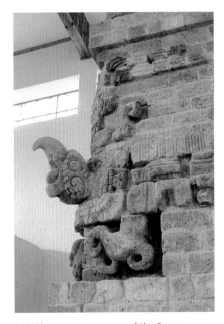

142. Macaw on one corner of the Copan ballcourt façade, as reconstructed in the sculpture museum.

PHOTOGRAPH BY RICK FREHSEE, 1997.

143. *K'an* cross elements and maize configurations along the molding of the ballcourt façade.

PHOTOGRAPH BY THE AUTHOR, 2008.

144. Maize element in macaw's tail.

DRAWING BY THE AUTHOR.

145. *Ak'bal* sign in macaw's tail.

DRAWING BY THE AUTHOR.

146. *K'an* cross motif from Palenque.

DRAWING BY THE AUTHOR.

147. *Ajaw* roof ornaments from the ballcourt.

PHOTOGRAPH BY THE AUTHOR, 1986.

A symbol that sculptors carved along the ballcourt's cornice was the *k'an* cross, which is often found at other Maya sites in bands depicting sacred liquid. An example can be seen on the sanctuary of the Temple of the Foliated Cross at Palenque (**146**). The *k'an* cross seems to represent the precious essence of the yellow maize kernel as it was created in a mountain cave from an underground pool of water. From there it rose to the surface of the earth, sprouting as the maize plant. Maize foliage designs that split apart along the cornice alternate with the *k'an* crosses. We reconstructed these directly beneath the vertical *ajaw* roof ornaments (**147**). I like to interpret these humorous faces, with their open ("shouting") mouths, as the souls of the budding maize seeds, the mature kernels of which were ground into dough by the Maya deities to form humans. They might visually represent the sound of the messages carried by the bird deities. Roof ornaments throughout Copan tend to provide clues to the supernatural essences embodied in structures—in this case the sacred relationships among the sun, the earth, maize, and humans.

EXHIBIT 36

Stucco Bird Replica from Ballcourts I and II

Earlier versions of the Copan ballcourt have been known since the time of the Carnegie excavations, but it was not until the Proyecto Arqueológico Acrópolis Copán (PAAC) in the late 1980s that the façade designs of these versions were discovered. The first structure, Ballcourt I, was originally situated somewhat south of the court's final location some 300 years before Structure 26 and the Hieroglyphic Stairway took their ultimate forms. When Rudy Larios was repairing the first terrace of Structure 26, masons discovered fragments of stucco designs underneath the terrace. The restoration work was halted, and PAAC excavators uncovered the exciting find: a partially preserved stucco macaw sculpture from the earlier ballcourt (**148**). The bird was modeled directly onto the court's substructure,

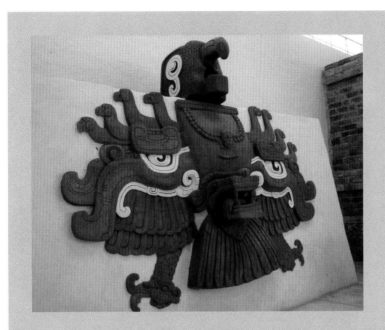

STUCCO MACAW FROM BALLCOURTS I AND II

The stucco macaw from Ballcourts I and II displays an unusual feature not carried over to its counterparts in the stone mosaic of Ballcourt III. From the bird's groin juts a feathered serpent head holding a severed arm in its open mouth. A single circle or dot is incised on the arm, representing the numeral 1 in the Maya and Mesoamerican numerical notation system. Bill and I have interpreted this as the arm of Hunahpu ("One Hunter"), one of the Hero Twins in the myth retold in the Popol Vuh. The tale goes that Hunahpu tried to shoot down the mythical macaw Vucub Caquix, a sun imitator, with his blowgun, and the beast tore off his arm. Although we cannot be certain that the myth was identical in Classic Maya times, this stucco image offers evidence of strong continuity over the centuries. At the site of Izapa in nearby highland Guatemala, an even earlier stela carving, dating to the Late Preclassic period (300 B.C.–A.D. 250), depicts what appears to be the same scene.

The feathered serpent head on the sculpture bears a remarkable resemblance to feathered serpents found in stone at Teotihuacan. This lends further support to the idea that K'inich Yax K'uk' Mo', who constructed Ballcourt I around A.D. 430, had a strong affiliation with this central Mexican metropolis.

(LEFT) Museum replica of the macaw (exhibit 36).

PHOTOGRAPH BY RICK FREHSEE, 1997.

(RIGHT) Stela 25 from Izapa, Guatemala.

DRAWING BY THE AUTHOR.

Feathered serpent in stone from Teotihuacan, about A.D. 550.

PHOTOGRAPH BY THE AUTHOR, 1996.

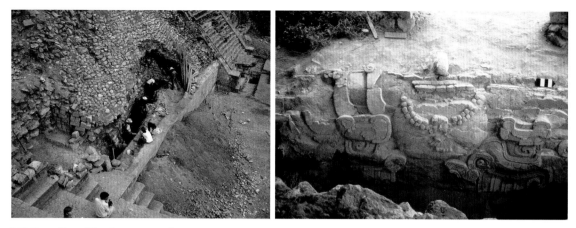

148. Excavation of the stucco macaw from Ballcourts I and II, 1987.

PHOTOGRAPH BY WILLIAM L. FASH.

149. The stucco ballcourt bird following excavation and conservation, 1988.

PHOTOGRAPH BY WILLIAM L. FASH.

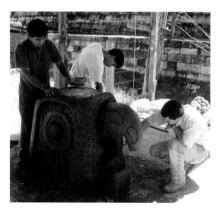

150. Sculptors Marcelino Valdés and Jacinto Ramírez and assistant José Pérez replicating the stucco macaw for the sculpture museum, 1995.

PHOTOGRAPH BY THE AUTHOR.

rather than sculpted on the building façade as in the final court, and it was once painted a vibrant red (**149**). Refurbishments kept it an active component of the façade throughout the Ballcourt II phase. It was eventually covered over with the stone façade of Ballcourt III.

In time, the position of another stucco bird on Ballcourts I and II was discovered during continuing tunnel excavations. Little of the bird's body was preserved, but it did have an intact head. Together the birds provided enough information to enable us to make a composite reconstruction of the entire design for display in the museum. I drew the design out, and Marcelino Valdés, Jacinto Ramírez, and their assistants replicated it the same way they re-created Rosalila (**150**). The original stucco design was reburied because of its extreme fragility.

EXHIBITS 37 & 38

Sculptures from Temple 11

Temple 11 dominates the public plaza of the Principal Group at Copan, looming large at its southern end atop the artificial mass of the Acropolis. Built by Yax Pasaj Chan Yopaat, the last ruler in Copan's royal dynasty, the temple was a grand building scheme and a fitting political message designed to marshal support for a dynasty whose end was drawing near. From the doorways of the temple, visitors today find their best view of the Great Plaza and the surrounding hills (**151**). A refreshing breeze always seems to blow on the summit, no matter how stifling the day, and one's imagination easily begins

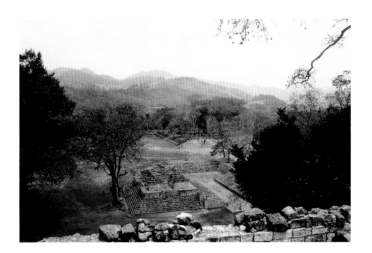

151. View of the Great Plaza and surrounding hillsides from Temple 11.

PHOTOGRAPH BY THE AUTHOR, 1987.

to create scenes from the ancient past on the plazas stretching out below. At the top, two massive ceiba trees crown the east and west ends of the ruined temple. Their roots have dislodged walls and sculptures over the years, but now they actually help to hold the structure together (**152**). They have become as much a part of the ruined city as any stone monument.

Images of two giant *pawahtun* have fallen from the lofty façade of Temple 11. Four *pawahtun* and four *bacab* were believed to crouch at the corners of the world, supporting the earth and the sky, respectively. These are generic Yucatecan Mayan names for these deities. Their water-lily headdresses celebrated the alliance of Yax Pasaj Chan Yopaat with the forces of nature and the Maya cosmos. Water-lily headdresses can also be seen on the mirror images of the ruler on Stela N, which still stands at the base of the staircase to Temple 11 (see **60**). This headdress seems to have reached its height of popularity during the reign of Yax Pasaj Chan Yopaat, and it was found throughout the Maya area in the Late Classic period. I believe that as part of royal attire it designated the wearer as a powerful water manager, someone who carried out civic and ritual duties related to water. The patron of water managers was God N, representing the scribal role of the *pawahtun*. The extensive reservoir and drainage systems at Copan and other Maya cities were engineering feats that began with the cities' first layouts. By the Late Classic period (A.D. 600–900), population increases had forced Maya engineers to be ever more adept at managing water resources for their cities and

152. Massive ceiba tree on the summit of Temple 11.

PHOTOGRAPH BY THE AUTHOR, 1987.

153. Colossal *bacab* head from Temple 11, with water-lily fragment restored.

PHOTOGRAPH BY RICK FREHSEE, 1997.

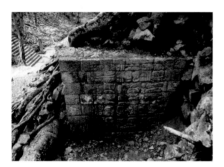

154. Southeastern hieroglyphic panel from Temple 11, in place at the site before transfer to the museum.

PHOTOGRAPH BY THE AUTHOR, 1987.

155. Southeastern hieroglyphic panel from reconstructed Temple 11, in the museum (exhibit 38).

PHOTOGRAPH BY RICK FREHSEE, 1997.

surrounding settlements. At a time when the management of resources was crucial for the well-being of the burgeoning populace, the ruler on Stela N was appropriately dressed as God N to associate himself with fertility, the sacred waters of creation, and control over water.

The old *bacab* or *pawahtun* head displayed in exhibit 37, a hallmark of Copan known since the earliest expeditions, graced the platform on the northeast side of Temple 11, looking east, until it was transferred to the museum (**153**). A replica now takes its place at the site, for the absence of the head, which is as familiar as the ceiba trees, would create a strange void. A twin head, much more battered from its fall off the temple, sits at the northwestern base of the staircase. Both heads were adorned with tied water-lily headdresses, shown with scalloped edges and a crosshatched interior representing the water-lily pad. Its stem wraps around the wearer's head, holding the pad in place by a knot in front. Usually a fish was depicted nibbling on the flower's edge, but here a scar is seen where one has broken off and been lost.

The Temple 11 *bacab* heads were parts of two enormous figures that once supported an immense crocodile, the body of which spanned the north façade. Downslope on the north side of the temple, one of their huge hands is embedded among the blocks of fallen wall. Proskouriakoff, in her 1938 field notes, was the first to recognize that enormous carved claws and blocks with beaded scales amid the jumble composed the body of a colossal saurian creature. (A possible head for the creature lies in the West Court, although it looks more serpentlike than crocodilian.) It is well known that the Maya likened the earth's surface to the back of a crocodile, which four strong *pawahtun* supported at each of the cardinal points. In Copan's days of grandeur, these two giant *pawahtun* were visible from great distances supporting the earth crocodile atop Temple 11.

In its layout, Temple 11 takes the form of an asymmetrical cross with four doorways, one opening to each of the cardinal directions. Framing the doorways perpendicularly at one time were eight tall hieroglyphic mosaic panels paired facing each other. The carving style on the panels is shallow, and the larger-than-average glyphs often span the surfaces of several blocks. The panel displayed as exhibit 38 in the Copan Sculpture Museum was rescued from the gnarled ceiba roots engulfing the eastern doorway (**154, 155**). In the late 1930s, the opposite-facing panel was transported to the Copan Regional Museum of Archaeology out of similar preservation con-

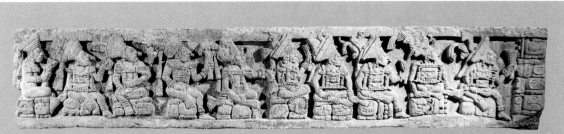

TEMPLE 11
DETAIL OF CARVED STEP

On a final version of the doorway to the inner chamber of Temple 11, framed by the serpent maw, an access step was carved with 20 exquisite figures. Each personage is seated on a glyph. Half the group faces left, and the other half right, so they all look inward toward the center. The scene is reminiscent of the one carved on Altar Q, where 16 dynastic rulers sit above their name glyphs. In this case the glyphs appear to name both rulers and other officials, or possibly a sequence of deified ancestors. Maudslay removed the carving in the 1880s with the permission of the Honduran government, and it has since been housed in the British Museum. The probable ancestors depicted on the step may have been conjured up from the supernatural realm during rituals carried out by the ruler. They are situated as players in the ruler's performances, displaying his divine status and privileged access to the gods in the cosmic realm.

cerns. At the site, the Carnegie Institution almost fully restored all but the two eastern panels. Epigraphers Berthold Reise, Linda Schele, and David Stuart, working independently over the years on the remainder of the inscriptions, replaced as many of the outstanding blocks as possible in their original panel locations.

The doorway texts contain astronomical data, including the timing of the Venus cycle, or 819-day count, in relation to dedicatory and fire rituals performed by Yax Pasaj Chan Yopaat for the temple. Schele also deciphered records of Yax Pasaj Chan Yopaat's accession date, two appearances of Venus as the evening star, a solar eclipse in A.D. 771. An unusual feature for any Maya site is that the glyph panel on the right in each pair is carved in mirror image to the one on the left and is read "backward," from right to left. That is the case with the panel displayed in the sculpture museum.

Alfred Maudslay was the first to excavate the interior of Temple 11, in the nineteenth century. He cleared out its four corridors and found a staircase leading to what was probably a second story. An interior chamber, the doorways of which were accessible from the north and south corridors and were framed by stylized,

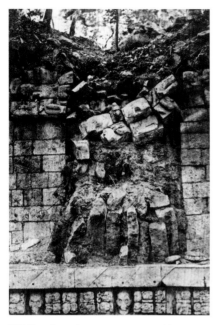

156. Temple 22 doorway as uncovered by Alfred Maudslay, 1886.

open-mouthed serpents, contained a deep shaft. A bone with Yax Pasaj Chan Yopaat's name and image carved on it was one of the many artifacts collected from this feature; it is displayed in the Copan Regional Museum of Archaeology. The doorway serpents' heads form an underworld maw, a portal to the realm of the ancestors. These are common features in the architecture of Copan, seen also in the interior niche of Temple 16 and the lower register of Structure 9N-82. Whereas the sculpture on the exterior façade of Temple 11 emphasizes the sixteenth ruler's role in the fertility and sustenance of the polity, the interior sculpture situates him within the larger cosmological realm.

EXHIBITS 39–41

The Temple on Structure 22

In 1886, when Maudslay first excavated the temple atop the pyramid he numbered Structure 22, some of its statues were still in place, as was its beautiful sculptured doorway (**156**). But restoration was not part of his program, and after his departure, parts of the newly uncovered building gave way to the elements and tumbled further into disarray. A few years later, members of the Peabody expedition stacked the fallen sculpture on the stairways of the surrounding platforms as they cleared more of Structure 22. Again, no restoration was carried out. When the Carnegie expedition appeared on the scene in 1936, its archaeologists found that the doorway had caved in, and the room had to be reexcavated in order for restoration to proceed. The restoration of Structure 22 that visitors see today was carried out under the supervision of Aubrey Trik as part of the Carnegie Institution project (**157**).

The temple at the top of Structure 22 is often called the "Temple of Meditation," a name given to it by the Honduran poet Carlos Izaguirre, who was inspired by its exquisite inner sculptured doorway and its elevated position at the north end of the East Court. Other scholars have described it as a temple dedicated to Venus and maize. Today it is believed to have been conceived of as the primordial Yax Hal Witznal, meaning "First True Mountain of Creation," or more generically "Sustenance Mountain." Its inner doorway is believed to depict the night sky and a representation of the Milky Way, in this instance, carved as the body of the Starry-Deer-Caiman with bloodletting associations. Iconographic elements that appear on the tem-

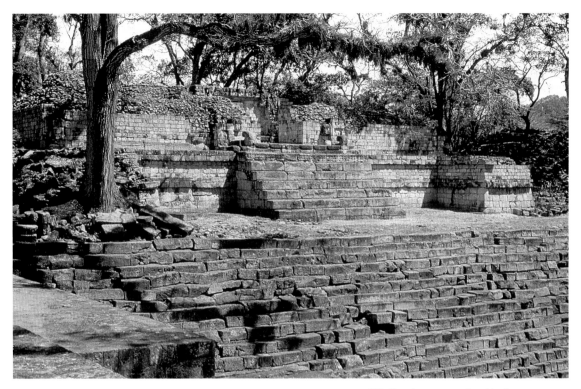

157. Structure 22 as restored by the 1939 Carnegie expedition.

PHOTOGRAPH BY WILLIAM L. FASH, 1987.

ple along with the *witz* monsters on the corners and the interior celestial doorway fit with all the varied components of the Maya creation myth. The temple represented the sacred mountain where maize was born, and the East Court plaza below it was equated with the primordial sea.

Maya creation myths are generally set in a watery place, a cool, clear blue-green (*yax*) pool referred to as the primordial sea, in which floated a turtle that represented the land. The most sacred maize kernels were found beneath three stones in a cave in a sacred mountain, through which flowed the fertile waters of the primordial sea. When lightning struck the stones, the kernels germinated and the earth split apart to allow the maize to sprout. In many carved and painted scenes, images of the cracked turtle carapace, Yohl ahk, with the maize god emerging from it, represent this story (**158**). The back of the turtle is often depicted as carrying three stones (**159**).

Simon Martin's research concludes that Maya ideology held the death and transformation of the maize god, representing the natural corn cycle, as a central metaphor for life and death in Maya religion.

158. Maize resurrection scene depicted on a painted ceramic plate.

DRAWING BY MARC ZENDER.

159. The mythical turtle carrying three hearthstones for cooking maize, depicted as a constellation in the Madrid Codex.

REDRAWN BY THE AUTHOR FROM THE MADRID CODEX, P. 71A.

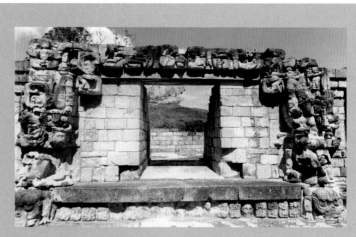

The inner doorway of Structure 22's temple, reconstructed in the 1930s.

PHOTOGRAPH BY WILLIAM L. FASH, 1987.

STRUCTURE 22
SCULPTURED DOORWAY

The most spectacular feature of the Structure 22 temple still standing in the twentieth century was the sculptured doorway to its inner chamber. Because it was eroding rapidly, it was moved indoors to the Copan Sculpture Museum, and a replica now graces the temple on the site. Marcelino Valdés and Jacinto Ramírez recreated the inscription below the doorway using Maudslay's early photograph as a guide to add details that are now eroded from the original.

The entire doorway represents an animated cosmic model establishing the sacredness of the cavelike inner room, a place where priests performed bloodletting rituals and conjured the ancestors. A *bacab* squats on each side of the door above skeletal heads that symbolize the underworld.

With upraised arms, the *bacab* figures support a two-headed deer-hooved dragon (the "Starry-Deer-Caiman," perhaps named Itzam Kab Ain) that represents the Milky Way, arching across the heavens at the time of creation. Its celestial head, with a sun (*k'in*) sign in its forehead and a large stingray spine in its headdress, faces east. A crocodilian or reptile head decorated with star signs faces west. The lazy-S-shaped motifs that compose the dragon's body may be the milky substance of the stellar clouds in the night sky. Cavorting in their twists and turns are small figures that might be assistants to the ancestors.

The bench text commemorates the first *k'atun* (20-year) anniversary of the accession and rule of Waxaklajun Ubaah K'awiil, Ruler 13. This would mean that he commissioned the Yax Hal Witznal temple for this occasion and to create a magnificent space for communication with the supernatural world.

The sacrificial death of maize at harvest-time leads to burial as seeds in the mountain cave. Once the lightning bolt *k'awiil* strikes the mountain, penetrating the cave and germinating the maize, the maize rises triumphant from the journey through the fissure. While underground, the maize god body gives rise to fruit trees such as cacao. This union of maize and cacao suggests that ingesting drinks made from these fruits commemorated their resurrection and represented the continued sustenance of humanity.

It is possible that the temple atop Structure 22 was made to overlook a representation of the primordial sea. The plaza below it was enclosed on all sides by pyramids and stairways leading to the platforms on which the East Court structures were built. A partial corridor on the south side at plaza level provided for drainage and pedestrian access. A corbel-vaulted drain also led water away eastward toward the Copan River. These narrow channels could easily have been blocked to restrict the flow of water and create a shallow pool in the plaza. When allowed to fill, the plaza might have functioned something like the Southeast Asian *thirta,* a sacred pool used as a place of ablution or cleansing rituals (**160**).

Whether or not this surmise is correct, the temple on Structure 22 abounds with sculpture symbolizing the maize cycle, the sacred mountain and its cave, and the earth's fertility. Because this temple's façade, with its thousands of sculptured blocks, was one of the most ornate on the Copan Acropolis, the massive piles of sculpture stacked up around the building after the Peabody and Carnegie clearings have been a challenge to separate into motif groups and rearticulate. But among the sorted motifs we have identified maize deities (**161, 162**), huge guardian figures (**163**), friezes of *ajaw* faces and *k'an* crosses with vegetation, and *witz* masks representing the sacred mountain. The maize deities, positioned such that they are rising from the *witz* masks, are some of the most beautiful and expressive examples of Copan artistry, each with a slightly different, individualized countenance. The early excavation teams prized the finest examples of these maize deities, and some of them were shipped—with permission in those days—to institutions such as the Peabody Museum and the British Museum.

The flowers and vegetation motifs on the temple suggest the supernatural realm of the flowery paradise in the otherworld. The building's outer doorway was carved to represent the gaping mouth of the cave monster, from which issued the voice and messages of

160. *Thirta*, or sunken courtyard, at Angkor, Cambodia.

PHOTOGRAPH BY THE AUTHOR, 2010.

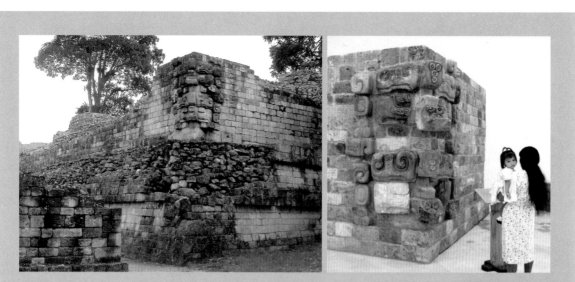

(LEFT) Corner *witz* masks as reconstructed on the temple of Structure 22.

PHOTOGRAPH BY THE AUTHOR, 1988.

(RIGHT) Two of the masks as reconstructed in the museum.

PHOTOGRAPH BY RICK FREHSEE, 1996.

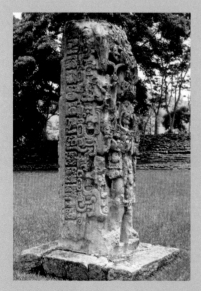

Stela B, showing stacked *witz* monsters.

PHOTOGRAPH BY WILLIAM L. FASH, 1974.

STRUCTURE 22 | EXHIBITS 40 AND 41

WITZ MASKS

On the corners of the Structure 22 temple, Aubrey Trik, working for the Carnegie Institution, reconstructed two stacked supernatural *witz* (mountain) masks. David Stuart believes these mark the temple as a sacred mountain. After analyzing nearby sculpture piles in 1986, Linda Schele added the missing nostrils and foreheads. My colleagues and I think each corner of the temple had three masks. The uppermost ones, serpentlike, were each topped by a supernatural bird, not unlike the *witz* monsters on the sides of Stela B in the Great Plaza. In the museum we reconstructed two stacked *witz* masks; the other masks remain on the actual building at the site.

Repeated at least 16 times around the temple façade were smaller versions of the *witz* masks with *tuun* signs (grapelike clusters) on their brows, signifying dripwater cave formations. These *tuun witz* monsters are paired on the façade with the graceful maize deity sculptures (shown from the waist up) that probably sat directly above them on the original temple. The *tuun witz* heads sprout lively maize vegetation from their earspools and may personify the earth from which the maize grows.

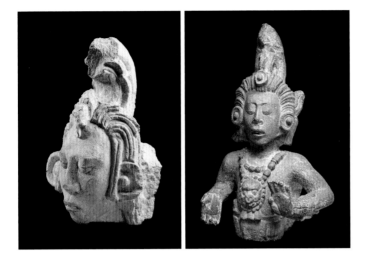

161. Maize god from Temple 22, now at the Peabody Museum.

PHOTO BY HILLEL S. BURGER, COURTESY PEABODY MUSEUM OF ARCHAEOLOGY AND ETHNOLOGY, © PRESIDENT AND FELLOWS OF HARVARD COLLEGE, NO. 95–42–20/C727.

162. Maize god from Temple 22, now in the British Museum.

COURTESY BRITISH MUSEUM, WWW.BRITISHMUSEUM.ORG/ IMAGES/MM028700_M.JPG.

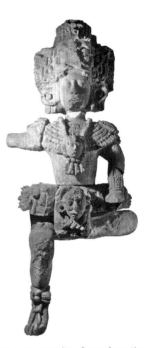

the deity the temple embodied. The uppermost step, leading into the monster's mouth, is actually formed of huge stone incisors.

An important contribution to understanding the meaning and function of the temple was made by archaeoastronomer Anthony Aveni. He proposed that the structure was built in alignment with the path of the planet Venus in the sky. The small windows in the temple facing east and west were used for sighting the planet's first risings as evening and morning star. Priests recorded this informa-tion for use in calendar cycle prognostications in their almanacs. Astronomical tables anticipating favorable cycles of Venus and its conjunction with the movement of the sun were important compo-nents of Maya codices, serving for the timing of ritual events and planting. If Aveni is correct, then the cosmological symbolism expressed on the temple, especially on its interior doorway and bench, may place the sacred mountain of sustenance and the flow-ery paradise within a larger universe and tie the success of the agri-cultural cycle to celestial events.

163. Large guardian figure from the Structure 22 temple. In the roof crest of the temple, immense human figures seated on cushions in poses of royal ease appear to guard the sacred space. Each holds in one hand a serpent lance with a flint tongue. This guardian was reconstructed in 1989 from sculpture in the collections of the Peabody Museum.

PHOTOGRAPH BY WILLIAM L. FASH, 1989.

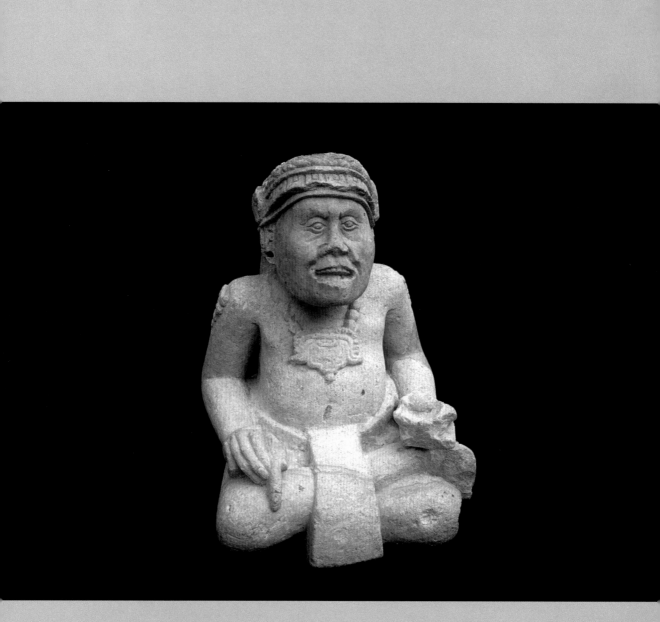

Scribes and Sculptors

Ancient scribes and sculptors left their marks indelibly on the city of Copan, not only on its public buildings and temples but also on private residences. Based on documents recorded at the time of the Spanish conquest, scholars believe that the office of scribe was inherited, probably along noble lines. Scribal implements such as shell inkpots and ceramic paint pots found during excavations and represented on sculptures, as well as hieroglyphic inscriptions, inform researchers today about this specialized profession (**164**). A group of deities are the principal scribal gods, including Itzamna (God N), the Monkey Scribes, and Pawhatuuns.

Less is known of sculptors than of scribes, but the talents of many skilled sculptors were obviously required for Copan to have grown to such grandeur. Using jadeite axes, sharpened bone tools, and obsidian points, they worked the volcanic tuff into fluid, three-dimensional forms. The ancient Maya believed that sculptures embodied the supernatural forces they were carved to represent, so they sometimes ritually buried or destroyed carvings in order to dispel their powers. At some Maya sites, sculptors carved their names into their monuments, but those at Copan did not. Alongside the artistic sculptors worked many architectural stone carvers, together creating the animated architectural façades and freestanding monuments that make Copan so special.

Particularly revealing about scribes and other high-ranking members of Copan society are sculptures unearthed in a part of Copan called Las Sepulturas (**165**). This large residential area lies roughly one-half mile (1 kilometer) due east of the Principal Group

164. Scribe figure from the fill of Structure 9N-82.

PHOTOGRAPH BY WILLIAM L. FASH, 1983.

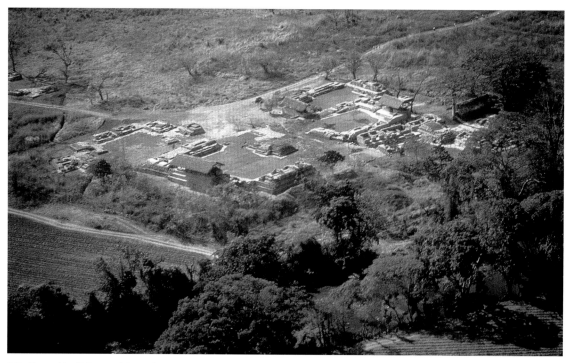

165. The residential area of Copan known as Las Sepulturas.

PHOTOGRAPH BY WILLIAM L. FASH, 1993.

along a bend in the Copan River. Before 1977, little was known about the area except that some tombs had been observed there—hence the local name, meaning "the sepulchers."

EXHIBIT 44
Group 9M-18, Structure 9M-146

In 1977, as part of Gordon Willey's Harvard project, his team excavated a building at Las Sepulturas belonging to Group 9M-18. Earlier, Willey and Richard Leventhal had created a typology of four house group sizes for the Copan Valley. In order to learn about people and activities outside the Principal Group, they chose to investigate Structure 9M-146, a type 3 site, their third largest category. The archaeologists had no expectation of finding elaborate inscriptions at a type 3 site, but in Structure 9M-158 they discovered a beautifully carved hieroglyphic bench—now often called the "Harvard bench"— the first of its kind to be scientifically excavated outside the Principal Group. The bench discovery led to a reevaluation of the role of noble

families in the social and political structure of ancient Copan and paved the way for further investigations into the lives and history of the people who supported the city's rulers.

EXHIBIT 42
Group 9N-8, Structure 9N-82

In 1978, during the first phase of the Proyecto Arqueológico Copán (PAC I), Bill Fash dug a test pit in the central plaza of Group 9N-8 in Las Sepulturas that revealed a stratigraphic sequence dating all the way back to the Preclassic period (1500 B.C.–A.D. 250). In the 1980s, during the second phase of the project, William Sanders and his team undertook extensive excavations there. Bill expanded his plaza excavations and uncovered a platform, a living surface, and burials rich with jade and Preclassic pottery (now displayed in the Copan Regional Museum of Archaeology) dating to 100 B.C.

Meanwhile, David Webster and Eliot Abrams cleared the front and interior of the main building on this plaza, Structure 9N-82, discovering a huge array of sculptural fragments and an elaborate interior sleeping bench much like the one from Structure 9M-146 (**166**). The front of the bench was carved with a full-figure hieroglyphic

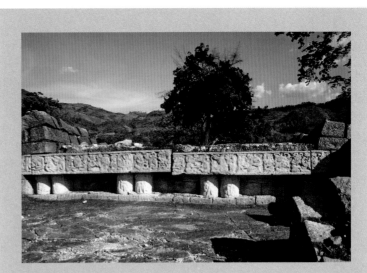

PHOTOGRAPH BY WILLIAM L. FASH, 1977.

A HIEROGLYPHIC BENCH FROM LAS SEPULTURAS

Built-in benches for sitting and sleeping in residential rooms at Copan are usually plain, with smooth stucco surfaces, but nobles of the royal court became fond of having carved ones. This bench, discovered in Structure 9M-146 in 1977 during Gordon Willey's Harvard project, was once the pride of a member of the nobility living in the Las Sepulturas zone. After I carefully cleaned and drew it in the field, it was transferred to the Copan Regional Museum of Archaeology in Copán Ruinas for safekeeping. Nineteen years later it was moved to the Copan Sculpture Museum for display as exhibit 44.

The inscription on the bench records a ceremony performed in the building by Yax Pasaj Chan Yopaat in A.D. 782. Its carving commemorates the noble owner's role as a courtier in the service of Ruler 15, the preceding ruler. The lively, full-figure glyphs bring the text to life with amusing gestures such as tickling and snatching objects from one another. Despite erosion and the collapse of the building's roof, the splendid bat emblem glyph of Copan that ends the text was found still well preserved. In the duality favored by the Maya, *bacab*, symbolizing fertility, and death gods, representing destruction, are paired on the columns supporting the inscription.

166. The hieroglyphic bench from Structure 9N-82, in place during excavation, 1981. The beautiful full-figure hieroglyphic bench text is dated to 9.17.2.12.0, 11 Ajaw 3 Keh (September 10, 773), probably the date of the building's dedication. Then follows the name of its owner, Mac Chaanal, a statement that he is the son of a Lady Ah K'in, (a title still used for calendrical daykeepers in sixteenth-century Yucatán), the name of his father, and the statement that the owner of the house serves as "one who venerates" for Ruler 16, Yax Pasaj Chan Yopaat. In Late Classic Copan, Ruler 16 particularly appears to have engaged in rituals at the largest outlying residential groups and sanctioned the heads of those groups to carve their own monuments, which always included mentions of the ruler.

PHOTOGRAPH BY WILLIAM L. FASH.

inscription dating it to the reign of Ruler 16. The bench has been on display in the Copan Regional Museum of Archaeology for many years. Subsequent analyses of the sculpture and artifacts from Group 9N-8 have provided scholars with new material for understanding the sociopolitical structure and daily life of Copan's supporting population in relation to the ruling establishment.

Structure 9N-82 became the largest structure systematically excavated outside of the Principal Group at Copan. Known popularly as the Scribe's Palace and the House of the Bacabs, it was the building where the methods of sculpture analysis were first devised that gave birth to the Copan Mosaics Project four years later. The PAC II investigators plotted the position of every block fallen from the building's sculptured façade. At first, working at the front of the building, Webster and Abrams marked the sculpture blocks as points inside grid squares. They numbered the pieces and then removed them all to the laboratory. When completing the excavations at the back, or south side, of Structure 9N-82, Bill refined the methodology. There he drew each piece fully on a grid map so that the relationships between the fallen pieces were clear and easy to reconstruct. Significantly, he excavated three figures from the upper register of the façade whose pieces had fallen into discrete groups, making possible a more accurate sculpture reconstruction than ever before attempted. He set the pieces face up in a large sandbox he designed, positioning them as they must have been on the masonry façade. His refinements of sculpture recording during excavation and analy-

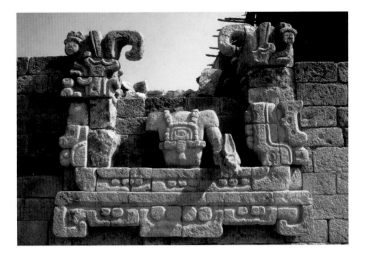

167. Figure of a scribe in a serpent-framed niche on the façade of Structure 9N-82.

PHOTOGRAPH BY WILLIAM L. FASH, 1983.

sis paved the way for all future façade sculpture work at Copan (see sidebar, p. 10).

On the lower register of the front of Structure 9N-82 we reconstructed the carved scribal figures that gave the building one of its popular names, the Scribe's Palace. The scribal figures emerge from serpent-framed niches on either side of the doorway (**167**). The split serpent heads, with some *chapaat* (centipede) characteristics, formed the opening maw or portal to the underworld and were united by an elongated element with beads. They sit above a T-shaped element that has the meaning *na,* or house. More recently, it has been suggested that this icon can be read as the house's ancient name, *Noh Chapaat Nah*. Each scribe figure wore a beaded water-lily pectoral and had outstretched hands, one holding a shell paint pot, and the other a stylus for writing or painting—the characteristic tools of the scribe.

Sadly, the heads of the scribe figures are missing, but an earlier carved scribal figure gives an idea of how they might have appeared. It also suggests the building's other common name, House of the Bacabs. Excavations in the fill of an earlier portion of Structure 9N-82 uncovered the carved body of a seated human figure and, some distance away, its broken head. This charming figure, carved fully in the round, is that of a dwarf or the Monkey Scribe depicted in Maya art and legends (see **164**). He, too, wears a water-lily pectoral and holds a shell paint pot and stylus, suggesting that he represented the patron of scribes. His netted headdress and the cave dripwater

168. Museum reconstruction of the façade of Structure 9N-82.

PHOTOGRAPH BY RICK FREHSEE, 1996.

clusters on his shoulders suggest a reading of *pawa* (net), and *tuun* (dripwater stone), or *pawahtun. Pawahtun* are the old-man figures of the underworld who support the surface of the earth rather than the sky, as their counterparts the *bacab* do. In coining the name "House of the Bacabs," David Webster chose the more generic term *bacab* to describe the supporting figures. The *Pawahtun* also carry characteristics of the old deity Itzamnaaj, who invented writing.

When the scribe figure was buried, perhaps after the actual scribe who lived in the house died, new versions of the scribal patron were carved and placed in the doorway niches for the building's next phase or refurbishment. If the tradition of scribal functions passed to the next generation, then logically the next scribe would have designed his new façade to honor his scribal ancestors and patron deity.

The niches and figures just described adorned the lower register of the Scribe's Palace façade. Carvings on the upper register repeated the scribal themes. As is true of most buildings at Copan, all the upper-register sculpture mosaics became dislodged and fell from

their original wall positions in ancient times. But analysis of the identified pieces from Structure 9N-82 showed that the configurations on the front and back façades were mirror images of each other, a common feature of Copan buildings. The front and back each displayed three human figures seated above *na* signs. They are believed to be depictions of actual people because their costumes show no supernatural attributes. Two other figures faced east and west, making a total of eight for the entire upper register of the building.

The front, or north, façade of the Scribe's Palace is reconstructed as exhibit 42 in the Copan Sculpture Museum (**168**). On the upper register, the central figure sits above his *na* sign in a position of royal ease within a recessed niche. These attributes emphasize his high rank, in contrast to the more exposed attendant figures at either side, who sit cross-legged. In his outstretched hands this central figure most likely held a shell inkpot and a stylus. He wears a headdress consisting of a water lily tied above a reptilian mask, with a magnificent splay of feathers draping outward. The beaded water-lily symbol that the *pawahtun* on the lower register wear as pendants can be seen upturned at the top of the upper figure's headdress. A thick jade bar pectoral overhanging a heavy beaded collar is carved on the personage's chest.

A burial found directly in front of Structure 9N-82 held the remains of a male who featured a large, rectangular jade pectoral as part of his attire. Bill proposed that this was the person portrayed as the central figure on the building's façade, an ancestor who is also mentioned in the inscription on the hieroglyphic bench from the interior room of Structure 9N-82, found by Webster and Abrams.

The attendants who sit on either side of the central figure gesture upward with their hands. In contrast to the higher-ranking person with his pectoral, the attendants wear only beaded collars. Their reptilian headdress masks are similar to the one worn by the central figure, but each is topped by a maize cob instead of a water lily.

The central figure on the back of the building was seated similarly above a *na* sign, and what little remains of his headdress indicates that it was another water-lily headdress. His attendants wore maize headdresses like their counterparts on the front, making a total of four figures with this headdress. The headdresses of the east- and west-facing figures, on either end of the building, are poorly represented, but two large *k'in,* or day, signs are associated with them.

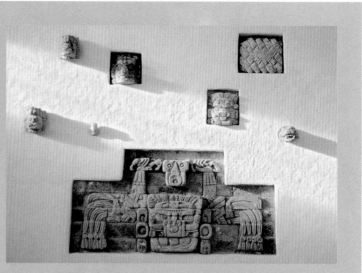

Mosaic mask (bottom), woven mat (top right), and carved heads.

PHOTOGRAPH BY THE AUTHOR, 2008.

SCULPTURE FROM LAS SEPULTURAS

Excavations in Las Sepulturas in the 1980s turned up large numbers of iso-lated sculptures, many of which were probably removed from their original locations over the centuries following the abandonment of the city. Some of these are displayed in exhibit 43. At the bottom of the panel is a recon-struction of one of several masks from Structure 9M-195, a noble family's living quarters 495 feet (150 meters) west of the group that included the Scribe's Palace. Eight identical masks were repeated around the building's façade. *K'an* signs inscribed in the foreheads of the masks probably signi-fied "precious" or "yellow." An unusual motif consistently found with these masks is that of a hand grasping a bony object. A Maya stela from the site of Emiliano Zapata in Chiapas, Mexico, shows a sculptor in the act of carv-ing a similar mask with this type of object as his tool. This has led scholars to conclude that "precious yellow stone" was an ancient Mayan name for sculpture. Perhaps a mask maker or a stone carver for the royal court occu-pied this residence, and the façade masks functioned as large icons that publicized his trade.

Other sculptures found scattered around the nearby plazas, such as the woven mat and the bird and jaguar heads in this exhibit, hint at the func-tions of other buildings in the area. The woven mat sign might have adorned the façade of a local council house, along the lines of Structure 22A, a building that I propose served as a central council house for Copan (see chapter 10). The animal heads might be patron animals or perhaps decorated the home of a hunter.

Sculptor carving a mask on a stela from the Emiliano Zapata site, Chiapas, Mexico.

DRAWING BY THE AUTHOR AFTER HOUSTON, TAUBE, AND STUART 2006.

I suggest that the water-lily and maize headdresses worn by the seated figures on this building indicate the existence of two operational or corporate groups. One, represented by maize, was organized along kinship lines and landholdings, and the other, represented by the water lily, was a water group formed by the union of several kin groups who shared the same water source. Ethnographic accounts record the existence of these two types of corporate groups in both Chiapas and Yucatán. The water groups would have managed the hydraulic aspects of everyday life in their residential sectors. This hypothesis would explain the prominence of the central water-lily figure on this structure's façade. In 1994, Karla Davis-Salazar conducted excavations to the west of this plaza group and found the remains of an ancient reservoir. The central figure on the façade of Structure 9N-82 might have held important scribal duties in conjunction with the office of water manager.

Investigations of the Scribe's Palace and other portions of Las Sepulturas have yielded a bounty of architectural, hieroglyphic, iconographic, and artifactual data to aid in understanding the religious, social, and political lives of the Late Classic inhabitants of Copan. Together these lines of evidence paint an increasingly clear picture of the way the larger residential areas operated. Scribes, sculptors, and no doubt residents occupying many other roles and professions gained prestige and economic power with time. Their authority within the social and political hierarchy perhaps eventually rivaled that of the ruler.

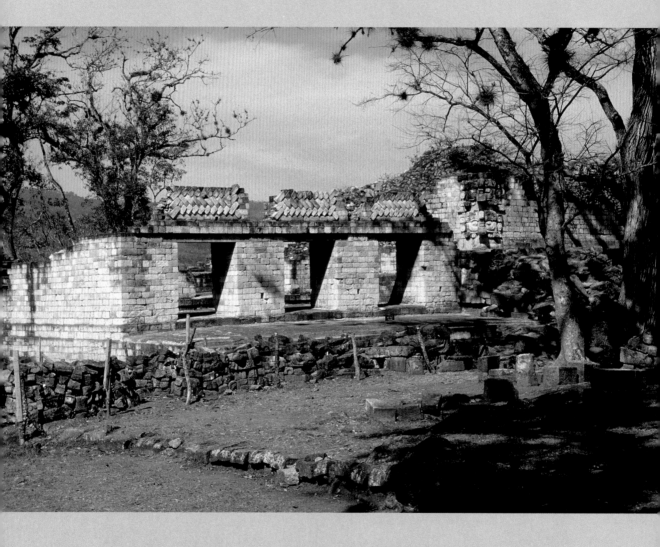

10

Community and Council

Although people are drawn to the grand artistic wonders of Copan's Principal Group, the Copan Valley was an equally fascinating landscape in ancient times, dotted with busy communities and splendidly decorated residences. Understanding how the ancient polity was held together, as well as the dynamics of power among the nobles and their families, has been a component of research at Copan for decades. Investigations of residential areas such as Las Sepulturas have helped unravel the nature of interactions between the ruling dynasty and the outlying communities. Within the Principal Group itself, the sculptures that once embellished a building called Structure 22A offer further clues to the social and political organization of Copan (**169**). Its motifs strongly suggest that it served as a community meeting place or council house, perhaps a place where representatives of residential districts met and community festivals took place.

EXHIBIT 46

Structure 22A

One of Tatiana Proskouriakoff's most valuable contributions to the archaeological study of Copan was the wonderful set of architectural reconstructions she produced for her 1946 book, *An Album of Maya Architecture*. Her hypothetical reconstruction of Structure 22A, part of a watercolor scene of Copan's East Court, reflects what was known of the building at that time (**170**). Limited excavations by the

169. Restoration of Structure 22A at the site.

PHOTOGRAPH BY WILLIAM L. FASH, 1993.

141

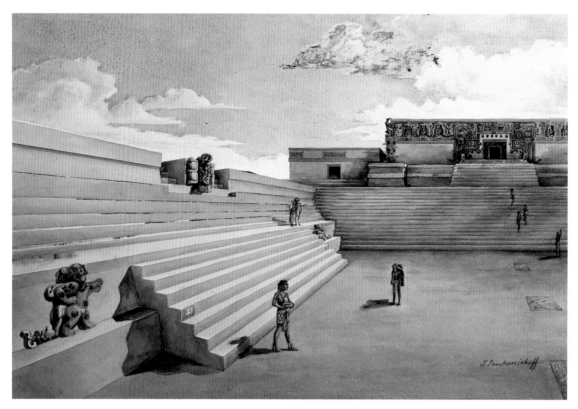

170. Watercolor reconstruction of Structure 22A (at rear) and the East Court by Tatiana Proskouriakoff, 1943.

171. Mat symbol as found in place on the east façade of Structure 22A.

Carnegie Institution in the late 1930s had revealed one doorway and an undecorated interior bench with a plain circular pedestal on top. Finding no hieroglyphic inscriptions, the investigators halted. Outside, on the east side of the structure, facing the larger Structure 22, a portion of the façade remained intact. On it could be seen a pattern of simple curving blocks laid at angles to form the design of a woven mat (**171**). From this example and other, similar stones visible on the surface surrounding the building, Proskouriakoff projected the existence of other mat designs around the entire façade. There the matter rested for nearly 50 years, until Proskouriakoff's insights once again inspired and guided a new generation of scholars who probed deeper into the ruins of Structure 22A.

Although this building on the Acropolis appeared relatively insignificant next to its larger, more elaborate neighbors, PAAC excavation teams set to work uncovering the remainder of its fallen walls and sculptures in 1988. Early on I suspected that the building might have been the city's council house, a structure known historically in

Yucatán as the *popolna,* or "mat house," from *pop,* "mat," and *na,* "house" (possibly *popol otoot* in the Chorti Maya of the Copan region). Rulers and noblemen convened in these houses while seated on woven reed mats. Sixteenth- and seventeenth-century records such as the *Libros del Chilam Balam* and the *Popol Vuh,* colonial Maya accounts of sacred history and religion, tell that among the most common titles for royalty and other nobles were "Lord of the Mat" and "Lord of the Jaguar Mat." The woven mat pattern, or *pop,* was a symbol of rulership, perhaps referring not only to the mats rulers literally sat upon but also, figuratively, to the interwovenness of the community and to unity among the nobles and rulers.

The historical documentary evidence suggests that council members were chosen from important patrilineages—descent groups traced on the father's side—and held office for specific terms before stepping down. Five years would have been a likely calendrical interval. The colonial sources also reveal that community or council houses were places where the Maya staged public festivals and learned traditional dances. Some living Maya villagers still gather at *popolna.* Researchers have witnessed town festivals, complete with feasts and dancing, at such buildings in traditional rural communities in Quintana Roo, Mexico.

172. Reconstruction of the Structure 22A façade in the museum.

PHOTOGRAPH BY BEN FASH, 2009.

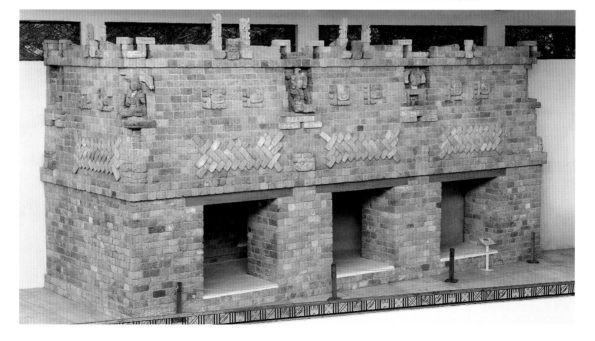

173. Detail of the Structure 22A façade showing woven matlike motif, a figure seated over a fish place name, and two 9 Ajaw glyphs.

PHOTOGRAPH BY RICK FREHSEE, 1996.

174. Fish sculpture excavated from a subfloor cache in Structure 32, resembling the fish glyph on Structure 22A (exhibit 53).

PHOTOGRAPH BY THE AUTHOR, 1990.

As digging proceeded through the debris of building stones and mortar at Structure 22A, nearly a thousand pieces of sculpted stone were uncovered, many lying exactly where they had fallen in antiquity. From their positions, the architectural and sculptural elements of all four sides of the building could be reconstructed on paper. It became clear that this small edifice had been an elegant one. Eventually we were able to reconstruct its front, south-facing façade as exhibit 46 in the Copan Sculpture Museum (**172**).

Structure 22A had an open front with three large entranceways, as would have been appropriate for a building with a public function. The knotted or woven matlike design, the building's most prominent decorative motif, was repeated three times on the front and back façades and twice on the short sides, for 10 examples in all. Its iconic significance was no doubt easily apparent to ancient Maya people of all ranks. Perhaps they were also able to interpret a hieroglyphic motif that includes the elements for *sak nik,* or "white flower," which was repeated around the cornice. *Sak nik te'il na* was another name for the community house in some Mayan dictionaries. We reconstructed several ornamental motifs on the building's cornice that seem to represent this concept. An *ajaw* face possibly symbolizing the *nik* flower is framed by two upright serpent stamens paired with circular elements representing the *sak* sign. The *na,* or "house," signs appear beneath the seated figures slightly lower on the building.

Paired above each interwoven motif on the north, south, and west façades were two hieroglyphic signs (16 in all), each composed of the bar and dot numeral representing the number nine attached to an *ajaw* day sign, the first day of the Calendar Round (**173**). This intentional pairing might indicate that the glyph had a double meaning. It seems to have marked the Calendar Round date falling on the day 9 Ajaw, and it also marked the building as a "nine *ajaw*" house, or "House of Nine Lords," possibly referring to nine councilors. Correspondingly, nine niches appear to have been placed around the façade, each containing a human figure seated above a large hieroglyph probably denoting a place name. I think these nine figures (or nine lords), each with a distinctive headdress and necklace or pectoral insignia, might represent the council representatives from various areas around Copan. Such a position existed among the Yucatec Maya in the sixteenth century; it was called *holpop* (*hol,* "head," *pop,* "mat"), or "he at the head of the mat." Alternatively, the figures might not be actual portraits of representatives but rather a merging

of ancestral and patron figures whom the council members embodied. Further study might reveal that the figures also have a connection with the *bolon tz'akab,* or "Nine Lords of the Night," who, according to ancient Maya belief, ruled the nocturnal landscape.

My colleagues and I believe we have identified the actual residential location associated with one of the place names on this building. The name over the pillar between the left and middle front doorways was represented by a glyph in the form of a fish. While excavating a royal family residence south of the Acropolis in the 1990s, Will Andrews and his team discovered a series of similar fish sculptures fallen from the façades. One had even been ritually buried as the major feature of a subfloor cache. This evidence supports the idea that the royal residential complex was known by this fish name, perhaps *cai nal.* Possibly the fish glyph on Structure 22A referred to the same residential complex, and the figure above it, to that area's representative at community council gatherings (**174**).

The 9 Ajaw glyphs on Structure 22A alone provide too little calendrical information to identify the year the building was dedicated. But the event would typically have been held at the end of a 5-, 10-, or 20-year cycle in the Maya calendar. Only three dates

PHOTOGRAPH BY BEN FASH, 2009.

STRUCTURE 22A
FIGURES SEATED ABOVE HIEROGLYPHIC PLACE NAMES

Exhibit 48 shows the reconstructed portions of four human figures that once sat in niches on the rear façade of Structure 22A. Epigraphers believe the large hieroglyphs beneath the figures—of which there were eight complete and a partial ninth on the building altogether—are place names. Some are also mentioned in Classic Maya texts from other ancient cities, suggesting that they denoted sacred places derived from a common mythology. They might have referred to residential wards or sectors of Copan, the names of which were taken from these mythological or supernatural places. The anthropologist Evon Vogt reminds us that mythological places in the modern Maya cosmology always have real-life counterparts in the surface world. I believe the named places were also closely associated with major water sources that were the unifying features for each of the residential communities represented at a council house like Structure 22A.

| Cai nal | Ho nic nal | Yax ok | Ik nab nal |
| Mo-[?]-aw | Ik Sa'nal | Ik Pa'nal | Nic |

Eight complete place name glyphs.

DRAWING BY THE AUTHOR.

PHOTOGRAPH BY WILLIAM L. FASH, 1988; DRAWING BY THE AUTHOR.

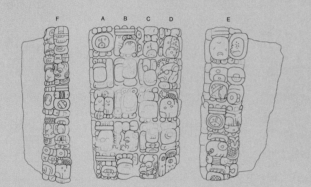

STRUCTURE 22A

THE "THRONE STONE" AND ITS INSCRIPTION

Exhibit 47 is a carved block known as the "throne stone," shown in this photograph as it was uncovered in the inner room of Structure 22A. The glyphs inscribed on it are similar in style to the small rounded signs on *incensarios* dating from the reign of Yax Pasaj Chan Yopaat, the last ruler of Copan. Indeed, the text refers to him and to two of the patron gods cited on his other monuments. The stone's distinctive shape is nearly identical to that of royal seats shown on many painted vases and relief carvings from other Maya sites. Heavy wear on the top suggests that it was used as a seat, most likely by Yax Pasaj himself. Although he probably was not the builder of Structure 22A, this possible royal seat in the inner chamber suggests that he continued to use the building and perhaps met with noble representatives there.

in the Late Classic period fit this cycle and fell on the day 9 Ajaw; they were in the years A.D. 682, 746, and 810. Judging from the archaeological stratigraphy of the neighboring Structures 22 and 26, together with David Stuart's decipherment of a dedication date of A.D. 715 for Structure 22, the first possibility is unquestionably too early. The sculptural style and other architectural details of Structure 22A, when compared with those of other, dated buildings at Copan, make the third date extremely unlikely as well. Therefore, both the archaeology and the epigraphy point to June 12, 746, as the most likely dedication date.

From just outside Structure 22A comes additional evidence that I think supports the interpretation of a public function for this building. In front of it stood a platform (numbered Structure 25 on maps) that measured 26 by 98 feet (8 by 30 meters) and was found to have been replastered several times, probably to keep its surface smooth. There is no evidence that it had a superstructure. Bill and I suggest that this raised surface was a dance platform used during performances and festivals. Two upright, grinning jaguars adorn the sides of the platform, and to me they appear to be in a dance pose, inviting the viewer to join in (**175**). Karl Taube suggests that the jaguars are iconic name glyphs for

Ruler 7, Bahlam Nehn, or "Mirror Jaguar," whose burial was found many layers beneath this platform. A large deposit of refuse found just off the southwest corner of Structure 22A contained pottery, stone tools used to process meat, charcoal fragments, ash, and stone burners or containers, all of which appear to represent the remains of ritual feasting.

If Structure 22A indeed functioned as a *popolna,* then it broadens the political and administrative model for ancient Copan. Rather than the ruler's acting alone, it would appear that by at least the time of Ruler 14, a council of representatives from the valley settlements was an essential part of the scene. My sense is that the representatives and the places they hailed from were tied into the Maya worldview through mythological place names and images of the supernatural patrons of those places.

Recently, other scholars have built on this interpretation from somewhat different viewpoints. Elizabeth Wagner's idea is that the mats decorating Structure 22A actually represent knots in nine sections that relate the place names and figures on the building to the *bolon tz'akab,* a name for the Nine Lords of the Night. Another is that the *sak nik* element on the building's cornice represents the expiring breath of dead ancestors, suggesting that the ruler constructed the building to honor nine deceased lords and supernatural deities. The "nine lords" concept is still little understood, but it is possible that people affiliated themselves and their social units with them as mythological or spiritual entities and locations. In any case, comprehending the full meaning of Structure 22A in ancient times can help in understanding residential settlement patterns and the distinctiveness of the building's functions and purposes. Certainly, researchers' ideas will continue to evolve as they learn more about ancient Maya political structure.

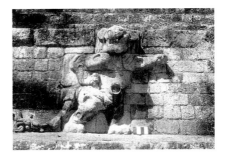

175. Dancing jaguar adorning the platform called Structure 25, in front of Structure 22A. (Scale = 25 cm.)

PHOTOGRAPH BY WILLIAM L. FASH, 1990.

Nobles and
Residences

The Copan Valley can be divided into two zones, an urban core and a rural sector. The urban core was densely populated, but settlements thinned as they radiated away from the center into the mountains. The residential areas east and west of the urban core were connected to the ceremonial center by two *sacbe,* or raised causeways. Archaeologists believe that an elite residential area just south of the Acropolis was the royal residential compound, and other noble families lived in urban wards throughout the valley. Archaeological evidence supports the idea that noble families in the valley were craft and ritual specialists, and their members often held political positions. During the eighth century, the time of the last dynastic rulers, the valley's population was swelling. Many more people could afford to build stone houses and ancestor shrines decorated with sculptured façades and carved benches. This suggests that competition for agricultural land and other resources also increased. Rival claims and power struggles no doubt ensued, undermining the control of the once unopposed dynastic rulers.

Study of the valley's urban residential areas is one of the most interesting windows into what life was like for the ancient Maya of Copan. Researchers doing "household archaeology" now use techniques such as analyzing the soil of ancient households in minute detail, looking for clues to people's activities there. One can picture the whole of Copan as a thriving metropolis with people streaming into and away from the center on market and festival days. The smoke and smells of cooking fires hung over the residential zones as people filled their days with food preparation, weaving, and making

176. Group 10L-2 (El Cementerio), as seen from the Acropolis. Structure 29 is in the foreground, Structure 32 in the background.
PHOTOGRAPH BY WILLIAM L. FASH, 1994.

pottery, tools, and jewelry. The sounds of masons and sculptors toiling on the new buildings going up or being redecorated could be heard everywhere. As more is learned about the ancient lifeways, one marvels at the Maya's accomplishments and reflects on the way customs have changed or stayed the same.

The last exhibits in the Copan Sculpture Museum highlight sculptured façades and other carvings from residential areas in the Copan Valley. The first of these, situated directly south of the Acropolis and designated Group 10L-2, was the residential compound of Copan's royal family during the Late Classic period (**176**). The second lay some 16 miles (25 kilometers) east of the Principal Group in an area called Río Amarillo, where apparently wealthy residents copied many of the sculpture motifs of their urban neighbors. Next is an area called Rastrojón, which lies a mile and a half (2 kilometers) northeast of the Principal Group. It is the site of a relatively new archaeological project that has made a promising start at reassembling fallen mosaics with central Mexican symbols. Finally, complementing Group 9N-8, home to the scribal specialists in Las Sepulturas, is a neighboring complex called Group 8N-11, at the end of the Las Sepulturas *sacbe* leading out of the urban core. This group housed an elite family able to employ some of the most highly skilled sculptors in all of Copan. In the museum, three building façades from Group 10L-2 are reconstructed, those of Structures 29, 32, and 33. Each has a very different sculptural program that offers insights into the building's function and meaning. Group 8N-11 is presented in exhibits 56, 57, and 58.

EXHIBIT 49
Group 10L-2, Structure 32

Structure 32, a residence with three vaulted rooms and sleeping benches in its final phase of construction, was adorned with some of the finest high-relief carving in Copan. Built by the royal family in the late eighth century, during the reign of Yax Pasaj Chan Yopaat, the building featured an iconographic theme of water and fecundity, illustrated predominantly by three repeating motifs: human personages with water-lily headdresses, rain god masks, and vertical water-lily roof ornaments. In exhibit 49, the front façade of the central

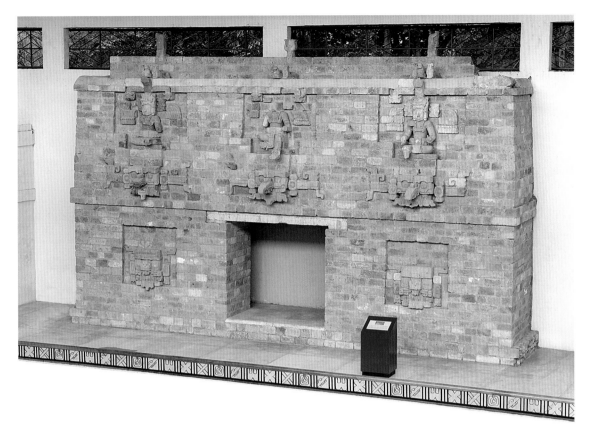

177. Museum reconstruction of the front façade of the central room of Structure 32 (exhibit 49).

PHOTOGRAPH BY BEN FASH, 2009.

room of the three is reconstructed (**177**). On the lower register, framing the doorway, are two snub-nose deities with jaguar characteristics such as snarling mouths and wild eyes (**178**). They wear heavy earspools that sprout plants. Although we reconstructed only two masks in the museum, four decorated the building altogether. The other two were probably set into the substructure framing the stairway, immediately below the masks exhibited here. Perhaps all four were iconic name glyphs for the ancestor buried in an earlier phase of the building.

On the upper façade, six male figures, three each on the front and back, sat above Chahk, or rain god, masks. In a pattern reminiscent of that on Structure 9N-82, the Scribe's Palace (see **168**), two smaller sun god heads and torsos adorned the east and west façades. The long snouts on the masks and the water-lily vegetation sprouting

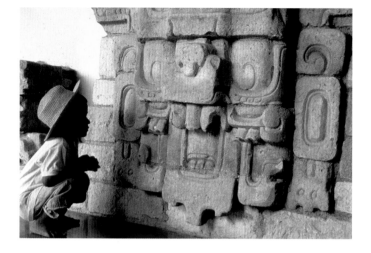

178. Detail of snub-nose jaguar mask from the substructure of Structure 32, before transfer to the museum.

PHOTOGRAPH BY RICK FREHSEE, 1992.

from their earflares identify them as Chahk, the Maya god of rain, thunder, and lightning. A similar creature portrayed in the stucco decoration at Palenque is sometimes referred to as the Water-lily Monster. Karl Taube has noted this creature's association with the number 13, perhaps corresponding to the watery paradise between the 13 levels of heaven and the 9 of the underworld. A related Yucatecan term is *xikin chahk,* translated as *flor aquatica,* or water plant, and described in dictionaries as "the ear of Chahk," which brings to mind the water-lily vegetation scrolls attached to the ear-spools. On an altar that Peabody Museum excavators in 1892 found fallen from the interior of Structure 32 (Altar F´), epigraphers have identified the hieroglyphic name Chahk, perhaps one of the noble family's principal patron deities.

Two earlier versions of Structure 32 lie beneath the final construction phase. The earliest structure on this spot seems to have consisted of one room atop a long platform, also facing north, like the later buildings. No tombs, offerings, or sculptures were found associated with this phase.

Belonging to the second, or middle, phase of construction was a tomb that Peabody workers uncovered below the building's central staircase in the 1890s. Although it had been looted in antiquity, it must once have contained the remains of a prominent person. Will Andrews believes the second-phase building was a funerary temple, not a residence like the final version. Nevertheless, its sculptural

Peabody Museum excavation of Structure 32, 1892.

EXHIBITS 49–53
GROUP 10L-2

Group 10L-2, the Late Classic royal residential compound at the southern edge of the Acropolis, is commonly referred to as El Cementerio because of the many elaborate burials found there during early investigations. At the site today one can still see more than 25 buildings arranged around three rectangular plazas. Structures 29 and 32, once elaborately decorated with mosaic sculptures, are the largest buildings in the group. Parts of the compound, including Structure 32, were originally cleared in 1892 during the Peabody Museum expedition. In 1990, as part of the PAAC, Will Andrews commenced new investigations to conserve the buildings that had already been exposed, and to secure a broader understanding of the history and use of this residence over time. Under Andrews's direction, eight buildings were excavated and restored and deeper plaza excavations were conducted to determine how long people had lived in the area.

Simultaneous excavations beneath the Acropolis showed that an earlier royal residential group lay buried beneath what are now Structures 21 and 22. It appears that sometime around A.D. 600, the royal residence was relocated from that spot to the area south of the Acropolis now housing Group 10L-2. Pottery analysis and hieroglyphic texts suggest that all the visible architecture at this locale can be attributed to Yax Pasaj Chan Yopaat, Ruler 16.

Group 10L-2 appears to have been the home of a cohesive lineage from around A.D. 700 until the collapse of central political authority in the region in the ninth century. The remains of charred lintels suggest that the buildings were purposefully burned, especially the royal ancestor shrine, Structure 29. We cannot yet reconstruct how or why the ruling family vacated the premises, but they might have been forced out by contingents outside the group. Later, Postclassic people scavenged sculptures from the toppled buildings. What remains today is the skeleton of a once vibrant and colorful royal residential zone.

Circular altar in Group 10L-2 with a text mentioning Yax Pasaj Chan Yopaat. Artist Gregorio Arias is drawing the altar's inscription. Archaeologists and epigraphers believe Group 10L-2 was the residence of Yax Pasaj Chan Yopaat, Ruler 16, and his extended family. Hieroglyphic texts mentioning Yax Pasaj Chan Yopaat and his supernatural patrons appear on this drum-shaped altar, displayed in exhibit 50, and on other altars and artifacts uncovered at the group. The inscribed date falls between A.D. 783 and 802, and the text mentions the royal family's patron, Chahk.

PHOTOGRAPH BY THE AUTHOR, 1990.

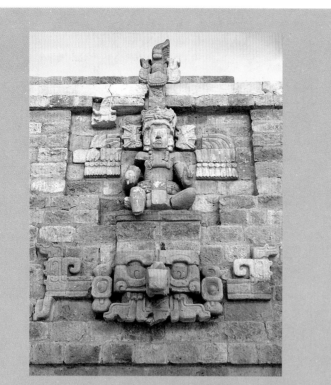

STRUCTURE 32
FIGURE SEATED ABOVE A CHAHK MASK

Six male figures above Chahk masks on Structure 32 are seated with one leg folded under and the other dangling forward in what art historians call "the posture of royal ease." Only one complete figure, from the southwest side of the structure, was excavated in a relatively pristine state. All the others were disturbed and missing their well-carved and attractive heads. The only remaining head wears a tied water-lily assemblage as the central part of his headdress, flanked by serpents and plumage. Fragments from the areas where the other figures were found indicate that they all wore the water-lily headdress, a skyband belt with loincloth, and a heavy, jade bead necklace. The headdress was common on depictions of rulers and nobles throughout the Maya area during the Late Classic period, especially at Copan during the reigns of Rulers 15 and 16. The opposing hand gestures perhaps signal these personages' identity with Chahk and the water-lily as intermediaries between the earth and the watery realm.

A key to the figures' placement on the structure was gained from a piece of the headdress element found still attached to a thick piece of stucco from the roof's edge. This evidence placed them high on the façade, forming part of the cornice. Just above them, two water-lily buds complete the water scene, and a vertical flower is embedded in the roof plaster.

decorations expressed a theme strikingly similar to that of the later building. They include a human head with a water-lily headdress, vertical water-lily roof ornaments, and a fish left as a dedicatory offering in a stone-lined chamber when the floor of the final building was sealed (see **174**). As I mentioned in chapter 10, the fish strongly resembles one carved above the western doorway of Structure 22A on the Acropolis, which I think was a Late Classic council house, or *popolna,* for the Copan polity. Sections of other stone fish were found in excavations of other nearby structures on the plaza. I believe the fish hieroglyph was a place name for this community, which was likely represented at the council house, convening with the ruler.

The fish, water-lily, and Chahk motifs signify to me that Group 10L-2 was strongly associated with Copan's water management system. Ancient Maya sculptors often carved symbols reflecting people's names and professions on headdresses and in toponyms. A large water reservoir lay due south of Group 10L-2, and I believe water management was an important part of everyday and ritual life for the people living south of the Acropolis. Engineering the drainage of potable water from the Acropolis temples and plazas into the reservoirs took careful plan-

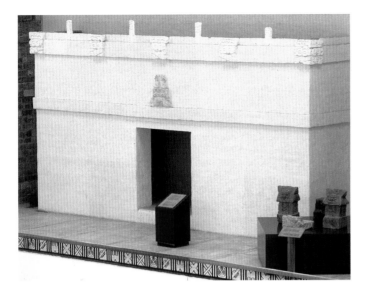

179. Museum reconstruction of Structure 33 (exhibit 51). The molding on this building may have been part of its sculptural message, for it appears to be a headband to which motifs are affixed as if they are medallions. This image recalls the Maya idea of buildings as personified beings, with personalities and spirits. When houses were roofed with thatch, the binding of the thatch was referred to as the binding of the structure— in essence, the tying of its headband. This is what seems to be implied on Structure 33.

PHOTOGRAPH BY RICK FREHSEE, 1997.

ning and considerable expertise. As Elliot Abrams has mentioned in his studies of the way the ancient villagers built Copan, it seems that these architects and engineers were held in high esteem and regulated important decision-making in Copan's government. The water from the Acropolis was metaphorically produced by the mountains and valleys the ancient Maya artificially created in the form of their temples and courtyards. Runoff from these constructed features was likened to freshwater from mountain springs and caves and therefore purer than water from streams or ponds.

As of this writing, no agreed-upon reading of the fish glyph exists among epigraphers. Some researchers think it is related strictly to fertility and cosmology and is not a place name at all. Andrews and I have suggested, however, that it could be read as *ca nal* (or *cai nal*), "place of the fish." This could certainly refer to a pond such as the reservoir, and it is also conceivable that ancient Maya residents raised fish there. Perhaps the people of Group 10L-2 were keepers of *cai nal,* the fish place, among other duties. I believe the water-lily headdress was a sign of a water-management profession throughout the Maya region. It is interesting that at Copan, the water-lily headdress became increasingly popular in sculptural depictions during the reign of Yax Pasaj Chan Yopaat, who lived, and perhaps grew up, as a resident of Group 10L-2.

180. Detail of crossed bundles and Tlaloc motif from Structure 33, during analysis.

PHOTOGRAPH BY THE AUTHOR, 1990.

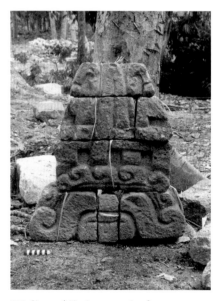

181. Star and Mexican year sign from Structure 33, during analysis.

PHOTOGRAPH BY THE AUTHOR, 1990.

EXHIBIT 51
Group 10L-2, Structure 33

The next building from Group 10L-2 to be exhibited in the museum is a relatively early one (**179**). Architectural stratigraphy and stylistic clues such as sparse, low-relief sculpture suggest that it was contemporaneous with the second phase of construction of Structure 32. This modest building is called Structure 33 south, and it was the only decorated building of three in the Structure 33 complex, which sat on the west side of the main plaza in Group 10L-2. Although the entire platform supporting the structures was quite long, this southernmost building was very small.

Structure 33 south was clearly a sleeping room, for most of it was filled with a large, C-shaped bench. Its dominant motif, carved on the upper molding, is the "crossed bundles" (probably representing bundles of reeds or thatch), which is paired either with a circular mirror bundle topped by a year sign or with Tlaloc eyes surrounded by scrolls and surmounted by a *na* (house) sign (**180**). Above the doorway and on the rear of the building, a large year sign over a star sign rests on the lower molding (**181**). This unusual motif seems closely related to butterfly and year signs found in the colorful pages of much later central Mexican codices, and it might have had calendrical significance in A.D. 800 as well (**182**). Short, vertical ornaments representing feathers topped the roof of this tiny structure.

Various interpretations have been offered for the motifs on this building, including the view that the *na* signs signified it as the house of a female, and the crossed bundles perhaps identified it as the queen mother's house. This is stretching the interpretation farther than can presently be confirmed. Probably, before Yax Pasaj Chan Yopaat took power as the sixteenth ruler, this residential structure was added onto the plaza in Group 10L-2. Its occupant most likely had strong ties to the dynastic lineage, because he or she was allowed to display iconography associated with the founder. The crossed bundles, mirrors, and Tlaloc motifs are related to central Mexican motifs pertaining to the New Fire ceremony, as found on the final versions of Structures 26 (Ruler 15) and Structure 16 and on Altar Q (Ruler 16) on the Acropolis. The earlier Structure 33 seems to have been a forerunner in the dynastic lineage's sculptural proclamations reaffirming its affiliation with central Mexico and with this ceremony, previously celebrated at Teotihuacan.

In the museum, we decided that Structure 33 was the best candidate on which to re-create the plastered and painted exterior of a stone-carved building, to approximate for visitors the way the structures likely appeared in ancient times. Today, on most buildings one sees the individual stone blocks exposed, but in ancient times the texture of the stone and mortar was concealed under a smooth coat of plaster. The intricate carvings viewers now appreciate often became obscured after many replasterings. Although stucco and color remains have been found on many other sculptures, we found no traces of color preserved on Structure 33. Our color scheme for the year-sign motif above the doorway is purely hypothetical, derived from a similar representation in the Codex Nuttall.

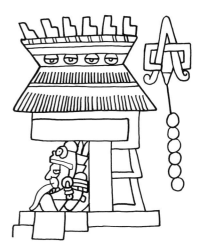

182. Year sign next to a structure with star eyes on its roof, from the Codex Nuttall.

DRAWING BY THE AUTHOR AFTER NUTTALL 1975.

EXHIBIT 52

Group 10L-2, Structure 29

Structure 29 is a large, L-shaped structure on the elevated northern terrace of Group 10L-2. Both the structure's dominant position above the group and its heavily decorated façade hint at its magnificence and importance. Embedded in the architecture and sculpture are many symbols with celestial references. It appears that the building was an ancestral temple, associated with death symbolism and the realm of the ancestors. The long, vaulted rooms had stepped interior niches in the walls rather than sleeping benches, suggesting a ritual rather than a residential function. Importantly, there were nine of these interior niches, signifying the nine levels of the underworld. Carved decoration also appeared inside the rooms, which is unusual. It consisted of circular jaguar spots appearing near the medial molding and continuing upward toward the ceiling. In Maya art the night sky was represented as a jaguar pelt, so the motif was probably meant to transform the interior into the starry night sky.

During the excavation of Structure 29, the PAAC team devoted great care to recording the precise locations of the fallen pieces of sculpture (**183**). The building offered an ideal situation, because its fallen façade had gone relatively untouched since its collapse. Almost all the sculpture lay where it had fallen, face down and covered with wall debris and centuries of accumulated soil. This kind of preservation enabled us to reconstruct the façade with considerable accuracy. It was also our good fortune that when sculpture fell from the

183. Excavation of collapsed sculpture from the western façade of Structure 29.

PHOTOGRAPH BY THE AUTHOR, 1990.

western façade in ancient times, it was dislodged from the wall en masse, perhaps by a one-time event such as an earthquake. Before a single piece was lifted from the ground, excavators removed the overburden horizontally to reveal all the sculpture fallen together. Maps and photographs were made, with the fallen positions carefully plotted in each excavation unit. When the lifting commenced, each semi-articulated piece was placed on the ground next to the others with which it had fallen. It took many days of painstaking work to remove and reconstruct all the sculpture. In the end, we put the upper portion of the west façade back together on the ground, complete even with the plain wall stones in the spaces between the sculptures. This reconstruction is still in place at the site, next to Structure 29. Because the motifs were repeated identically around the building, this effort allowed us to reconstruct the sculpture on the other sides, which had fallen in a less orderly fashion.

On the east side of the platform supporting Structure 29, a staircase led up to the building. Decorating the northeast and southeast

Detail of supernatural figure on Structure 29 façade.

PHOTOGRAPH BY RICK FREHSEE, 1996.

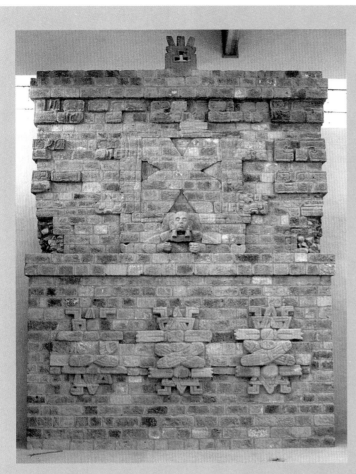

Reconstruction of the southern façade of Structure 29 (exhibit 52).

PHOTOGRAPH BY WILLIAM L. FASH III, 1996.

STRUCTURE 29
SOUTH FAÇADE

The main configuration on the upper register of this façade is the solar ancestor cartouche—a large, rectangular space framed by a border with three beads clustered on either side. In the four corners of the cartouche, stylized centipede serpents project from crescent-shaped cutouts. The cartouche is carried on the shoulders of a large, humanlike figure shown from the torso up. The geometric shapes that had fallen from the interiors of these cartouches have been reconstructed as four-lobed *k'in* signs. This flowerlike motif is a day sign and a symbol for the sun.

The ancestor cartouche is known from iconography at other Maya sites, including Palenque, Yaxchilan, and Chichen Itza. Generally, when a male ancestor is associated with the cartouche, the interior sign is a sun symbol; when the association is with a female ancestor, it is a lunar sign. Copan sculptors, ever creative, carved the sun sign on Structure 16's cartouche as a three-dimensional depiction of K'inich Yax K'uk' Mo' apotheosized as a sun deity (see chapter 5, exhibit 7).

It is significant that the ancestor cartouches repeat 10 times on Structure 29, because 10 is the number associated with the Maya death god. J. Eric Thompson recorded that the Lacandon Maya had an underworld god known as Suncunyun (or U Zacun Yum), a brother of the death god, who was said to carry the sun through the underworld on his shoulders during his nightly journey. Other Maya groups believe that a similar god carried the souls of the dead through the underworld and released them into a watery paradise. Perhaps the stocky, humanlike figures on Structure 29, shown carrying the 10 cartouches on their shoulders, are a Late Classic representation of this idea. Here the souls of the ancestors, who were venerated in this temple, emerge from their underworld journey, which mirrors that of the sun.

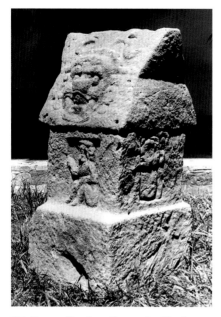

184. House effigy from Group 10L-2. The three house models displayed in exhibit 53, each carved in two parts, were used in house dedication rituals, perhaps as gifts from the ruler himself. On them are inscribed the names of the royal family's patron gods. These miniature houses are best understood as temporary abodes for gods and goddesses in the human world. Rituals activated the manifestation and presence of spirit. The positions of most of the models during excavation suggested that they had fallen from the terrace of Structure 29, a possible ancestor shrine.

PHOTOGRAPH BY THE AUTHOR, 1990.

185. The crossed bundles in the Wite'naah glyph as it appears on Altar Q.

DRAWING BY THE AUTHOR.

corners of the platform were two skeletal dragon heads, or death masks (see chapter 6, exhibit 25). These heads perhaps served to personify the platform as part of the underworld.

The south façade of Structure 29 was the only side that had sculpture on its lower register, and this is the façade we reconstructed for display in the museum. Its heavily decorated upper register shows evidence of an ancestor solar cartouche that was repeated 10 times around the building. Between the cartouches, resting along the lower molding, were 13 stepped niches (two are shown on the corners in exhibit 52) that may signify the cave entrances to the 13 levels of heaven. I interpret the stepped niche as representing half of a quatrefoil, or four-lobed, symbol that Linda Schele called *ol*, which was seen as a portal to the supernatural world. In my interpretation, the unseen half is understood as hidden below the architectural molding, which on this building served as a horizon line. I believe this illustrates an ancient Maya belief recorded by Karen Bassie-Sweet, namely, that the 13 levels of heaven and the 9 levels of the underworld were reached via caves on the horizon.

Filling the spaces between the niches and cartouches are numerous lazy-S-shaped scrolls that symbolize clouds, swirling much the way fog hugs the hillsides and the horizon at sunrise. They set the background and create an atmosphere in which this scene of ancestor transformation unfolds. When the residents of Group 10L-2 called forth their ancestors in rituals and ceremonies, the smoke from their incense imitated the clouds and fog and carried their message to the ancestors. Small house effigies associated with Structure 29 show smoke curling from the heads of fire deities (**184**). According to David Stuart, each model in exhibit 53 is labeled a "holy-house-shrine," a sleeping place (*wayabil*) for a spirit companion.

On the lower register of the south façade is a cluster of three identical motifs that had fallen together on the terrace immediately in front of the south wall. The motif is the crossed bundles, the so-called founder sign known from Copan's hieroglyphic texts (**185**). This is the only example of a hieroglyph directly associated with Structure 29. I believe this motif, bound by year signs above and below, is the "bundle of years," or *xuihmopilli*, symbol so well documented for the New Fire ritual celebrated in highland Mesoamerica at the conclusion of every Calendar Round cycle of 52 years. The

crossed-bundles sign topped by the round "face" is a glyph (possibly representing a mirror) found in the text on Altar Q; the combined motif is commonly associated with the ruling dynasty at Copan and the founding event carried out by K'inich Yax K'uk' Mo'. The appearance of these motifs on Structure 29 may indicate a celebration of three 52-year cycles.

The unusual placement of these motifs on the lower register, along with their deep relief, sets them apart from the imagery on the upper façade. They appear to designate this building as an ancestral temple commemorating the ruling dynasty and affiliating the occupants of Group 10L-2 with K'inich Yax K'uk' Mo'.

Atop the roof of Structure 29 were upright ornaments in the form of stylized flowers. Each has an inverted, cutout *ik* sign on its face, which signifies an absence of breath, a metaphor for death. Water from the roof spilled out of two stone drain canals on the north and west sides of the structure. In essence, the roof, where water collected and from which stone flowers sprouted, emulated a watery paradise, the ultimate resting place of the ancestors' souls.

EXHIBIT 54

Río Amarillo Motifs

A tributary river called Río Amarillo lends its name to the archaeological site on its banks, about 16 miles (25 kilometers) east of Copan's main center. The same river becomes the Copan River as it enters the Copan Valley, and it no doubt served as a communication and transportation link between the two areas. Sylvanus Morley first mentioned the site in his *Inscriptions at Copan.* In his time it was also known to local people as La Cantellada, "the stone source."

The site's first major construction phase came in the Early Classic period (A.D. 250–600), and its earliest known sculptures appeared during the reign of Copan's Ruler 12, around A.D. 600. Two rectangular altars discovered by Morley in 1913 and now on display in the Copan Regional Museum of Archaeology are inscribed with the name of Ruler 12 and bear the Copan emblem glyph. One altar mentions the founder of the dynasty, K'inich Yax K'uk' Mo'. This has led researchers to believe that the site, like the river, was a tributary of

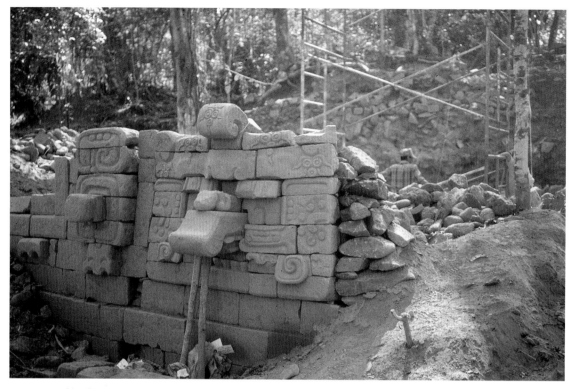

186. Reassembly of *witz* mask sculpture after excavation at Structure 5, Río Amarillo.

PHOTOGRAPH BY THE AUTHOR, 1996.

Copan and remained under the influence of the ruling dynasty throughout the Late Classic. No inscriptions have been found that give the name of the local governor or ruling lineage. Sculpture from the building façades, however, indicates that the ruling family had direct ties to Copan's royal dynasty.

In the mid-1970s, an archaeological team directed by Gary Pahl conducted excavations at Río Amarillo to determine how long people had lived there and, it was hoped, to find new inscriptions. They found none, but the work did reveal the presence of sophisticated mosaic façade sculptures on several buildings. One of them, Structure 5, was being undercut and threatened by the river, and some of its carvings had already fallen into the riverbed.

By the 1990s, the fate of Structure 5 looked ominous. More sculpture was tumbling into the river with each rainy season. At IHAH's request, Bill Fash had archaeologist William Saturno, then his graduate student, expand on Pahl's earlier excavation strategy,

excavating new plaza pits, house mound areas, and the west side of Structure 5. These investigations secured ample new data with which to reconstruct several motifs from this structure. With the construction of a wall, efforts were made to stop the river cut from further eroding the building.

Structure 5 was heavily decorated with a variety of motifs, most of which appeared on other buildings at Copan, but not all mixed together as they were on this building. It seems that the Río Amarillo architects and masons borrowed a little from each of several buildings and created a composite message. On the upper register, resting on the medial molding, at least six *witz* masks encircled the building (**186**). Above the masks sat images of human figures dressed in the Teotihuacan warrior costume. Each wore an elaborate feather headdress, not unlike those on Structure 9N-82 in Las Sepulturas (see chapter 9, exhibit 42). The upper portions of these figures, including the heads, were pillaged from the site sometime in the past; only legs and loincloths remained to be found during the excavations.

Isolated motifs such as *ajaw* faces, war serpent shields, skulls, and crossed bundles adorned other portions of Structure 5 or possibly a nearby structure (**187, 188**). The Río Amarillo war serpent shield is reminiscent of the shields of K'inich Yax K'uk' Mo seen on Altar Q and Structure 16, his ancestral temple. The skulls might have come from a small skull rack similar to that on the stairway panel at Structure 16 (chapter 5, exhibit 7). Such a feature might have adorned the steps of the largest structure at Río Amarillo, but no excavation has been carried out to confirm this.

The sculpture of Río Amarillo is easily distinguished from the sculpture of Copan by a difference in stone. The Río Amarillo stone is a denser, gray volcanic tuff. The earth at the site, however, contains a large proportion of iron oxide, which stains the gray stone noticeably red when the two come into contact. This led us to believe, mistakenly, at first that the stones' original color was red. Significantly, not a trace of lime plaster exists on any of the sculpture from Structure 5. My hypothesis is that the builders took advantage of the red earth not only as mortar but also as a clay finishing layer with which to coat the surfaces of the stone sculptures. This might have been an economical way to imitate the red-painted lime treatments at Copan and elsewhere.

187. War serpent shield from Río Amarillo.
PHOTOGRAPH BY THE AUTHOR, 1997.

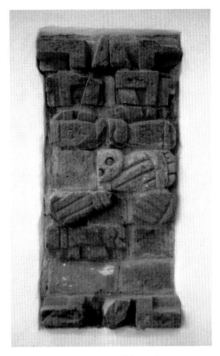

188. Crossed bundles motif from Río Amarillo. A crossed bundles and year-sign motif, nearly identical to the motif on Structure 29 in Group 10L-2, appeared on at least three sides of Structure 5 at Río Amarillo. It seems that this icon or emblem proclaimed that the structure and its occupants had an affiliation with the ruling dynasty in Copan and with the New Fire ceremony celebrated every 52 years.
PHOTOGRAPH BY RICK FREHSEE, 1997.

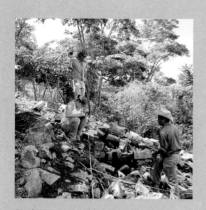

Student interns Eliud Guerra, Emily Martorano, and Serafín Jiménez excavating at Group 6N-1 in the Rastrojón area, August 2007.

PHOTOGRAPH BY THE AUTHOR.

Rastrojón sculptural motifs displayed in exhibit 55.

PHOTOGRAPH BY BEN FASH, 2009.

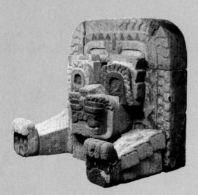

Feline sculpture from the Xalla compound at Teotihuacan, with paws similar to those at bottom left in the exhibit.

REPRODUCED BY PERMISSION FROM MATOS MOCTEZUMA AND SOLÍS OLGUÍN 2002.

MOTIFS FROM THE RASTROJÓN RESIDENTIAL ZONE

On the hillside northeast of the Principal Group, between the streams Quebrada Salamar and Quebrada Seca, sat a residential zone whose largest complex of structures, Groups 6N-1 and 6N-2, is commonly called Rastrojón. Today the terrain appears covered in scrub brush, but one can imagine that in ancient times this was a prosperous, terraced, cultivated zone dotted with households.

Despite the sizes of Groups 6N-1 and 6N-2 and the abundance of sculpture on their surfaces, little research had been conducted there in years past. Random surface collections of sculpture were made in the 1960s and 1970s, which were studied and partially assembled for exhibit 55. Aware that much remained to be investigated, Bill Fash, Jorge Ramos, and I started a new project at Rastrojón in 2007. No calendrical inscriptions have been discovered as of this writing, but the final constructions appear to be stylistically late. Much of the sculpture is well executed and intentionally oversized, meant to be seen when people entered the valley from the east. Central Mexican iconography abounds, in keeping with the popularity of this style during the reigns of Rulers 15 and 16.

Because we do not yet have the full collection of stone sculpture from Rastrojón, it is difficult to rejoin the motifs. A sample of what we have attempted is displayed in exhibit 55, which will no doubt change as the project and analysis progress. One of the most striking pieces is a pair of enormous feline paws. Perhaps these were originally displayed at the base of a staircase or framing the entrance to a structure. So far we have discerned no other parts of the cat to help identify its form. Comparative aid might come from a feline sculpture newly found in the Xalla residential group at Teotihuacan, Mexico, which has outstretched paws and a split scroll falling from its mouth.

Other motifs are war serpent images and Mexican year signs. Their angularity and solidity differentiate them stylistically from more curvilinear sculptures at other Copan residential sites, perhaps indicating a different sculptor's hand. Such differences give a sense of the competition that might have existed between residential groups or guilds of stone carvers.

The Rastrojón sculptures raise many questions. Why did a distant residential site possess such a great quantity of varied and sophisticated sculpture? How did the inhabitants manage to install such massive sculptures on their buildings? Why was the central Mexican theme so visible at this residential group? Did these people send a representative to the council house on the Acropolis? Ongoing investigations may provide answers to these and other questions.

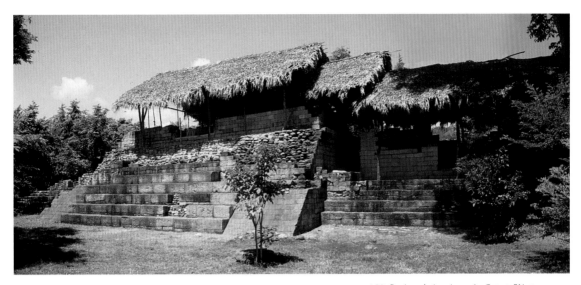

189. Restored structures in Group 8N-11.

PHOTOGRAPH BY THE AUTHOR, 2000.

EXHIBITS 56–58

Group 8N-11, Structures 8N-66C and 8N-66S

The exhibits in the Copan Sculpture Museum present the Principal Group and all the investigated residential groups that have well-documented sculpture programs. The last group of exhibits highlights façade sculptures from a large group at one end of the *sacbe,* or elevated causeway, that connects the Sepulturas residential zone with the Principal Group (**189**). The sculptures on display were uncovered during two excavation seasons, the first in 1981 under Evelyn Rattray of the Universidad Nacional Autónoma de México and the second in the early 1990s under David Webster of Pennsylvania State University. The excavated pieces have been matched to others that IHAH had collected much earlier and placed in storage.

Viewing the sculpture from Group 8N-11, one is immediately struck by the sculptors' superior carving abilities. They lavished attention on every detail, such as strands of hair and delicately incised earspools. The carved bench from the central building in the group (8N-66C) is a delightful full-figure representation of a Maya skyband, one of the finest examples of artistry from the Copan Valley (**190**). Four celestial images from the bench, corresponding to the four cardinal directions, were chosen to decorate the drop ceiling in the museum.

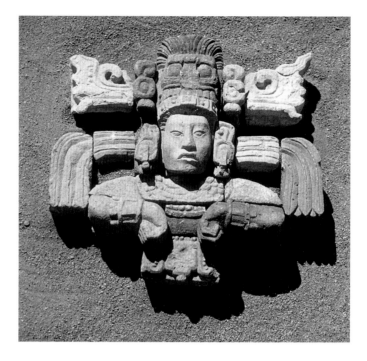

190. Upper façade figure from Structure 8N-66S in maize deity attire, reconstructed in sandbox. Note the intricate rendering of details such as the earspools and hair.

PHOTOGRAPH BY THE AUTHOR, 1990.

Archaeologists describe Group 8N-11 as a "subroyal" elite household group, meaning that it was the residence of a wealthy nobleman and his extended family. David Webster nicknamed it the "Skyband Group," although this is not a translation of a Maya name, and it does not appear as a title or label on any monument or structure. The group of richly decorated structures stood out at the end of the causeway in the densely settled Las Sepulturas zone, just over half a mile (1 kilometer) from the urban core. Whereas many Sepulturas groups have multiple courtyards, Group 8N-11 had only a single courtyard enclosed by its largest structures. Built up next to the dominant courtyard buildings were smaller, secondary living quarters that recent research by archaeologist Lisa Collins suggests might have been slave quarters. Evidence for construction and people living at the group dates primarily to the Late Classic reigns of the last two dynastic rulers.

Of the six main buildings surrounding the 8N-11 courtyard, only three have been excavated on the eastern side: Structures 8N-66N (north), 8N-66C (central), and 8N-66S (south). The others, too, may someday reveal sculptural façades or hieroglyphic inscriptions if they are investigated. The smallest building of the three, Structure

(LEFT) The skyband bench displayed in exhibit 57.

PHOTOGRAPH BY RICK FREHSEE, 1997.

(RIGHT) Detail of skyband bench showing moon goddess (left) and night sun god.

PHOTOGRAPH BY THE AUTHOR, 1990.

STRUCTURE 8N-66C

SKYBAND BENCH

The main interior room of Structure 8N-66C housed the elaborately carved bench now displayed in exhibit 57. Carved benches found in nobles' residences usually bear hieroglyphic inscriptions explaining who commissioned them and when. This bench carried another type of message, a skyband. Although often discounted as merely decorative combinations of celestial symbols, skybands may in fact give temporal placements in the Maya calendar on the basis of their night sky representations. Much is still to be learned about the celestial symbol arrangements in skybands.

This bench is divided into nine panels, of which three show a repeating personified head. The end panels show the heads of *moan* birds in profile, and between the birds are four panels with lively, gesturing, full-figure beings. The first, on the left, is the moon goddess, followed by the night sun god, the day sun god, and a representation of a bright star (possibly Venus) with a scorpion tail, associated with the directions north, west, east, and south, respectively. The moon goddess clasps a rabbit within the crescent symbol signifying the cave of her emergence. The night sun (see **17**) is marked with *akbal* (darkness) signs on his leg and arm. In contrast, the day sun emerges from a solar cartouche and is marked with *k'in* (daytime sun) signs. The possible Venus figure grasps a star sign and sports a scorpion tail, which may indicate the cycle phase (morning or evening) in which the planet appeared when the bench was dedicated.

This linear depiction of the sky is supported by four pedestals carved with crouching figures. The two end figures represent *bacab*, or Maya sky-bearing deities, which also appear on Structure 22's inner doorway. Their wrinkled faces, water-lily headbands, and shell pendants are characteristic features of these deities, whose job it was to support the corners of the sky.

The skyband bench was a place where the head of the residential group conducted his business and perhaps was inaugurated. A similar throne with *moan* birds and a skyband was depicted with a seated ruler on Stela 25 at Piedras Negras. Seated on such benches, rulers symbolically placed themselves at the center of the universe.

(TOP TO BOTTOM) Moon goddess, night sun, day sun, and Venus or star figures from the skyband bench, as painted on the museum's drop ceiling.

PAINTINGS BY THE AUTHOR.

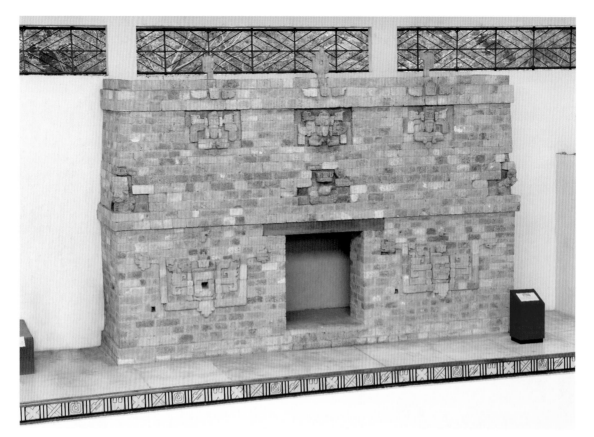

191. Museum reconstruction of the façade of Structure 8N-66S (exhibit 56).

PHOTOGRAPH BY BEN FASH, 2009.

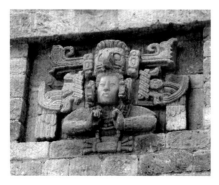

192. Central figure on the façade of Structure 8N-66S.

PHOTOGRAPH BY THE AUTHOR, 2006.

8N-66N, had no sculptural façade but rather a thatched roof, as did all the smaller structures in the group. The sculptured façades on Structures 8N-66C and -66S show that the noble from this residence was prestigious enough to employ a labor force of masons and sculptors equivalent to that which erected buildings for the royal family in Group 10L-2. The carving is even slightly more elaborate than that on neighboring Group 9N-8, the Scribe's Palace. During the reign of Ruler 16, many residential groups began erecting decorated façades. This might indicate a sharing of power, perhaps prompted by an increasingly demanding noble class, or it might be evidence of masons' gaining prestige and decorating their own compounds.

A complete frontal reconstruction of Structure 8N-66S is displayed in the sculpture museum as exhibit 56 (**191**). On the lower register, flanking the doorway, are two masks surrounded by vegeta-

tion. Water-lily plants frame rectangular spaces for the wild-eyed masks, and vegetation sprouts from their earspools and heads. Unfortunately, their protruding noses were never found (only the tenons), despite the remarkable cohesion of fallen mosaic pieces on the platform directly beneath their original positions. This suggests that they were broken off before the building collapsed. This mask—with its scroll eyes, cropped hair, wavy beard, and oval-encapsulated brightness symbol on the forehead—is an unusual deity in the Maya pantheon. Possibly an iconic name glyph for the patron of this group, it seems to be related to watery places and may hail from the realm of the primordial sea, the fertile place of creation.

Higher on the building, the plant and fertility themes continue. Human figures are decorated in the maize god costume weighted down with a dangling, water-lily pendant. The central maize god figure is different, having a more elaborate headdress, ear ornaments, and a jade bar pendant instead of the water lily (**192**). This may be the noble patriarch of the group who commissioned the building, as on the structure 9N-82 façade. The headdresses of the maize god figures are smaller versions of the larger masks flanking the doorway below. In all there were eight figures, which—as on the Copan ballcourt—is in keeping with the number personified by the maize god.

Emerging from stepped niches repeated seven times above the medial molding are images of an aged deity (**193**). He has been referred to as the "*k'atun* lord" because in his headdress he wears a *k'atun* symbol. His eyes appear closed, and only a heavily beaded collar is shown below the head. He might be a representation of the number five, or *ho,* because the glyphic head variant seen in inscriptions wears the same headdress. Or he might merely be an animated *k'atun* sign, the name of the 20-year period in the Maya calendar.

The stepped niches resting on the molding of Structure 8N-66S are the upper portions of full quatrefoil signs (**194**). The lower portions are "hidden" behind the molding. The quatrefoil is a symbol for the open mouth of a cave and often refers to the entrance to the underworld. The ancient Maya believed that celestial bodies entered caves on the horizon at the end of every day and began their underworld journey, only to reemerge from another cave portal at the start of the next day. On this building, as on Structure 29 in El Cementerio, I believe the stepped niche symbolizes the cave, and the molding is the horizon. Beaded water drops cling to the borders of the niches, signifying the purity of water from this source. Because caves and

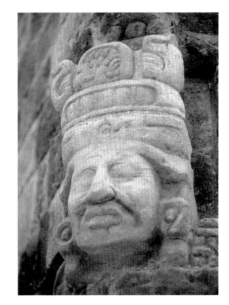

193. Detail of *k'atun* figure from Structure 8N-66S.

PHOTOGRAPH BY RICK FREHSEE, 1996.

194. Stepped niche and quatrefoil cave symbol from the molding of Structure 8N-66S.

DRAWING BY THE AUTHOR.

195. Examples of carved eccentric flint (top) and vegetation roof ornaments (bottom) from Structures 8N-66C and 8N-66S, respectively. (Scale = 25 cm.)

PHOTOGRAPH BY THE AUTHOR, 1990.

196. Rattle motif from Structure 8N-66C.

PHOTOGRAPH BY THE AUTHOR, 2006.

natural springs were often given supernatural names, the aged *k'atun* lord may refer to the name of such a place, over which the residents of Group 8N-11 held jurisdiction.

Comparative research has led me to interpret buildings with stepped niches and water-lily iconography as residential complexes that were seats of water management groups—non-kinship-based groups that shared and cared for the same water source. Agricultural groups, in contrast, based on kinship ties, might have been symbolized by maize iconography. Water-lily and maize imagery occurs together on this structure in a fertility theme in which the water lily predominates. Coupled with the stepped niche, it may mark this residence as that of the head of a community water-source group.

The central building in Group 8N-11, Structure 8N-66C, carries a different theme from that of its smaller neighbor, 8N-66S. Whereas the roof ornaments of 8N-66S are vegetation, those on 8N-66C are bold, stylized, eccentric flint knives, symbols of human sacrifice (**195**). A repeating rattle motif decorated the upper façade, recalling the rattles held by the monkey gods with *ik* rattles in Copan's West Court. Each rattle is composed of three blocks—a ball shape for the rattle gourd, a feather tuft, and a wooden handle (**196**).

After much analysis based on initial work by Daniela Epstein, our team was able to reconstruct six rectangular solar cartouches fallen from 8N-66C. Two of these are displayed in the museum as exhibit 58 (**197**). The solar ancestor cartouches on Structure 29 and the giant one on the stairway of Structure 16 served as models for piecing these back together. As in all other presently known examples from Copan, the central element is a sun god or a sun-related motif set into a shield that has a carapace-like border with four corner crescents and scalloped gouges along the edges between them. On Structure 8N-66C, the sun god K'inich Ajaw is recognized by his filed teeth and crossed eyes and by a *k'in* sign in his forehead (**198**). The characteristic tuft of hair extends out from his forehead, surrounded in this instance by twisted *pop*, or mat, elements. The figure wears a large knot pectoral made of several lengths of rope. This was traditionally considered a rope for binding war captives. A smoking *ajaw* element wound with more rope tops the sun god's feathered headdress and completes his name.

The sun god is depicted as an armless bust (as is the *k'atun* lord) and is surrounded by a border framed with sets of three liquid beads.

197. Museum reconstructions of the solar cartouches from Structure 8N-66C (exhibit 58).

PHOTOGRAPH BY BEN FASH, 2009.

198. The sun god on Structure 8N-66C.

DRAWING BY THE AUTHOR.

The eccentric flint knives on the roof of this building, together with the sun god's ropes for captives, may mark him as the warrior aspect of the sun. The month Pax in the Maya calendar is often symbolized by a sun god image with similar characteristics. Victoria Bricker and Harvey Bricker have determined that the structure's doorway was aligned with the sun on the day of its zenith passage. This may be another characteristic component embedded in the warrior sun god imagery. The captive knot is also found on the northeast representative figure on Structure 22A and may mark an affiliation between the head of this residential group and the central council administration.

What really lends fanfare to this sculptured façade are the high-relief rattles slanting outward from the crescents at the corners of the solar cartouches, replacing the more commonly used serpent motif. Like the upright rattles on the façade, each of these rattles is constructed of three blocks, but the slanting motion and the waving feathers add a feeling of movement seldom captured in the stone sculpture on other buildings. Perhaps they signify the music of a procession or a warrior dance that occurred in the month of Pax. A tall Maya drum used in warrior dances was also called *pax*. Once again we see the connections linking music, dance, festivals, the community, and the council house.

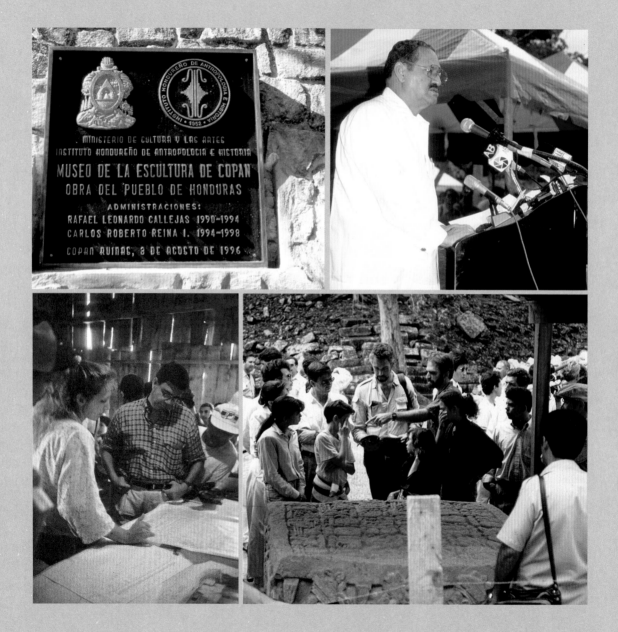

12
Museum and Community

Inaugurated on August 3, 1996, the Copan Sculpture Museum has become a significant feature on the physical and cultural landscape of Honduras (**199**). It presents many magnificent Copan sculptures to the public for the first time, and its reconstructions of building façades allow the mosaic configurations to be viewed nearly as they were seen on the original structures. Each building had a different purpose for the ancient residents of Copan, and as the ruins are pieced back together and studied, the complex fabric of past life in the city is further revealed. The heritage that is being rediscovered brings to the modern people of the area a new sense of identity with and respect for the past. Although traditional Maya culture and languages disappeared from the Copan Valley long ago, their roots can still be detected in the townspeople's daily lives. The residents of Copán Ruinas, who have served the museum as excavators, artists, masons, carpenters, administrators, photographers, and teachers, together with their families, shared in this rediscovery and dedicated their efforts to making the museum possible (**200, 201**).

In the ancient Mesoamerican world, Copan stood at the forefront in the use of architecture as a means of visual communication. Since the first popular accounts of its stone art and architecture appeared, scholars have debated the meanings and purposes of these masterful artistic expressions. Copan, with its animated imagery, was always considered to display the highest level of achievement in Maya art. Its temples, palaces, and administrative buildings came alive with sculptural decorations that personified the living and supernatural forces inhabiting the Maya world in a way the sculpture of few other cities could rival.

199. Clockwise from top left:

A, Bronze plaque at the entrance to the museum, 1996.

B, Honduran President Carlos Roberto Reina speaking at the museum's inauguration, August 1996.

C, Honduran President Rafael Leonardo Callejas (in sunglasses at left of center) at Altar Q while touring the site with Ricardo Agurcia (center) and Bill Fash (right, pointing), 1993.

D, Presentation of the initial museum plans to President Callejas, with the author (left) and Angela Stassano, 1993.

A, B, PHOTOGRAPHS BY RICK FREHSEE; C, PHOTOGRAPH BY THE AUTHOR; D, PHOTOGRAPH BY WILLIAM L. FASH.

200. Clockwise from top left:

A, Francisco Canán (left) and Santos Rosa at work, 1996.

B, People involved in creating the drop ceiling painting, 1995. Left to right, back row: Juan Ramón Guerra, Vicente Posas, Bill Fash, Mario Bueso, Alberto Dera, Carlos Chinchilla; front row: Rudy Larios, Luis Reina, Nathan Fash, the author, Reina Flores, Oscar Cruz.

C, The team from Copán Ruinas and nearby villages making a digital photographic record of the Hieroglyphic Stairway, 2007: Reina Flores (center) and, clockwise from her, Harold Cabellero, Erasmo Ramírez, Karina Garcia, and Joel Villeda.

D, Painters of the stucco bird replica, 1996. Left to right: Bill Fash III, Ben Fash, Julia Drapkin.

A, PHOTOGRAPH BY WILLIAM L. FASH III; B–D, PHOTOGRAPHS BY THE AUTHOR.

The imagery on Copan's buildings was a form of visual language that conveyed similar conventional meanings to all who viewed it. Unlike the written word, conveyed in hieroglyphs and probably comprehended only by the literate, the large sculptural symbols and motifs on the building façades could be understood by people of all social ranks. In a cosmopolitan city like Copan, the imagery was probably designed to cut across cultural lines as well and to be understood by people who spoke different languages. The wonderfully imaginative Copan sculptors gave material expression to spiritual beliefs and helped spread Copan's religion and art to other areas. In the hands of leaders and groups seeking to mystify and enthrall, the sculpture façades were powerful instruments. Rulers'

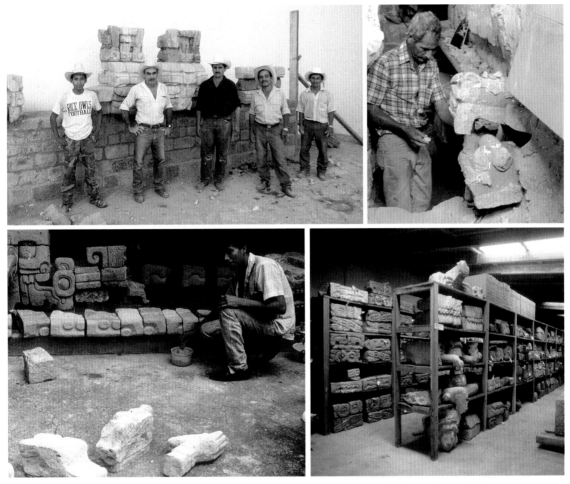

201. Clockwise from top left:

A, Museum crew at the beginning of exhibit installations, 1995. Left to right: Victoriano Reymundo (mason assistant), Santos Vásquez Rosa, Juan Ramón Guerra, Eleodoro Machorro, Francisco Canán.

B, Ismael Gonzales working on the stucco restoration of the Ballcourt I bird, 1993.

C, Sculpture in storage at CRIA in the 1990s.

D, Carlos Jacinto preparing replicas for Las Sepulturas, 1995.

PHOTOGRAPHS BY THE AUTHOR.

names, emblems, and sacred place names were emblazoned in iconic form for everyone to see and read.

Now far removed from the seventh and eighth centuries, when most of these works were created, we must look for clues to ambiguous meanings that have been lost with time. Our ideas about the sculptures' messages change as we learn more through excavation and analysis, which is why it is usually necessary to present possibilities in conditional terms rather than offer statements as facts. To understand the complex religious concepts reflected in the sculptural images, it is useful to grasp the idea of *personification*. As Bill and I wrote in a 1996 article on visual communication in Classic Maya architecture, personification is the notion that everything

one experiences has a spiritual personality that can be visualized and represented. The ancient Maya saw water, for example, as a living force that took many forms. It visual representation as liquid from a mountain spring or lake (often in the form of a serpent with water-lily attributes) differed from its depiction as rain (a Chahk mask), dew (beads), or vapor (scrolls). Maize, in its many cycles and stages of development, also took many guises, from seed (*k'an* cross), to sprout (curling vegetation), corncob (maize deity), and drying stalk.

The sculpture of Copan offers many vivid examples of the concept that supernatural forces reside in the everyday world. The waterbird from the Híjole structure, which may once have adorned Structure 22 (see chapter 6), is perhaps the most masterful one extant in carved stone. The Rosalila temple (chapter 3) is certainly a magnificent and well-preserved example that, when reconstructed in the museum, allows modern viewers to feel and contemplate the effect such a building had on people who stood before it on the ancient Copan Acropolis (**202**). The museum reconstructions help visitors envision the pageantry and the public and private rituals that took place against these symbolically charged backdrops in the city core and in outlying residences alike.

Political messages and symbols that struck a unifying chord in the community, such as the woven mat motif decorating Structure 22A, would have been easily identifiable by anyone who viewed the buildings from the plazas below. Although we can only hypothesize about who attended events in the Principal Group, I have proposed that different social groups participated in events in the center in calendrically timed rounds. In time, powerful groups in the outlying residences created their own animated façades for local enhancement and enjoyment.

Copan's unusually prolific sculptors and masons no doubt played a direct role in this development. As their skill and numbers increased, so, it seems, did the desire to build bolder residences to complement or rival those at the center. Public architectural projects most likely attracted laborers from smaller chiefdoms or other political units, workers who hoped to improve their quality of life by attaching themselves to a wealthy polity. Attracting and training masons and sculptors generated greater power for the ruling dynasty by creating a permanent, skilled workforce for public projects undertaken in the Principal Group. Studying the connection between

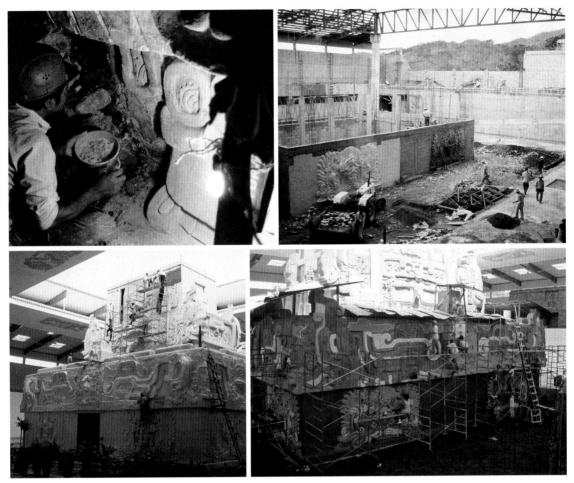

202. Clockwise from top left:

A, Fidencio Rivera stabilizing the Rosalila stucco in the tunnel, 1993

B, Rosalila construction in progress, 1995.

C, Painting the Rosalila replica, August 1996.

D, Rosalila construction in progress, 1995.

PHOTOGRAPHS BY THE AUTHOR.

political status, social power, and architecture, Bill and I have proposed that Copan sculptors and masons formed a special, elite interest group beginning in the Early Classic period, with the founding of the polity. By the Late Classic period, this group would have wielded significant economic power.

In the Copan Valley, 14 residential groups are known to have displayed sculptural façades, and four groups have yielded hieroglyphic benches inside buildings. These finds draw our attention to the economic consequences of architectural construction and its sculptural embellishment. In the Late Classic period, commoners made up an estimated 85 percent of the households in the valley, and elites, 15 percent. Less than 1 percent of the total populace consisted of the

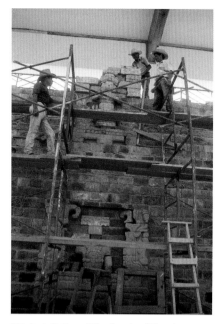

203. Installation of the façade of Structure 9N-82 in the museum, 1995.

PHOTOGRAPH BY THE AUTHOR.

actual ruler's household. Scholars estimate that it would have taken 30 workers approximately one year to build the residential Structure 9N-82, and two years for 50 workers to build the larger Structure 22 on the Acropolis (**203**). The essential point is that architecture is a valuable artifact that reflects social power relations.

Buildings within roughly a half-mile radius of Copan's urban core and in the more rural parts of the valley, such as at Rastrojón just to the northeast of the Principal Group and at Río Amarillo farther to the east, display a wide array of styles and messages in their façade sculptures. Few of them have yet been completely excavated or reconstructed, but on the basis of their sculptural themes and the sites' divergent histories, we can predict that their social and political standings varied significantly as well.

We are still a long way from understanding the internal power politics behind the collapse of royal authority in ancient Copan, but continued investigation of residences and urban structures holds great promise for helping us understand the roles various actors played in producing status and power in Copan. The buildings and their sculptured decorations undoubtedly reflect the inexorable process by which regal order devolved into political chaos and the end of divine rule.

The study of Copan's sculpture is endless, for new interpretations can arise with every new piece unearthed. For example, we are only beginning to understand the meaning and use of color on the sculptures. Advanced technology that allows us to see microscopic remains of pigments in the stucco and stone pores—traces invisible to the naked eye—promises to open a new world of insights into this fascinating subject. Three-dimensional records are being created that offer new means of preserving information and reconstructing fallen façades. Yet despite these new advances, we must continue to preserve the originals, for nothing surpasses the genuine artifact as a means of experiencing and studying the past through our own visual senses.

The Copan Sculpture Museum, however, is important to its community and its nation in ways that reach far beyond its aesthetic appeal and its wealth of information about the ancient Maya. At the museum's groundbreaking, Honduran President Rafael Leonardo Callejas proclaimed it the first cultural monument of the nation that served to foster a national identity. For the Copan community and those of us who worked on the project, it represents more than an

204. The Casa Galeano, a history museum and cultural center in Gracias, Honduras, and a young tour guide at the museum. The renovated house is part of a larger historical and cultural project in the Department of Lempira. One can read about the project in English and Spanish at www.colosuca.com.

PHOTOGRAPHS BY THE AUTHOR, 2006.

affiliation with the Maya past; it represents what a hybrid cultural community—native people, *ladinos,* and foreigners—could accomplish together by appreciating and preserving an important legacy. As an educational tool, the museum helps thousands of schoolchildren learn about the ancient Maya and become more culturally conscious. It is intended to strengthen respect for indigenous artistic achievements and to be a catalyst for equality and justice for native people in the future.

People of Maya descent are far from the only Honduran citizens to possess native ancestry. Indeed, Honduras has substantially more non-Maya indigenous people, such as the Lenca, than Maya descendants, but their cultures and histories tend to be marginalized in the media and in textbooks in favor of Maya heritage. The Copan Sculpture Museum, rather than setting the Maya in competition with other indigenous groups in the country, encourages the others to rally support for promoting their rich cultural heritages as well. This is beginning to happen, and new museums and cultural centers are springing up in other areas. One example is Casa Galeano, a history museum and cultural center in Gracias, Honduras, that features Lenca traditions (**204**).

Today in Honduras, historians such as former Honduran Minister of Culture Rodolfo Pastor Fasquelle and Darío Euraque, a previous

director of IHAH, are attempting to balance the cultural identities of Honduras by investigating the overemphasis on Maya heritage that often dominates public attention. Euraque and Pastor have both commented on the way non-native political leaders go to the extreme of characterizing themselves as "Maya" by employing ancient Maya icons and rituals in public events, including the creation of elaborate backdrops featuring Maya symbols for use during presidential inaugurations. Copan, the largest and most heavily visited Maya site in Honduras, lies at the center of this discussion. Without careful thought, efforts to popularize the Maya could eventually erase actual history. Although it was natural to create a museum at the most dynamic, world-renowned archaeological site in Honduras, in choosing the name for the Copan Sculpture Museum, Bill and I spoke out against including the word "Maya." We and some colleagues saw it as exploiting an ancient cultural affiliation that did not represent the ethnic diversity of Honduras as a whole—or even of ancient Copan, which, in its Classic period heyday, was a cosmopolitan city that housed enclaves of people from throughout Mesoamerica.

Museums such as the Copan Sculpture Museum offer tangible benefits along with the fostering of ethnic and national identity. Among their many other challenges, developing nations of the twenty-first century must find ways to keep their people employed and to better educate them. From the inception of government-funded archaeological projects in Honduras, foreign researchers have trained Honduran nationals in all aspects of archaeological work, building a cadre of professionals who lend continuity to the archaeological investigations, maintain the ruins, run the museums, and conduct independent research. Besides creating jobs, the construction and operation of a museum can prompt municipal improvements and generate revenue from tourism.

In Copán Ruinas, residents embraced the idea of the sculpture museum and the goal of using national and foreign aid for a purpose that would benefit the community for years to come. The economic effect was plainly visible as Copanecos improved their homes and installed public facilities such as a new secondary school. Many more children in Copán Ruinas now attend school beyond sixth grade than was formerly the case. Older children no longer leave the town in large numbers but instead find jobs in the town's growing economy. New hotels and restaurants offer a variety of accommodations for travelers and provide employment for residents. These changes, act-

ing to keep families together, have helped strengthen family ties, the backbone of contemporary *ladino* societies.

The Copan Sculpture Museum brought together a diverse group of government officials, townspeople, professionals, and academics to create a new cultural resource that evokes pride in everyone who contributed. Copanecos' sense of investment in the museum, fused with its economic benefits, should sustain local interest in the museum and in the preservation of the Copan ruins far into the future. In addition, the town has forged long-term ties with outside institutions that will continue to support the museum and provide intercultural and professional exchanges. Reciprocity is already in evidence as the Copan Sculpture Museum and Harvard University exchange replicas and jointly conduct conferences, training events, symposia, and university courses.

The exquisite sculptured façades of ancient Copan, now deservedly displayed in the Copan Sculpture Museum, contribute to the appreciation of Mesoamerican art, religion, and history by indigenous descendants, other Honduran nationals, and foreigners alike. It is the wish of everyone involved in the sculpture museum that this renewed appreciation will inspire people to preserve and study this priceless legacy for future generations.

Acknowledgments

This book began as a short exhibition guide but became a much larger and more comprehensive treatment of the history and meaning of Copan's sculptures. Its growth resulted from my close involvement in the development of the Copan Sculpture Museum, from conceptualization and exhibit planning to installation of exhibits and composition of label texts. When Olga Joya, then director of the Instituto Hondureño de Antropología e Historia (IHAH), asked me to produce a book for museum visitors, I felt it was both a huge responsibility and a great privilege—an opportunity to help educate people about the museum's mission and the research projects that led to its creation. I was also glad for the chance to explain the challenges of building a museum in a developing country. The integration of the local workforce in the project was a key component of the museum's success.

In chapter 1 and elsewhere throughout the book, I have described the roles played by many of the contributors to the museum project and the archaeology that guided it. Here I want to thank all those not mentioned in the chapters, for everyone's role was important.

Throughout the project team's many years of work and collaboration, we were fortunate to have the support and trust of the Instituto Hondureño de Antropología e Historia. During the administration of Honduran President Rafael Leonardo Callejas, IHAH's director, José María Casco, administered funds granted by the United States Agency for International Development (USAID, 1993–95) for the workforce of the Proyecto Arqueológico Acrópolis Copán (PAAC) and for exhibit installations. Casco's successor, historian Olga Joya, continued this support during the administration of President Carlos Roberto Reina, often lending valuable IHAH staff members to facilitate the work. They included Carmen Julia Fajardo, director of the Department of Anthropological Investigation; financial director Saul Bueso; exhibition director Salvador Ichigoyen, who helped with installations and label preparation; and Laura Gálvez, IHAH assistant director, who translated the label texts. At IHAH's regional office, Bertha de

Madrid cheerfully did museum-related clerical work, prepared reports, sent faxes, and straightened out finances as we rushed in and out of her office.

In 1993 IHAH contracted Lee Parsons, an archaeologist and museographer from the Milwaukee Public Museum of Anthropology, to review the plan for the interior of the museum. Lee helped determine the museum's color selection and general circulation flow. He suggested adding the "sculptural art" niches under the ramp, and he designed the panel on the lower level where the large sculpted bat is displayed. The museum's introductory panels are also a direct result of his efforts.

During construction of the museum building, the field supervisors were Miguel Morazán B., Rolando Hernández, and Dennis Barahona.

It almost literally "took a village" to create the reconstructed and replicated monuments on display at the Copan Sculpture Museum. Among the many people from the town of Copán Ruinas who were part of the team—in addition to those mentioned elsewhere in the book—José Adán Péres and Luis Paz ably assisted in building the replica of the temple called Rosalila. Others who kneaded mounds of clay for modeling the temple's sculptures and then helped make molds and cast the results were jacks-of-all-trades Erasmo Ramírez, Efraím Ramírez, Francisco Fajardo, Rufino Membreño, and Marco Tulio Cantillano, a veteran excavator who also assisted with exhibit installations. Erasmo Ramírez is now regularly charged with the upkeep and painting of the museum replica, and Rufino Membreño serves as head of the Restoration Lab in Copan. Eleodoro Machorro, another master mason and excavator, performed miracles with electrical installations and was one of many hands to build the Rosalila replica.

Other Copanecos who deserve recognition and thanks are the following, in alphabetical order. Hector (Tito) Aguirre, a technical illustrator for the Copan Mosaics Project in the 1990s, recorded vast amounts of sculpture and aided me in assembling the monster mask from Structure

9M-195, Las Sepulturas. Artist Gregorio Arias catalogued and drew hundreds of sculptures for PAAC many years before the museum work; his careful renderings helped organize the excavated material. Rene Cantillano, a technical assistant during PAAC, catalogued and photographed hundreds of sculptures that later went into the museum. Janeth Cueva was a great asset with computer skills that aided me in setting up the sculpture catalogue database in 1993. At other times she did clerical work and helped run the library. Melvin Espinoza assisted as a draftsman and painter. Obdulio ("Lulo") Garza, an excavator for many years, was an important replica assistant and electrician. Ismael Gonzales was an excavator of unparalleled dexterity and found himself in particular demand when stucco restoration began.

Hernando Guerra was head of the Restoration Lab during the years the museum was under construction. He skillfully repaired broken pieces and supervised the production of replicas of monuments such as Stela A. Carlos Jacinto constantly amazed me with his artful restorations and replications. In the museum, the subtle touches applied to complement broken edges are all his, as is the painterly hand seen on the stelae and other monument replicas at Copan and Las Sepulturas. Concepción Lazaro, a master of pottery restoration, worked in sculpture restoration as well. Don Daniel Lorenzo, with 30 years' experience as an excavator, is now busy training the next generation, which I hope will acquire his steady energy.

Refugio Murcia was a gentle soul and draftsperson who prepared maps for publication and catalogued sculpture beginning with the Proyecto Arqueológico Copán (PAC I). Sadly, she passed away before the museum was begun. Manuel Paz excavated for years and was part of the core team working on exhibit restoration. His reliability and polite demeanor landed him a job as a museum guard after the opening. Fidencio Rivera is another master at excavation and stucco restoration; he played an especially important role in preserving information on the original Rosalila temple. Finally, we were fortunate to have Héctor Suchite and Napoleón Zerón work on excavations and assist the masons with exhibit reconstructions.

Sculptors Marcelino Valdés and Jacinto Abrego Ramírez, besides their other contributions to the museum, replicated the fantastic stucco macaw from the first ballcourt at Copan, which is on the second level of the museum. My sons William Fash III and Ben Fash, along with student Julia Drapkin, painted this replica.

For help in finding a suitable paint to use on the exhibits, I thank PAAC project conservators Harriet Beaubien and Susan Peschken for referring me to Frank Preusser, a leading conservator, who in turn steered me toward the Keim Company of Germany. I am also grateful to Mame Cohalan of Cohalan Company in Port Lewes, Delaware, which distributes Keim paints in the United States, for helping me order the appropriate products and deal with the complexities of getting the paints delivered to Copan.

Initially, Harvard University funds paid for the paint and its exorbitant freight costs, which were later kindly reimbursed by the Honduran Institute of Tourism, headed by Ricardo Martínez. National Geographic artist Christopher Klein, who painted the wonderful reconstruction paintings of Rosalila for the magazine, supplied dozens of quality brushes for the detailed work. The National Geographic Society also generously donated the potted plants that graced the museum during its inauguration.

Reina Margarita Flores, photographer and archivist, simultaneously ran IHAH's photo studio, archive, and library and later added the supervising of the sculpture catalogue inventory to her many responsibilities. She also made the photographs of my drawings, which I projected onto the museum's ceiling panels in order to trace designs to be painted on them. Carpenters Alberto Dera and Carlos Chinchilla assembled the ceiling panels and supporting frames, and driver Vicente Posas made numerous trips to San Pedro Sula for paints in just the right colors to satisfy my finicky eye.

A special acknowledgment goes out to the participants in the 1996 Harvard Summer Field School who helped paint in the museum: Darcy Callahan, David Carballo, Lisa Collins, Karla Davis-Salazar, Julia Drapkin, Heather Hurst, Catherine Magee, Davey Olson, Susan Peschken, and Zannie Sandoval. Others on hand to help were Maria Amalia Agurcia, Ellen Bell, Nathan Fash, Ana Edith Lara, Nelson Paredes, Luis Reina, Bill and Jaime Saturno, Lizzette Sotto, Trent Stockton, and Karl Taube.

An enormous amount of information and knowledge gained from the archaeological projects at Copan fed into the museum exhibits and into this book. In the formative years of the Copan Mosaics Project, art historian Jeff Kowalski came to Copan to help run a field school with Bill and me out of Northern Illinois University. He helped sort the motifs from the ballcourt, Structure 26, and Structure 32 in 1985–86. Those were the tough years, when no one believed the job was possible, and it took imagination, optimism, and perseverance to stick with it.

In addition, the Copan Mosaics Project saw more than 300 students, colleagues, and Earthwatch volunteers happily continue with us over the years. I cannot list them all here by name, but their contributions to the vast sculpture catalogue and conservation effort are at the core of the museum. Students and colleagues who assisted and contributed to the understanding of specific buildings and themes were Wendy Ashmore (Group 8L-10, Salamar), Cassandra Bill (Structure 29), Joe Brandon (Str. 32), Wendy Brown (Str. 26 and the Str. 22 *tuun witz),* Inga Calvin (Str. 32), Lisa Cascio (Rastrojón site), Richard Casey (ballcourt and Str. 26), Wade Collins (Str. 22 corner masks), Lara Cuthbert (Pile 5 feathers), Nina Délu (Str. 16), Daniela Epstein (Strs. 33 and 8N-66), Nathan Fash (ballcourt alley bird markers), Carrie Grimes (photo scanning), Barbara Gustafson (Altar Q bases), Rachel Hamilton (Str. 32), Heather Hurst (Río Amarillo and Rosalila), Darío Izaguirre (Str. 22A), Sarah Jackson (Pile 10), Chris Jensen (missing heads), Jodi Johnson (Strs. 29 and 41), Tom and Carolyn Jones (Str. 22A glyphs), Sheree Lane (Str. 22A excavations), Ankarino Lara *(incensarios),* Allan Maca (Str. 22 corner masks), Marvin Martínez (Str. 22A), Alfonso Morales (Strs. 16 and 22), Kim Morgan (Pile 9), Julie Miller (Strs. 21 and 21A), Sandra Noble *(incensarios),* Joel Palka (Strs. 16 and 26), Arnulfo Ramírez (Str. 22A), Jorge Ramos (Str. 16), Bill Saturno (Río Amarillo), Susan Sherman (Str. 32), Jenny Smit (Río Amarillo), Jeffrey Stomper (Strs. 16, 26, 22A, and 9M-195), Donna Stone (Strs. 26 and 22), Stacey Symonds (Str. 26 and ballcourt stucco bird), Jennifer von Schwerin (Str. 22), Vickie Wagner (Str. 26), Michael Wascher (Str. 22 corner masks), David Webster (Strs. 9N-82 and 8N-66), and Richard Williamson (Str. 26, ballcourt, and Papagayo).

Several people aided me in preparing this book. Colleagues David Stuart, Jeremy Sabloff, and Stephen Houston reviewed the manuscript in various permutations and made it a vastly better product. June Erlick, of the David Rockefeller Center for Latin American Studies at Harvard, and Mary Malloy, my instructor and thesis advisor at the Harvard University Extension School Graduate Program in Museum Studies, kindly read and commented on the earlier versions of the manuscript; their support and encouragement were most welcome. Jane Kepp edited the book, and her professional hand made it vastly easier to read.

Daniel Ellis and Glenna Collett performed miracles with the graphics and layout, pulling the project together visually. At the Peabody Museum, I am grateful for advice and editorial guidance from Joan K. O'Donnell and Donna Dickerson of the Peabody Museum Press, photographic assistance from archivists India Sparks and Patricia Kervick, and the technology imaging services of Julie Brown and Jessica Desany. Student assistants Carrie Grimes, Danielle Mirabal, and Erica Larsen helped with the figure organization at various stages. The fine translation by Patricia Solé and Anabella S. Paiz for the Spanish edition makes this work accessible to a wider audience.

Rick Frehsee, a long-time friend of Honduras, generously donated his time and professional photographs for the book. Rick passed away several years ago, and I am sad that he cannot see his photos in print. My heartfelt thanks to Reina Flores, who developed and printed many of the images from excavations, to Hector Eliud Guerra and Iliana Flores for their help in scanning images, and to my sons Ben and Bill for their excellent photos.

My sons, William III, Nathan, and Benjamin, were wonderfully tolerant and supportive throughout the many years it took to build the museum and write this book, not to mention the early years of the archaeology projects they all grew up with. Their enthusiasm for joining in the activities, whether photography, drawing, or painting, was cherished more than they know. I also thank Romelia Manchamé, whose meals and caring kept our home front in Copan together for many years.

Of course the person I have to thank for all this "fine mess" I got into is my husband and soulmate, Bill Fash. He was the originator of the Copan Mosaics Project and took part in the construction of nearly every museum exhibit. Because of his role in this enterprise from start to finish, he was obligated to read every word of the book in countless drafts, nudge me back to the computer when I continually found something else to do, put up with my marathon sessions once I got going, and feed us all when I forgot about meals. Together we have lifted countless rocks, lost sleep, nursed bruised fingers and backs, puzzled over sculpture fits, and cheered at new finds. It has been an exhilarating experience.

In Recognition

The Peabody Museum of Archaeology and Ethnology thanks the following organizations for their valuable contributions to the support of this publication.

The David Rockefeller Center for Latin American Studies at Harvard University works to increase knowledge of the cultures, histories, environment, and contemporary affairs of Latin America; foster cooperation and understanding among the peoples of the Americas; and to contribute to democracy, social progress, and sustainable development throughout the hemisphere.

Fundación Uno is a nonprofit organization based in Nicaragua whose mission is to enhance the welfare of underprivileged people in Central America. By creating programs that focus on education, health, social development and cultural preservation we are able to improve the development of these communities. Through its program Colección Cultural de Centroamérica, Fundación Uno preserves the history and culture of the region by sponsoring and publishing works that define, affirm, and strengthen Central American identity.

Bibliography

Abrams, Elliot M.

1994 *How the Maya Built Their World: Energetics and Ancient Architecture.* University of Texas Press, Austin.

Agurcia Fasquelle, Ricardo

2004 "Rosalila, Temple of the Sun-King," in *Understanding Early Classic Copan,* E. E. Bell, M. A. Canuto, and R. J. Sharer, eds., pp. 101–11. University of Pennsylvania Museum of Archaeology and Anthropology, Philadelphia.

Agurcia Fasquelle, Ricardo, and Barbara W. Fash

2005 "The Evolution of Structure 10L-16, Heart of the Acropolis," in *Copán: The History of an Ancient Maya Kingdom,* E. W. Andrews and W. L. Fash, eds., pp. 201–38. School of American Research Press, Santa Fe, N.M.

Agurcia Fasquelle, Ricardo, and William L. Fash

1992 *Historia escrita en piedra: Guía al Parque Arqueológico de las Ruinas de Copán.* Asociación Copán, Instituto Hondureño de Antropología e Historia, Tegucigalpa.

Agurcia Fasquelle, Ricardo, Donna K. Stone, and Jorge Ramos

1996 "Tierra, tiestos, piedras, estratigrafía y escultura: Investigaciones en la estructura 10L-16 de Copán," in *Visión del pasado maya: Proyecto Arqueológico Acrópolis de Copán,* W. L. Fash and R. Agurcia Fasquelle, eds., pp. 185–201. Credomatic, San Pedro Sula, Honduras.

Ahlfeldt, Jennifer

2004 "On Reconstructing and Performing Ancient Maya Architecture: Structure 22, Copan, Honduras (A.D. 715)." Ph.D. dissertation, Department of Art History, Columbia University.

Andrews, E. Wyllys, and Cassandra R. Bill

2005 "A Late Classic Royal Residence at Copán," in *Copán: The History of an Ancient Maya Kingdom,* E. W. Andrews and W. L. Fash, eds., pp. 239–314. School of American Research Press, Santa Fe, N.M.

Andrews, E. Wyllys, and Barbara W. Fash

1992 "Continuity and Change in a Royal Maya Residential Complex at Copán." *Ancient Mesoamerica* 3 (1):63–88.

Andrews, E. Wyllys, and William L. Fash, eds.

2005 *Copán: The History of an Ancient Maya Kingdom.* School of American Research Press, Santa Fe, N.M.

Ashmore, Wendy

1991 "Site-Planning Principles and Concepts of Directionality among the Ancient Maya." *Latin American Antiquity* 2(3):199–226.

Aveni, Anthony F., ed.

1975 *Archaeoastronomy in Pre-Columbian America.* University of Texas Press, Austin.

1980 *Skywatchers of Ancient Mexico.* University of Texas Press, Austin.

Bassie-Sweet, Karen

1991 *From the Mouth of the Dark Cave: Commemorative Sculpture of the Late Classic Maya.* University of Oklahoma Press, Norman.

1996 *At the Edge of the World: Caves and Late Classic Maya World View.* University of Oklahoma Press, Norman.

Baudez, Claude F.

1984 "Le roi, la balle y el maïs: Images de jeu de ball Maya." *Journal de la Société de Américanistes* 70: 139–51.

1994 *Maya Sculpture of Copan: The Iconography.* University of Oklahoma Press, Norman.

Baudez, Claude F., ed.

1983 *Introducción a la arqueología de Copán, Honduras.* 3 vols. Proyecto Arqueológico Copán, Secretaría de Estado en el Despacho de Cultura y Turismo, Tegucigalpa.

Baudez, Claude F., and Peter Mathews

1985 "The Sun Kings at Copán and Quiriguá," in *Fifth Palenque Round Table, 1983,* V. M. Fields, ed., pp. 29–38. Pre-Columbian Art Research Institute, San Francisco.

Becker, Marshall J., Charles D. Cheek, Claude F. Baudez, Berthold Riese, and Anne S. Dowd

1983 "La Estructura 10L-18," in *Introducción a la arqueología de Copán, Honduras,* vol. 2, C. F. Baudez, ed., pp. 383–500. Proyecto Arqueológico Copán, Secretaría de Estado en el Despacho de Cultura y Turismo, Tegucigalpa.

Bell, Ellen E., Marcello A. Canuto, and Robert J. Sharer, eds.

2004 *Understanding Early Classic Copan.* University of Pennsylvania Museum of Archaeology and Anthropology, Philadelphia.

Berlo, Janet

1983 "The Warrior and the Butterfly: Central Mexican Ideologies of Sacred Warfare and Teotihuacan Iconography," in *Text and Image in Pre-Columbian Art: Essays on the Interrelationship of the Visual and Verbal Arts,* pp. 79–117. British Archaeological Reports, International Series 180, Oxford.

Bricker, Harvey M., and Victoria R. Bricker

1992 "Zodiacal References in the Maya Codices," in *The Sky and Mayan Literature,* A. F. Aveni, ed., pp. 148–183. Oxford University Press, Oxford.

1999 "Astronomical Orientation of the Skyband Bench at Copán. *Journal of Field Archaeology* 26:435–442.

Carlson, Robert, and Martin Prechtel

1991 "The Flowering of the Dead: An Interpretation of Highland Maya Culture." *Man* 26:23–42.

Coe, Michael D.

1956 "The Funerary Temple among the Classic Maya." *Southwestern Journal of Anthropology* 12:387–493.

1957 "The Khmer Settlement Pattern: A Possible Analogy with That of the Maya." *American Antiquity* 22 (4):409–10.

1973 *The Maya Scribe and His World.* Grolier Club, New York.

2004 "Gods of the Scribes and Artists," in *The Courtly Art of the Ancient Maya,* Mary Ellen Miller and Simon Martin, eds., pp. 239–241. Fine Arts Museums of San Francisco and Thames and Hudson, San Francisco and New York.

Coe, Michael D., and Mark Van Stone

2005 *Reading the Maya Glyphs.* 2nd edition. Thames and Hudson, London.

Collins, Lisa Marie

2002 "The Zooarchaeology of the Copan Valley: Social Status and the Search for a Maya Slave Class." Ph.D. dissertation, Department of Anthropology, Harvard University, 2002.

Danien, Elin C.

2002 *Guide to the Mesoamerican Gallery at the University of Pennsylvania Museum of Archaeology and Anthropology.* University of Pennsylvania Museum of Archaeology and Anthropology, Philadelphia.

Davis-Salazar, Karla L.

2001 "Late Classic Maya Water Management at Copán, Honduras." Ph.D. dissertation, Department of Anthropology, Harvard University.

2003 "Late Classic Maya Water Management and Community Organization at Copan, Honduras." *Latin American Antiquity* 14:275–99.

Davoust, Michel

1994 "Glyphic Names for Some Maya Scribes and Sculptors of the Classic Period," in *Seventh Palenque Round Table,* 1989, V. M. Fields, ed., pp. 105–11. Pre-Columbian Art Research Institute, San Francisco.

de la Fuente, Beatriz

1996 "Homocentrism in Olmec Monumental Art," in *Olmec Art of Ancient Mexico.* Elizabeth P. Benson and Beatriz de la Fuente, eds., pp. 40–49. National Gallery of Art, Washington, D.C.

Demarest, Arthur

2004 *The Ancient Maya: The Rise and Fall of a Rainforest Civilization.* Cambridge University Press, Cambridge.

Euraque, Darío A.

2004 *Conversaciones históricas con el mestizaje y su identidad nacional en Honduras.* Centro Editorial srl, San Pedro Sula, Honduras.

Fane, Diane

1993 "Reproducing the Pre-Columbian Past: Casts and Models in Exhibitions of Ancient America, 1824–1935," in *Collecting the Past,* E. Boone, ed., pp. 141–76. Dumbarton Oaks, Washington, D.C.

Fash, Barbara W.

1992 "Late Classic Architectural Sculpture Themes in Copan." *Ancient Mesoamerica* 3:89–104.

2001 "Copán Archive and Database Project." Report to the David Rockefeller Center for Latin American Studies, Harvard University, and the Foundation for the Advancement of Mesoamerican Studies, Inc.

2004a "Cast Aside: Revisiting the Plaster Cast Collections from Mesoamerica." *Visual Resources* 20(1):3–17.

2004b "Early Classic Sculptural Development at Copan," in *Understanding Early Classic Copan,* E. E. Bell, M. A. Canuto, and R. J. Sharer, eds., pp. 249–64. University of Pennsylvania Museum of Archaeology and Anthropology, Philadelphia.

2004c "Hieroglyphs and Casts on the Move." *Symbols* (Spring): 3–6.

2005 "Iconographic Evidence for Water Management and Social Organization at Copan," in *Copán: The History of an Ancient Maya Kingdom,* E. W. Andrews and W. L. Fash, eds., pp. 103–38. School of American Research Press, Santa Fe, N.M.

2009 "Watery Places and Urban Foundations Depicted in Maya Art and Architecture," in *The Art of Urbanism: How Mesoamerican Kingdoms Represented Themselves in Architecture and Imagery,* William L. Fash and Leonardo López Luján, eds., pp. 230–259. Dumbarton Oaks, Washington D.C.

n.d. "Purpose and Meaning of Ancient Ceremonial Architecture: A Comparative Analysis of Southeast Asian and Mesoamerican Traditions." Unpublished paper in possession of the author.

Fash, Barbara W., and Karla L. Davis-Salazar

2006 "Copan Water Ritual and Management: Imagery and Sacred Place," in *Precolumbian Water Management: Ideology, Ritual, and Power,* L. Lucero and B. Fash, eds., pp. 126–43. University of Arizona Press, Tucson.

Fash, Barbara, and William Fash

1994 "Copan Temple 20 and the House of Bats," in *Seventh Palenque Round Table, 1989,* V. M. Fields, ed., pp. 61–67. Pre-Columbian Art Research Institute, San Francisco.

Fash, Barbara, William L. Fash, Sheree Lane, Rudy Larios, Linda Schele, Jeffery Stomper, and David Stuart

1992 "Investigations of a Classic Maya Council House at Copán, Honduras." *Journal of Field Archaeology* 19(4):419–42.

Fash, William L.

1983a "Deducing Classic Maya Social Organization from Settlement Patterns: A Case Study from the Copán Valley," in *Civilizations in the Ancient Americas: Essays in Honor of Gordon R. Willey,* R. M. Leventhal and A. Kolata, eds., pp. 261–87. University of New Mexico Press, Albuquerque.

1983b "Reconocimiento y excavaciones en el valle," in *Introducción a la arqueología de Copán, Honduras,* vol. 1, C. F. Baudez, ed., pp. 229–470. Proyecto Arqueológico Copán, Secretaría de Estado en el Despacho de Cultura y Turismo, Tegucigalpa.

1986 "La fachada esculpida de la estructura 9N-82: Composición, forma e iconografía," in *Excavaciones en el área urbana de Copán,* vol. 1, W. T. Sanders, ed., pp. 319–82. Instituto Hondureño de Antropología e Historia, Tegucigalpa.

1989 "The Sculptural Façade of Structure 9N-82: Content, Form and Significance," in *House of the Bacabs, Copán, Honduras: A Study of the Iconography, Epigraphy, and Social Context of a Maya Elite Structure,* D. Webster, ed., pp. 41–72. Dumbarton Oaks, Washington, D.C.

2001 *Scribes, Warriors and Kings: The City of Copan and the Ancient Maya.* 2nd ed. Thames and Hudson, London.

2002 "Religion and Human Agency in Ancient Maya History: Tales from the Hieroglyphic Stairway." *Cambridge Archaeological Journal* 12(1):5–19.

2005 "Toward a Social History of the Copán Valley," in *Copán: The History of an Ancient Maya Kingdom,* E. W. Andrews and W. L. Fash, eds., pp. 73–101. School of American Research Press, Santa Fe, N.M.

Fash, William L., and Ricardo Agurcia, eds.

1996 *Visión del pasado maya.* Asociación Copán, San Pedro Sula, Honduras.

Fash, William L., Ric`ardo Agurcia Fasquelle, Barbara W. Fash, and Carlos Rudy Larios Villalta

1996 "Future of the Maya Past: The Convergence of Conservation and Restoration," in *Eighth Palenque Round Table, 1993,* pp. 203–11. Pre-Columbian Art Research Institute, San Francisco.

Fash, William L., and Barbara W. Fash

1990 "Scribes, Warriors, and Kings: Ancient Lives of the Copán Maya." *Archaeology* 43(3):26–35.

1996a "Building a World-View: Visual Communication in Classic Maya Architecture." *RES: Anthropology and Aesthetics* 29/30:127–47.

1996b "Maya Resurrection." *Natural History* 4:24–31.

1997 "Investing in the Past to Build a Better Future: The Copan Sculpture Museum in Honduras, Central America." *Cultural Survival Quarterly* 21(1):47–51.

2000 "Teotihuacán and the Maya: A Classic Heritage," in *Mesoamerica's Classic Heritage: From Teotihuacán to the Aztecs,* D. Carrasco, L. Jones, and S. Sessions, eds., pp. 433–64. University Press of Colorado, Niwot.

Fash, William L., Barbara W. Fash, and Karla L. Davis-Salazar

2004 "Setting the Stage: Origins of the Hieroglyphic Stairway Plaza on the Great Period Ending," in *Understanding Early Classic Copan,* E. E. Bell, M. A. Canuto, and R. J. Sharer, eds., pp. 65–83. University of Pennsylvania Museum of Archaeology and Anthropology, Philadelphia.

Fash, William L., and David Stuart

1991 "Dynastic History and Cultural Evolution at Copán, Honduras," in *Classic Maya Political History: Hieroglyphic and Archaeological Evidence,* T. P. Culbert, ed., pp. 147–79. Cambridge University Press, Cambridge.

Fash, William L., Alexandre Tokovinine, and Barbara W. Fash

2009 "The House of New Fire at Teotihuacan and Its Legacy in Mesoamerica," in *The Art of Urbanism: How Mesoamerican Kingdoms Represented Themselves in Architecture and Imagery,* William L. Fash and Leonardo López Luján, eds., pp. 201–229. Dumbarton Oaks, Washington D.C.

Fields, Virginia M., and Dorie Reents-Budet

2005 *Lords of Creation: The Origins of Sacred Maya Kingship.* Scala Publishers, London.

Finamore, Daniel, and Stephen Houston

2010 *Fiery Pool: The Maya and the Mythic Sea.* Yale University Press, New Haven.

Freidel, David, Linda Schele, and Joy Parker

1993 *Maya Cosmos: Three Thousand Years on the Shaman's Path.* William Morrow, New York.

Galindo, Juan

1835 "The Ruins of Copán in Central America," in *Arqueología Americana: Transactions and Collections of the American Antiquarian Society,* vol. 2, pp. 543–50.

Gordon, George Byron

1902 *The Hieroglyphic Stairway, Ruins of Copán.* Memoirs of the Peabody Museum of American Archaeology and Ethnology, vol. 1, no. 6. Cambridge, Mass.

Gordon, George Byron, comp.

1896 *Prehistoric Ruins of Copán, Honduras: A Preliminary Report on Explorations 1891–1895.* Memoirs of the Peabody Museum of American Archaeology and Ethnology, vol. 1, no. 1. Cambridge, Mass.

Graham, Ian

1963 "Juan Galindo, Enthusiast." *Estudios de Cultura Maya* 3:11–36.

1993 "Three Early Collectors in Mesoamerica," in *Collecting the Past,* E. Boone, ed., pp. 49–80. Dumbarton Oaks, Washington, D.C.

2002 *Alfred Maudslay and the Maya: A Biography.* British Museum, London.

Grube, Nikolai, and Linda Schele

1987 "The Date on the Bench from Structure 9N-82, Sepulturas, Copan, Honduras." Copan Note 23. Copan Mosaics Project and Instituto Hondureño de Antropología e Historia, Copan, Honduras.

Houston, Stephen D., ed.

1998 *Function and Meaning in Classic Maya Architecture: A Symposium at Dumbarton Oaks, 7th and 8th October 1994.* Dumbarton Oaks, Washington, D.C.

Houston, Stephen D., and Takeshi Inomata

2009 *The Classic Maya*. Cambridge University Press, New York.

Houston, Stephen, and David Stuart

1996 "Of Gods, Glyphs, and Kings: Divinity and Rulership among the Classic Maya." *Antiquity* 70 (268): 289–312.

Houston, Stephen D., and Karl A. Taube

1987 "'Name-tagging' in Classic Mayan Script." *Mexicon* (Berlin) 9(2):38–41.

2000 "An Archaeology of the Senses: Perception and Cultural Expression in Ancient Mesoamerica." *Cambridge Archaeological Journal* 10(2):261–94.

Houston, Stephen, Karl Taube, and David Stuart

2006 *The Memory of Bones: Body, Being, and Experience among the Classic Maya*. University of Texas Press, Austin.

Jackson, Sarah

2004 "Interpreting Copán's Structure 21A and Hieroglyphic Bench." *Symbols* (Spring):7–9. Peabody Museum of Archaeology and Ethnology, Cambridge, Mass.

Kappelman, Julia Guernsey

2001 "Carved in Stone: The Cosmological Narratives of Late Preclassic Izapan-style Monuments from the Pacific Slope," in *Cosmos and History: A Mesoamerican Legacy*, A. Stone, ed., pp. 100–124. University of Alabama Press, Tuscaloosa.

Kowalski, Jeff K., and William L. Fash

1991 "Symbolism of the Maya Ball Game at Copan: Synthesis and New Aspects," in *Sixth Palenque Round Table, 1986*, M. Greene Robertson and V. M. Fields, eds., pp. 59–67. University of Oklahoma Press, Norman.

Kreps, Cristina F.

2003 *Liberating Culture: Cross-Cultural Perspectives on Museums, Curation and Heritage Preservation*. Routledge, London.

Lara, Ankarino

1996 "The Sculpted Stone Vessels of Copán, Honduras: A Stylistic, Iconographic, and Textual Analysis of the Saklaktuns." Senior honors thesis, Department of Anthropology, Harvard University.

Leventhal, Richard

1983 "Household Groups and Classic Maya Religion," in *Prehistoric Settlement Patterns: Essays in Honor of Gordon R. Willey*, E. Z. Vogt and R. M. Leventhal, eds., pp. 55–76. University of New Mexico Press, Albuquerque.

Longyear, John M.

1952 *Copán Ceramics: A Study of Southeastern Maya Pottery*. Carnegie Institution of Washington, Washington, D.C.

Lowe, Gareth W., Thomas A. Lee Jr., and Eduardo Martínez Espinosa

1982 *Izapa: An Introduction to the Ruins and Monuments*. Papers of the New World Archaeological Foundation 31. New World Archaeological Foundation, Provo, Utah.

Lucero, Lisa J., and Barbara W. Fash, eds.

2006 *Precolumbian Water Management: Ideology, Ritual, and Power*. University of Arizona Press, Tucson.

Mannikka, Eleanor

1985 "Angkor Wat: Meaning through Measurement." Ph.D. dissertation, Department of the History of Art, University of Michigan.

Marcus, Joyce

1976 *Emblem and State in the Classic Maya Lowlands*. Dumbarton Oaks, Washington, D.C.

Martin, Simon

2006 "Cacao in Ancient Maya Religion: First Fruit from the Maize Tree and Other Tales from the Underworld," in *Chocolate in Mesoamerica: A Cultural History of Cacao*, Cameron L. MacNeil, ed., pp. 154–183. University Press of Florida, Gainesville.

Martin, Simon, and Nikolai Grube

2008 *Chronicles of the Maya Kings and Queens: Deciphering the Dynasties of the Ancient Maya*. 2nd ed. Thames and Hudson, London.

Mathews, Peter

1979 "The Glyphs from the Ear Ornaments from Tomb A-1/1," in *Excavations at Altun Ha, Belize, 1964–1970*, vol. 1, D. Pendergast, ed., pp. 79–80. Royal Ontario Museum, Toronto.

Matos Moctezuma, Eduardo, and Felipe Solís Olguín

2002 *Aztecas.* Royal Academy of Arts, London.

Maudslay, Alfred P.

1889– *Biologia Centrali-Americana, or, Contributions to the*
1902 *Knowledge of the Fauna and Flora of Mexico and*
 Central America: Archaeology. 6 vols. R. H. Porter,
 London.

McKeever-Furst, Jill Leslie

1995 *The Natural History of the Soul in Ancient Mexico.*
 Yale University Press, New Haven, Conn.

Milbrath, Susan

1999 *Star Gods of the Maya.* University of Texas Press,
 Austin.

Miller, Mary Ellen

1986 "Copan, Honduras: Conference with a Perished
 City," in *City States of the Maya Art and Architec-*
 ture, Elizabeth P. Benson, ed., pp. 72–108. Rocky
 Mountain Institute for Pre-Columbian Studies,
 Denver.

Miller, Mary Ellen, and Simon Martin

2004 *Courtly Art of the Ancient Maya.* Fine Arts Muse-
 ums of San Francisco and Thames and Hudson,
 San Francisco and New York.

Morley, Sylvanus G.

1920 *The Inscriptions at Copán.* Publication 219.
 Carnegie Institution of Washington, Washington,
 D.C.

Mortenson, Lena

2001 "Las dinámicas locales de un patrimonio global:
 Arqueoturismo en Copán, Honduras." *Mesoamer-*
 ica 42(December):104–34.

Newsome, Elisabeth

2001 *Trees of Paradise and Pillars of the World: The Serial*
 Stela Cycle of "18-Rabbit-God-K" King of Copan.
 University of Texas Press, Austin.

Nuttall, Zelia, ed.

1975 *The Codex Nuttall: A Picture Manuscript from*
 Ancient Mexico. A Peabody Museum Facsimile.
 Dover Publications, New York.

Pasztory, Esther

1974 *The Iconography of the Teotihuacan Tlaloc.* Dumbar-
 ton Oaks, Washington, D.C.

Plank, Shannon E.

2004 *Maya Dwellings in Hieroglyphs and Archaeology: An*
 Integrative Approach to Ancient Architecture and
 Spatial Recognition. British Archaeological Reports,
 International Series 1324. London.

Proskouriakoff, Tatiana

1946 *An Album of Maya Architecture.* Carnegie Institu-
 tion of Washington, Washington, D.C. Reprint,
 University of Oklahoma Press, Norman, 1963.

1950 *A Study of Classic Maya Sculpture.* Publication 593.
 Carnegie Institution of Washington, Washington,
 D.C.

1960 "Historical Implications of a Pattern of Dates at
 Piedras Negras, Guatemala." *American Antiquity*
 25:454–75.

Sanders, William T., ed.

1986– *Excavaciones en el área urbana de Copán: Proyecto*
1990 *Arqueológico Copán, Fase II.* 3 vols. Proyecto
 Arqueológico Copán, Secretaría de Cultura y
 Turismo, Instituto Hondureño de Antropología e
 Historia, Tegucigalpa.

Saturno, William A.

2000 "In the Shadow of the Acropolis: Río Amarillo and
 Its Role in the Copán Polity." Ph.D. dissertation,
 Department of Anthropology, Harvard University.
 University Microfilms, Ann Arbor, Mich.

Scarborough, Vernon L., and David R. Wilcox, eds.

1981 *The Mesoamerican Ballgame.* University of Arizona
 Press, Tucson.

Schele, Linda

1989 "A House Dedication on the Harvard Bench at
 Copán." Copan Note 51. Copan Mosaics Project
 and Instituto Hondureño de Antropología e His-
 toria, Copan, Honduras.

1990 "Preliminary Commentary on a New Altar from
 Structure 30." Copan Note 72. Copan Mosaics
 Project and Instituto Hondureño de Antropología
 e Historia, Copan, Honduras.

1991 *Notebook for the XV Maya Hieroglyphic Workshop at*
 Texas: Yaxchilan, the Life and Times of Bird Jaguar.
 Institute for Latin American Studies, University of
 Texas, Austin.

Schele, Linda, and David A. Freidel

1990 *A Forest of Kings: The Untold Story of the Ancient*
 Maya. William Morrow, New York.

Schele, Linda, and Peter Mathews

1998 *The Code of Kings: The Language of Seven Sacred Maya Temples and Tombs.* Simon and Schuster, New York.

Schele, Linda, and Mary Ellen Miller

1986 *The Blood of Kings: Dynasty and Ritual in Maya Art.* Kimbell Art Museum, Fort Worth, Texas.

Schele, Linda, and David Stuart

1986 "Te-Tun as the Glyph for 'Stela'." Copan Note 1. Copan Mosaics Project and Instituto Hondureño de Antropología e Historia, Copan, Honduras.

Sharer, Robert J., David W. Sedat, Loa P. Traxler, Julia C. Miller, and Ellen E. Bell

2005 "Early Classic Royal Power in Copan: The Origins and Development of the Acropolis ca. A.D. 250–600," in *Copán: The History of an Ancient Maya Kingdom,* E. W. Andrews and W. L. Fash, eds., pp. 139–237. School of American Research Press, Santa Fe, N.M.

Shaw, Jonathan

1997 "Maya Museum: Renewing a Century of Harvard Connection to Copán." *Harvard Magazine* 99(3): 41–43.

Sheehy, James J.

1981 "Notas preliminares sobre las excavaciones en CV-26, Copan." *Yaxkin* 4(2):133–43. Tegucigalpa.

1991 "Structure and Change in a Late Classic Maya Domestic Group at Copan, Honduras." *Ancient Mesoamerica* 2(1):1–19.

Spinden, Herbert J.

1913 *A Study of Maya Art: Its Subject Matter and Historical Development.* Peabody Museum of American Archaeology and Ethnology, Cambridge, Mass.

Stassano, Angela

2005 Interview for "The Making of the Copan Sculpture Museum." Videotaped by Barbara Fash and Emily Dotton; translated by Barbara Fash. Peabody Museum of Archaeology and Ethnology, Cambridge, Mass., January 15.

Stephens, John L.

1841 *Incidents of Travel in Central America, Chiapas and Yucatan.* 2 vols. New York.

Stomper, Jeffrey Alan

1996 "The Popol Na: A Model for Ancient Maya Community Structure at Copan, Honduras." Ph.D. dissertation, Department of Anthropology, Yale University.

Strømsvik, Gustav

1935 "Copán." *Carnegie Institution of Washington Yearbook* 34:118–20.

1940 *Substela Caches and Stela Foundations at Copán and Quiriguá.* Contributions to American Anthropology and History 37. Carnegie Institution of Washington, Washington, D.C.

1950 *The Ball Courts at Copán, with Notes on Courts at La Union, Quiriguá, San Pedro Pinula, and Asuncion Mita.* Contributions to American Anthropology and History 55. Carnegie Institution of Washington, Washington, D.C.

Stuart, David

1986 "The Glyph for Stone Incensario." Copan Note 2. Copan Mosaics Project and Instituto Hondureño de Antropología e Historia, Copan, Honduras.

1989 "Comments on the Temple 22 Inscription." Copan Note 63. Copan Mosaics Project and Instituto Hondureño de Antropología e Historia, Copan, Honduras.

1991 "Hieroglyphs and Archaeology at Copán." *Ancient Mesoameric* 3(1):169–85.

1996 "Kings of Stone: A Consideration of Stelae in Classic Maya Ritual and Representation." *RES: Anthropology and Aesthetics* 29/30:148–71.

1998 "The Fire Enters His House: Architecture and Ritual in Classic Maya Text," in *Function and Meaning in Classic Maya Architecture,* S. D. Houston, ed., pp. 373–425. Dumbarton Oaks, Washington, D.C.

2000 "The Arrival of Strangers: Teotihuacan and Tollan in Classic Maya History," in *Mesoamerica's Classic Heritage: From Teotihuacan to the Aztecs,* D. Carrasco, L. Jones, and S. Sessions, eds., pp. 465–514. University Press of Colorado, Niwot.

2008 "Sourcebook for the Maya Meetings." Mesoamerican Center, Department of Art and Art History, University of Texas at Austin.

Stuart, David, and Stephen Houston

1994 *Classic Maya Place Names.* Studies in Pre-Columbian Art and Archaeology 33. Dumbarton Oaks, Washington, D.C.

Taladoire, Eric

1981 *Les terrains de jeu de balle Mésoamérique et sud-ouest des Etats-Unis.* Mission Archéologique et Ethnologique Française au Mexique, Mexico, D.F.

Tate, Carolyn

1992 *Yaxchilan: The Design of a Maya Ceremonial City.* University of Texas Press, Austin.

Taube, Karl A.

1992 *The Major Gods of Yucatan.* Dumbarton Oaks, Washington, D.C.

2000 "The Turquoise Hearth: Fire, Sacrifice, and the Teotihuacan Cult of War," in *Mesoamerica's Classic Heritage: From Teotihuacán to the Aztecs,* D. Carrasco, L. Jones, and S. Sessions, eds., pp. 269–340. University Press of Colorado, Niwot.

2004 "Structure 10L-16 and Its Early Classic Antecedents: Fire and the Evocation and Resurrection of K'inich Yax K'uk' Mo'," in *Understanding Early Classic Copan,* E. E. Bell, M. A. Canuto, and R. J. Sharer, eds., pp. 265–95. University of Pennsylvania Museum of Archaeology and Anthropology, Philadelphia.

Tedlock, Barbara

1992 *Time and the Highland Maya.* 2nd ed. University of New Mexico Press, Albuquerque.

Tedlock, Dennis

1996 *Popol Vuh: The Mayan Book of the Dawn of Life.* Rev. ed. Simon and Schuster, New York.

Thompson, J. Eric S.

1970 *Maya History and Religion.* University of Oklahoma Press, Norman.

1971 *Maya Hieroglyphic Writing: An Introduction.* 3rd ed. University of Oklahoma Press, Norman.

Tozzer, Alfred M.

1941 *Landa's* Relación de las cosas de Yucatan: *A Translation.* Papers of the Peabody Museum of American Archaeology and Ethnology 18. Cambridge, Mass.

Trik, Aubrey S.

1929 *Temple XXII at Copán.* Publication 509. Carnegie Institution of Washington, Washington, D.C.

Turner, B. L. II, William Johnson, Gail Mahood, Frederick M. Wiseman, B. L. Turner, and Jackie Poole

1983 "Habitat y agricultura en la región de Copan," in *Introducción a la arqueología de Copán, Honduras,* vol. 1, C. F. Baudez, ed., pp. 35–142. Proyecto Arqueológico Copán, Secretaría de Estado en el Despacho de Cultura y Turismo, Tegucigalpa.

Valdés, Juan Antonio, Federico Fahsen, and Héctor Escobedo

1994 *Obras maestras del Museo de Tikal.* Parque Nacional Tikal, Instituto de Antropología e Historia de Guatemala, Ministerio de Cultura y Deportes, Guatemala City.

Viel, Rene

1999 "The Pectorals of Altar Q and Temple 11: An Interpretation of the Political Organization at Copán, Honduras." *Latin American Antiquity* 10: 377–99.

Vogt, Evon Z.

1969 *Zinacantan: A Maya Community in the Highlands of Chiapas.* Harvard University Press, Cambridge, Mass.

1981 "Some Aspect of the Sacred Geography of Highland Chiapas," in *Mesoamerican Sites and World-Views,* E. P. Benson, ed., pp. 119–42. Dumbarton Oaks, Washington, D.C.

Volwahsen, Andreas

1969 *Living Architecture.* Translated by Ann E. Keep. Grossett and Dunlap, New York.

Von Winning, Hasso

1987 *La iconografía de Teotihuacan: Los dioses y los signos.* Universidad Nacional Autónoma de Mexico, Mexico City.

Wagner, Elizabeth

2006 "Ranked Spaces, Ranked Identities: Local Hierarchies, Community Boundaries and an Emic Notion of the Maya Cultural Sphere at Late Classic Copán," in *Maya Ethnicity: The Construction of Ethnic Identity from Preclassic to Modern Times,* F. Sachse, ed., pp. 143–64. Proceedings of the Ninth European Maya Conference, Bonn, December 10–12. Verlag Anton Saurwein, Markt Schwaben, Germany.

Webster, David, ed.

1989 *House of the Bacabs, Copán, Honduras: A Study of the Iconography, Epigraphy, and Social Context of a Maya Elite Structure.* Dumbarton Oaks, Washington, D.C.

Webster, David, Barbara Fash, Randolph Widmer, and Scott Zeleznik

1996 "The Skyband Group: Investigation of a Classic Maya Elite Residential Complex at Copan, Honduras." *Journal of Field Archaeology* 25(3):319–43.

Whittington, E. Michael

2001 *The Sport of Life and Death: The Mesoamerican Ballgame.* Thames and Hudson, London.

Willey, Gordon R., William R. Coe, and Robert J. Sharer

1976 "Un proyecto para el desarrollo de investigación y preservación arqueológica en Copán, Honduras, y vecinidad." *Yaxkin* 1:10–29. Tegucigalpa.

Willey, Gordon R., Richard M. Leventhal, Arthur A. Demarest, and William L. Fash

1994 *Ceramics and Artifacts from Excavations in the Copán Residential Zone.* Papers of the Peabody Museum of Archaeology and Ethnology 80. Cambridge, Mass.

Willey, Gordon R., Richard M. Leventhal, and William L. Fash

1978 "Maya Settlement in the Copan Valley." *Archaeology* 31(4):32–43.

Wisdom, Charles

1940 *The Chorti Indians of Guatemala.* University of Chicago Press, Chicago.

1961 *Los Chortis de Guatemala.* Ministerio de Educación Pública, Guatemala City.

Index

Entries in boldface indicate illustrations.

117; stucco, 118, 119, 120; sun and, 115, 117; symbolism of, 114

Machorro, Eleodoro, **175**

Madrid Codex, 126

maize, 118, **118**, 176; cacao and, 127; creation story, 99; cycle, 127; iconography, 170; resurrection scene, **126**; sacrificial death of, 127

maize deities, 125, 127, 128, **129**, **166**, 169, 170, 176

"Man of Tikal," 96, **96**

Margarita structure, 37, **38**, 42; modeled stucco of, **44**

Martin, Simon, 91, 125–126

Martorano, Emily, **164**

masks: carving of, 138, **138**; chahk, 154, **154**, 176; corner, 65, **95,** 125, 128, **128**; death, 86, 94–95, **95**, 160; jaguar, **152**; monster, 85–86, **86**; mosaic, 86, **138**; mountain, 86, 127, 128, **128**; reptilian, 137; skeletal, 43, 63, 86; substructure, **40**, **41**; temple, 109; Tlaloc, 63, 67, 69, **70**, **74**; war serpent, 111, **111**; *witz*, 86, 127, 128, **128**, **162**, 163

masons, 36, 38, 42, 163, 168, 176; economic power of, 177

masterpiece, 6, 12, **82**, 83

mat symbol, **142**, 143, 170

Maudslay, Alfred P., 26, 27, 49, 70; Altar Q and, 44; excavation by, 123–124; Hieroglyphic Stairway and, 102; Structure 16 and, 67, 68; Structure 22 and, 124; Temple 22 doorway and, 124

Maya, 3, 96–97; ancestor reverence by, 35; architecture of, 4, 21, 29, 113, 175; art of, 28, 68, 91, 95, 113, 135, 157, 173; astronomy of, 21; calendar, 51, 53; Chorti, 21, 43, 143; creation myth of, 114, 125; Kiche, 61; Lacandon, 159; language of, 21, 23, 173; map of, **22**; religion, 43, 112, 125, 127; subjugation of, 22, 23; symbols of, 180; urban centers of, 21, 101; worldview of, 80

Membreño, Rufino, 64

Mesoamerica, map of, **22**

Milky Way, 124, 126

Miller, Julie, 74, 76, **76**

milpa (agricultural field), 6, 115

moan birds, 167

molds, 15, 16, 41

monkey, 25, 83, 84, 85, 170

Monkey Scribes. See *pawahtuns*

moon, 35, 36, 65, 98, 167

moon goddess, **167**

"Moon Jaguar." *See* Ruler 10

Morley, Sylvanus, 28, 31, 49, 102, 108, 161; Proskouriakoff and, 29; stelae and, 54; Structure 26 temple inscription and, 106

motifs: *ajaw*, 84, **84**, 85, 114, 163; butterfly, **76**, 77, 79, **111**, 156; centipede (*chapaat*), 65, 110, 135; feather, 10; fish, 122, **144**, 145, 154, 155; flower, 57, 77, **77,** 84, 127, 144, 154, 159, 161; fringed eye, **110**; human figure, 10; mask, 10; sculptural, **76**, 77, 85, 110–111, **110**, 164, **164**, 174; serpent, 17, 42; vegetation, 10, 127, **170**; war serpent, 46; woven mat, 59, 138, **138**, 142, 143, 144, **144**, 176

"Motmot" floor marker, 78–81, **78**, **79**

mountain, sacred, 4, 6, 42, 43, 66, 70, 114, 125, 127, 128, 129. *See also* Rosalila

mountain cave, **70**, 99, 118, 127; of origin, 63

Mo'witz Ajaw, 73

Museo Etnografico Castello d'Albertis, Genoa, 59

mythology, 145

na (house), 135, 137, 143

National Geographic Society, 93

National Science Foundation, 33

natural disasters, 24

New Fire ceremony, 45, 110, 156, 160, 163

niche, 16, 83, 84, 85, 86, 94, 95, 108, 124, 136, 137, 144, 145, 157, 160, 169, 170; rectangular, 65; serpent, 66, 68, 111, 135, **135**

night sky, 56, 124, 126, 157, 167

night sun god, **17**, **167**

nik ("flower"), 84, 144

9 Ajaw glyphs, **144**, 145–146

Nine Lords of the Night, 145, 147

noble, 59, 105, 111, 131, 132–133, 138, 141, 143, 146, 149, 152, 154, 166, 167, 168, 169

numerology, 110, 115

Núñez Chinchilla, Jesús, 30, **30**

obsidian, 7, 25, 72, **76**, 77, 79, 110, 131

Obsidian Butterfly (Itzpapálotl), 77

offerings, 38, 43, 50–51, 52, 59, 63, 92, 94, 152; ceramic, 80; dedicatory, 58, 80, 154; directional, **79**; fire, 42, 67; food, 90, 91; incense, 56; termination, 39. *See also* rituals

Olmec, 95, 96, 97

One Hunter, 119

origin myth, 45, 66, 109. *See also* Tollan

Owens, John, 27, 102

owls (*kuy*), 69, 109

PAAC. *See* Proyecto Arqueológico Acrópolis Copán
PAC. *See* Proyecto Arqueológico Copán
Pacal, tomb of, 43
Pahl, Gary: excavations by, 162
paint pot, 131, 135
paints, 15–16, 51
Palenque, 21, 26, 43, 56, 59, 104, 152, 159
Palka, Joel, 63
Papagayo structure, 94, **95**, 102, 105
Pastor Fasquelle, Rodolfo: cultural identities and, 179
patron deity, 73, 101, 136, 152
patron god, 98, 146, 160
pawa ("net"), 136
pawahtuns (Monkey Scribes), 121, 122, 136, 137
Pax, month of, 171
pax ("drum"), 171
Peabody Museum of Archaeology and Ethnology, 13, 28, 30, 67, 102, 106, 127, 129, 152; Copan Sculpture Museum and, 73; expeditions by, 27, 58, 153
pectoral insignia, 67, 144, 135, 137, 170
Pennsylvania State University, 17, 29, 32, 33, 165
Pérez, José, **120**
period ending. *See* rituals
Phillip II, King, 25
Piedras Negras, 51
pigment, 39, 51, 80, 96
place name, 105, 144, 147, 154, 155, 175; hieroglyphic, 145, **145**
plaster, 26, 27, 39, 40, 41, 46, 50, 73, 76, 103, 108, 156, 163; roof, 154
platform, 5, 47, 58, 62, 64, **65**, 66, **66**, 67, 70, **91**, 95, **97**, 122, 124, 127, 133, 147, 152, 156, 158, 160, 169; dance, 90, 146; outset, 63
Plaza B, 98
"Plaza de los Muñecos," 97
political message, 120, 176
political structure, 133, 147
pop (mat), 143, 144, 170
Popol Vuh, 61, 77, 81, 115, 119, 143
popolna ("mat house"), 143, 147, 154
population, ancient, 12, 24, 25, 102, 121, 134, 149
Posas, Vicente, **174**
Preclassic period, 23–24, 96, 133
primordial sea, 125, 127, 169
Principal Group, **29**, 85, 89, 90, 116, 120, 131, 132,

134, 141, 150, 164, 176; conservation efforts at, 33; Copán Ruinas and, 24; excavation of, 30, 31, 32, 33; Las Sepulturas and, 165; public projects at, 176; restoration of, 29, 30; sculptures from, 86
Proskouriakoff, Tatiana, **29**, 51, 122, 141, 142, **142**; ballcourt and, 116; Copan stelae and, 54; drawings by, 29–30, **29**
Proyecto Arqueológico Acrópolis Copán (PAAC), 8, 9, 18, 37, 39–40, 76, 118, 153, 157; excavations by, 14, 142; subprojects of, 33
Proyecto Arqueológico Copán (PAC I), 31, 76, 133
Proyecto Arqueológico Copán (PAC II), 32, 33, 133, 134, 139
pu signs, 64, 66, **76**

Quarry Hill, **24**
quatrefoil, 78, 80, 94, 160, 169
Quebrada Salamar, 164
Quebrada Seca, 164
Quebrada Sesesmil, 28
quetzal bird, 42, 46
Quintana Roo, Mexico, 143
Quirigua, 96, 104, 111, 114

rain, 3, 6, 19, 143, 66, 67, 99, 102, 150, 151, 152, 162, 176
Ramírez, Erasmo, **174**
Ramírez, Jacinto Abrego, **14**, 15, **15**, 18, 120, **120**, 126; floor marker by, 78; Rosalila replica and, 41
Ramos, Jorge, 64; drawings by, 15
Rastrojón, 150, 164, 178; sculptural motifs from, 164, **164**
rattle motif, 170, **170**, 171
Rattray, Evelyn, 165
rebirth, 43, 59, 64, 71, 85, 87, 113, 115, 117
reconstruction: 12, 14, 29, 65, 68, **73**, 74, **74**, 77, **106**, 108, 116, **116**, 117, **117**, 120, 134, 138, 158, 173, 176; architectural, 29, **29**, 30, **112**, 141, **142**; codes, 12; of Rosalila, 39, 41, **41**; of stairways, 63, 64, 102, 104; of solar cartouches, **171**; of Structure 8N-66S, 168, **168**; of Structure 9N-82, **136**; of Structure 22A, 141, **142**, **143**; of Structure 29, **159**; of Structure 32, **151**; of Structure 33, **155**; sandbox, **10**, **110**, **166**
red, 6, 36, 51, 71, 96, 120, 163
regeneration (*k'exol*), 43
Reina, Carlos Roberto, 9, **172**
Reina, Luis, 17–18, **174**

underworld, 6, 43, 56, 61, 63, 64, 65, 66, 70, 72, 77, 78, 79, 80, 81, 86, 115, 117, 126, 136, 152, 157, 160; journey, 62, 159, 169; maw of, 124, 135

UNESCO World Heritage site, 3

United States Agency for International Development (USAID), 7, 33

Universidad Nacional Autónoma de México, 165

University of Pennsylvania, 29, 31, 33

urban core, 149, 150, 166, 178

Uxwitik (ancient name for Copan), 47

Uxwitza (Three Water Hills place), 105

Valdés, Marcelino, **14,** 15, **15,** 18, 120, **120,** 126; Rosalila replica and, 41

vaulted room, 150, 157

Vásquez Rosa, Santos, 13–14, **13, 174, 175**

Venice Charter (1964), 12

Venus, 123, 124, 129, 167

Villeda, Joel, **174**

visual communication, 173–176

Vogt, Evon, 145

volcanic tuff, **24,** 25, 50, 131, 163

Vucub Caquix, 115, 119

Wagner, Elizabeth, 147

Wak Lom Cha'an (Six Sky Piercer, or fire serpent), 110

War Serpent, **111,** 164; masks, 111, **111;** shields, **163**

warfare, 24, 101, 102, 111

warrior cult, 67, 70, 79

warrior figures, 79, **111;** Tlaloc, **69,** 77, 109

Warrior Serpent, 79

warrior soul, 79, 111, 161

water, 24, 43, 67, 87, 99, 103, 114, 118, 121, 122, 125, 127, 139

water cascade, 86, 87, **87**

water-lily imagery, 139, 152, 154, 155, 169, 170

Water-lily Monster, 152

water management, 121, 139, 154, 155, 170

water sources, 23, 139, 145, 170

water symbolism, 87, 114

waterbirds, 86–87, **87**

wayabil (house effigy), 160, **160**

Waxaklajun Ubaah K'awiil. *See* Ruler 13

Webster, David, 32, 133, 136, 137, 165; sculpture block and, 134; "Skyband Group" and, 166

Wélchez V., Raul, 11

West Court, 27, 122, 170

Wi' Ohl K'inich. *See* Ruler 8

Willey, Gordon R., 31, **31,** 132, 133

Wite'naah, 47, 109; glyph, **160**

witz masks, 86, 127, 128, 163; reassembly of, **128, 162**

witz monsters, **70,** 125, 128, **128**

woven mat, **138**

worldview, 4, 5, 59, 80, 147

Xalla compound, 164

Xibalba, 61

xikin chahk (water plant; "ear of Chahk"), 152

Xuihcoatl (Aztec meteor fire serpent), 110

xuihmopilli ("bundle of years"), 160

yax ("blue-green"), 40, 46, 47, 125; sign, 65

Yax (temple), 40, 80

Yax Hal Witznal temple, 124, 126

Yax Pasaj Chan Yopaat. *See* Ruler 16

Yaxchilan, 65, 115, 159

yaxk'in motif, **39,** 43, 65

year signs, 68, **156, 157,** 163, 164

Yehnal structure, 37, 38, 42; stucco design of, **44**

Yohl ahk (turtle carapace), 125

Yucatan Peninsula, 21, 29, 92, 134, 139, 143

Zotzi-ha (House of the Killer Bat), 81

Zuyua language, 109

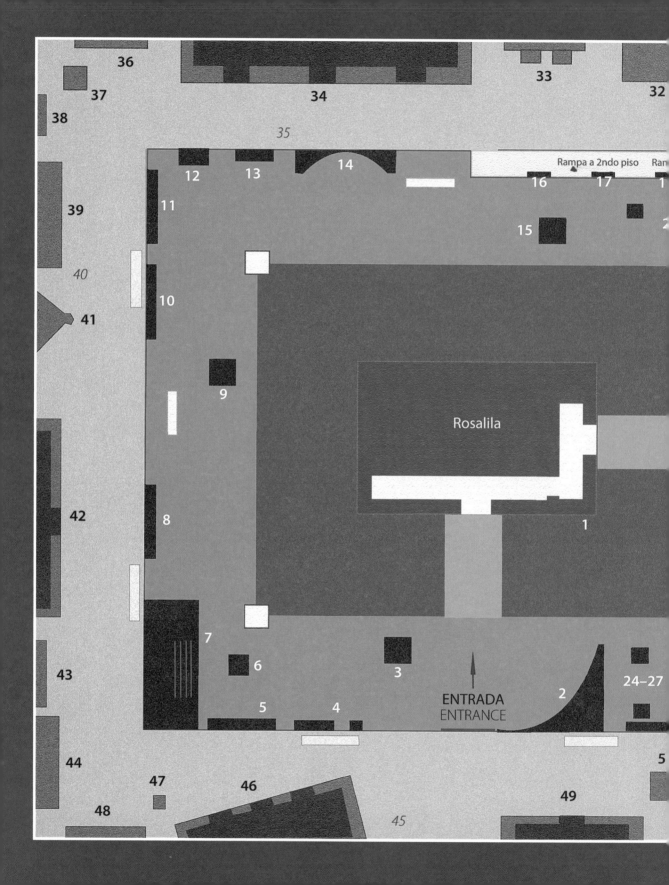